Pollyanna in the Brier Patch

Pollyanna
in the
Brier Patch

THE COMMUNITY ARTS MOVEMENT

Joseph Golden

Illustrations by David Hicock

SYRACUSE UNIVERSITY PRESS

The paper used in this publication meets the minimum requirements of American National Standard for Information Sciences—Permanence of Paper for Printed Library Materials, ANSI Z39.48–1984. ∞™

Library of Congress Cataloging-in-Publication Data

Golden, Joseph, 1928–
 Pollyanna in the brier patch.

 Bibliography: p.
 Includes index.
 1. Arts and society—United States. 2. Community arts projects—United States. I. Title.
NX180.S6G56 1987 700'.1'030973 87-9906
ISBN 0-8156-2408-5 (alk. paper)

Manufactured in the United States of America

Contents

Preface

*L*ike an album of photographs taken over a ten-year period, the essays, articles, and speeches assembled in this volume represent personal snapshots of the ambition, heroism, absurdity, and vulnerability of the community arts movement in the 1970s and 1980s.

The movement has become, in many respects, the apotheosis of cultural democracy in action—a demand for the freedom to assert the artistic prerogatives and goals unique to one's own community, to establish the arts as a resource for, and reservoir of, community identity, character, and pride, and to expose the wealth of creative treasures that lie in among the grass roots.

Heady prerogatives. Noble goals.

The race to achieve them has been hectic, if not tumultuous. The community arts movement is young, barely a generation old, but has taken on some formidable and demanding tasks. Five of the more prominent tasks are viewed as solemn mandates: restore the relevance of the arts; get the arts back into the school curriculum; turn our communities into an Eden of the Arts; saturate the nation with visiting performing artists; prescribe the arts as an antidote to the malaise of urban centers.

These five popular mandates constitute the structure of this book. The collected pieces are the snapshots—both sympathetic and critical of what the mandates mean and how well they are being fulfilled.

Even when they appear to be critical, they are not angry. The potential of a community arts movement in the United States—surely a most powerful grass-roots effort to celebrate creativity, beauty, and civility—is virtually limitless and ought to be a source of enormous optimism. When this optimism fails to guard itself against, and adapt to, the thorny imperatives of a not wholly sympathetic society we see the image of Pollyanna in the Brier Patch.

The purpose of these essays is to point out the thorns and perhaps to offer some protection against them.

Introduction

The title adopted here—*Pollyanna in the Brier Patch*—is not in-tended to irritate or mystify a children's librarian. However, I must admit there are some elements of a children's story about it—complete with the usual assortment of good little boys and girls, innocently building sand castles and mud pies, dressing up like mommies and daddies to put on a show, drawing mischievous little pictures on the backyard fence.

And, of course, the familiar collection of mean guys—the vil-lains who invade the secret gardens, step on the sand castles, and kick over the paint pails. And the inevitable variety of good fairies who, with a twitch of a wand, would turn spinach into popsicles and rainy days into weenie roasts, then banish the bad guys like so many ticks from a flea collar.

Well, this is not a course in children's literature. And if it were, I wouldn't be talking about sweetsie kids in sand piles, or good fairies.

The literature has grown up and consorts with the real world. The only field that will sometimes try to cling to the Pollyanna syndrome—a view of the world and its people as infinitely beautiful, as always giving and loving, as constantly perfectible—has been us: the community arts agency folks.

We have thrived on the self-contained notion that our percep-tion of beauty, truth, and quality of life will produce good and rele-vant things—including lots of bucks. That to perpetuate our good and relevant deeds on behalf of the arts we need to be an entity of the world, but somehow privileged to stay apart from it. We are a

bit startled, in fact, when the good and relevant pearls we cast produce grunts, not rapture.

A city council turns us down. "Those Philistines! Don't they know what joy we can create?"

A fund drive fails: "How do we now expose the children to the magic of great music?"

A trade union rejects our request: "Don't they understand how beautiful the dancers are?"

Despite the familiar barrage of everyday problems, the scrounging for dollars, the battling of bureaucracies, the hand-wringing over volunteers and boards, and all those wonderful agonies we deserve medals for, many of us have staunchly hung onto our virginity in the belief that the inherent power of the arts would protect and sustain us. That it was enough to "love the arts" and enshrine the artist.

We are Pollyannas who failed to notice that we were wandering into the brier patch. We are, in fact, naked babes in a field of cold and stinging thorns that have always been there and that now have the poor taste to make themselves felt. Conveniently, we can pin the blame on Gonzo's friend. It would be simple and satisfying to blame our current suffering on those insensitive featherheads in Washington.

The rationale for our tremors and vulnerability is reinforced by our trade publications. If we read the analyses prepared by the American Council for the Arts, National Assembly of Local Arts Agencies, National Assembly of State Arts Agencies, Arts & Government, and all those other agency publications, we find them enthralled with "the big crisis." These reports drip with "it has been rumored," "we are led to believe," "write immediately," "recision," "reconciliation," "cutbacks," and "the new tax legislation." The rumbles, gossip, and sudden changes have strung some of us out, transforming us into Gelusil Warriors and Migraine Marauders.

All this disaster talk is becoming so redundant and labored it has all the excitement of an early episode of *Leave It To Beaver.*

But we're caught up in it—and believe that we can actually *see* the thickening clouds blocking out the grants and actually *feel* the earth ready to gape and swallow up our clothesline art shows.

I don't mean to minimize the prevailing condition and threat—but who is affected, really? A number of cultural organizations will die in a glorious affirmation of the Darwinian theory of natural selection. They were weak and marginal to begin with, and now

have a splendid excuse for packing it in. *Requiescat in pacem.*

A large number of organizations will wonder what the shouting's about. I talked by phone to nearly two hundred such organizations while with the National Endowment for the Arts (NEA), most of them blithely unconcerned about the behavior of Washington bureaucrats. Especially the community art associations (CAAs) that never did ask for federal assistance and got precious little from their state; CAAs that turn out a bustling bunch of programs that have community-wide impact, and that require very little investment—and invite no interference. Almost never having been suckled, they'll never need to be weaned.

Then there's a third group, relatively small in number, for which the 5-7 percent of NEA funding support means a lot more. They will agonize. Probably retrench. Maybe start getting serious about operational streamlining and tougher internal controls.

All three groups—in their Pollyanna-like enchantment—have been victims of, and contributors to, the present condition by engaging in a cultural inflation during the past fifteen years. It was a period during which the great gas bag of American arts has been expanding at an alarming rate. Our ears weren't, evidently, sharp enough to hear the tell-tale hisses as seams began to weaken. Arts councils appearing like fruit flies; service organizations being born in batches, stumbling over themselves to find an unused acronym; regional symphony orchestras going from doubles to triples when they can hardly fill the doubles; conferences, workshops, and meetings (an autonomous industry) that you could attend from September 1 to July 15 without either getting home or having time to wash your clothes; old movie houses being saved—sometimes in clumps—often without the money to fix them or the brains to run them; corporate support skyrocketing from $205 million in 1965 to $2.7 billion in 1985; presenters in the same city, each bringing in a folklorico dance company, each a chamber music series, each an opera company, each a classical pianist, and each the Amazing Kreskin—all in the same season.

It has been a glorious era—a muscle-stretching and mind-bending time. "More is better" has become our operational ethic—thanks to obligations imposed by union contracts, new theaters that need filling, and personal egos that need satisfying. Sugar plum fairies have been dancing all around the shiny new cultural institutions, facilities, and programs that bring grace and beauty to the impoverished landscape of the soul.

The momentum was there. We even had mayors and urban planners believing that by transforming the old glue factory into an arts center we could rescue and rehabilitate twelve blocks of downtown. There are those dumb good fairies again, goading us into commitments and policies that were untenable.

There was magic and dream in the air, a faintly unreal atmosphere, a natural setting for Pollyanna.

But then—as in any good children's story—the wicked witches appeared and dragged us into the briers. One was the Actor from the Golden West. The other was us.

I'll pass on the first. He and his administration have been robustly roasted for their arbitrary and ill-advised actions and need no further elaboration here.

Besides, we've done a good enough job as "heavies" ourselves. One might almost suggest that the calamity that has been burdening us lately is a calamity we, in part, created ourselves, that we invited. In our passionate and lyrical myopia, we may have failed to notice that we were waltzing ourselves into the brier patch.

It was easy. We all did it, despite a few red flags waving frantically at the corners of our eyes. We invited it when we fell comfortably into the knee-jerk expectation of public monies, operating under an imperious syllogism: the public needs the arts; the government collects public tax dollars; therefore, tax dollars should support the arts. (We seemed to have remembered little and learned less from the last time the U.S. government was in the arts-supporting business, and the equally whimsical and unceremonial fashion with which the Federal Theatre project was dumped.)

We invited it by tinkering at lobbying—earnestly, but sporadically—behaving more like sprinters than long-distance runners, more like hummingbirds than panthers, more like Cub Scouts than Teamsters.

Advocacy groups exist. Many are effective. But all will admit that it's hard to "go back to the well for still *another* letter"—an obligation that would hardly ruffle a member of the Moral Majority.

Does it mean that a born-again fundamentalist view of life is more worthy of hard work and intense loyalty, is more just, is more valuable, than the effort of an artist to foster a humane civilization?

We represent (if the arrogance is allowed) one of the major hallmarks of a relevant and healthy society. Judging by the fiscal and philosophical jerking around in Washington affecting the arts, the word hasn't gotten through.

We invited it when we accepted polite, ephemeral, and prag-
matic leadership at the national level, the kind that is ready to
capitulate to the administration's brutal cuts, ignoring the true
needs of their constituents, and fussing over the division of the
spoils.

We invited it when we indulged in internecine warfare, debat-
ing the turfs and prerogatives of agencies and associations and
muddying the waters by puerile arguments over issues of, say, popu-
lism vs. elitism.

We invited it when we indulged in a tedious proliferation of
service agencies, each professing to offer services to the field, the
discipline, the neighborhood, the region, the county, the state, the
nation. And all of them, collectively, lacking the clout of a Steamfit-
ter's local. All of them, collectively or individually, apparently help-
less to combat the insidious and pervasive anti-intellectualism, the
malignant inverse snobbery, the image of the artist as the pam-
pered darling of the wealthy that often seems to float like a suffocat-
ing miasma over Capitol Hill and elsewhere.

None of these sinister deeds are without the possibility for re-
demption. All the deeds are loaded with wonderful instruction. So
what do we do? What are our immediate options for dealing with
the gloomy conditions and the special contributions we've made
that helped create these conditions?

On a short-term basis, how about the following:

• Whimpering is nice. It's quiet, mostly private and tasteful
(screaming is tacky).

• Bitching is very fulfilling, especially if loud and authoritative.

• There are the traditional strategies: letters, phone calls, tele-
grams, and visits seem to have had an unexpected and under-
whelming effect. We seem to have produced a remarkable and direct
correlation between the volume of mail and the magnitude of cuts.
More mail, more cuts (another 5,000 bags and we go back to zero).
Sad. We were just beginning to build a good head of lobbying steam,
and the boiler explodes in our face.

• We might turn violent and try a few terrorist or guerrilla
tactics—ransack the American Council for the Arts office and hold
Lou Harris hostage. We might, at gun point, pirate a truckload of
New York City Ballet costumes. We might call a nationwide strike—
shut down everything—music, dance, theater, art museums, schools,
recording studios, and cabarets. Absolutely everything that pro-

duces delight, pleasure, or stimulation of the senses will be disallowed. We'll show 'em!

Talk about your economic impact! We'll cripple the nation. (It wouldn't work, alas. Some renegade, some scab, would be caught in a subway station whistling an aria from *Tosca*, and our united front would collapse.)

• We might declare war and launch MX missiles from our orchestra pits.

It won't work. No whimpering, bitching, letter-writing, or strikes. None of the above.

But we can—in the spirit of Pollyanna—still hope to extract temples from the trash *if* we're as ready to clean up our own act with the same enthusiasm as we're ready to attack someone else's.

I'd hate to think of us as just sitting back and plucking defeat from the jaws of victory. The threatening and gloomy conditions may just prove to be a great cathartic, a great opportunity to cleanse, purify, and, like good evolutionary creatures, adapt. (Besides, what are the options?)

Maybe, for instance, it's the moment to start reassessing bulk. Arts leaders at the local level are like kids in a candy store: Gimme an arts council, a symphony orchestra, two dance companies, one film society, three amateur theater groups, and a dark old movie house. We want it all.

A cornucopia of dance companies, choral societies, mime groups—good enough as manifestations of personal ego or as devices to fulfill amateur needs, or as wonderful therapy—are clogging the roads that only professionals should walk and draining off state and federal dollars that only professionals should get.

This seems to attack our cherished notion of cultural pluralism, our populist romance with arts support at the grassroots level. But who supports cultural pluralism in medicine? Or law? Or atomic physics? The question being raised here is: Is it a good moment to reassess our own priorities? Do we keep the natives happy or ensure the preeminence of the artist?

It's also a good time to reenergize our search for private dollars: 95 percent of U.S. corporations *still* do not give a dime to the arts. (When the *Wall Street Journal* reports that corporations won't give more to make up the gap, it is reporting on the 5 percent that already give.)

The reason: arts are perceived as an insulated phenomenon, fabricating a narrow mystique, protected by a handful of turned-on

patrons, and that does not significantly improve the environment in which the corporate product is produced or sold. As a president of a major corporation asked me: What the hell do you guys do for me?

Arts continue to be viewed as the frosting, not the cake, which tells us something about the new language we have to learn (consolidation, cost efficiency, marketing), the new programs we have to create, the new bridges we have to build. Not just to get their bucks, but to demonstrate that we can dramatically modify the climate in which these corporations operate.

It's an opportune time to think very hard about the creation of a National Congress of the Arts as a means of establishing the cultural and political integrity of arts institutions.

Small wonder that governments and corporations are puzzled.

I represent arts in the big cities—give me money.

I represent arts in the big cultural centers—give me money.

I represent alliances of arts councils—give me money.

I represent symphony orchestras—give me money.

I represent regional, multi-state arts consortia—give me money.

I represent potters, weavers and belt-makers—give me money.

And so on.

What a time to seriously study pulling it all together. And because we have no choice, it is nicer to do it in a planned manner.

Models abound.

Curiously, community arts agencies are in the best position to survive, to achieve that degree of indispensability at the local level that ensures continuation (or, if the reverse, will accelerate their disappearance).

This indispensability will be the reward for those agencies that have worked to penetrate, to burrow into the marrow of their communities, for those agencies that adopt a centrifugal style of service—that is, spinning outward in 360 revolutions toward all facets and phenomena of community life, imbedding the energy and thought of the artist into the total community's mind.

For those agencies that are as comfortable in a Youth Probation Center as an art gallery, in a labor hall as a concert hall, in a school for the retarded as in a school for the dance.

For those agencies that recognize the real, bottom-line value of the arts—as instruments that can influence the way a community perceives its own ambition and potential.

For those agencies—and the number that are beginning to surrender their cultural myopia is increasing—the reward needn't wait

until the gates of Heaven open. These are the agencies that can turn the brier patch into a rose garden.

These are the agencies that, unlike their overblown and calcified big brothers and sisters, have the resilience and nimbleness that the dinosaur institutions ache to possess.

The "calamities" that we bemoan over cocktails—the fiscal, and psychological effect of threatened and radical change in Federal policies—need not become the cataclysm we think.

Like Pollyanna, it can be viewed as a rare opportunity to look again, begin again, and aggressively dream again.

And we can look, begin, and dream with some optimism if we recognize that the challenge facing us is really a very simple one: to perpetuate and embody those cravings for excellence in the human spirit that the artist is uniquely suited to satisfy.

Simple. And it has nothing to do with the Reagan administration, the 1980s, the 1990s, or the twenty-first century. The challenge always has been, and forever will be, the same. Only the climate changes, providing either a hospitable or hostile environment in which the challenge is faced.

The next few years will seem to offer a less than friendly climate. Not because of what appears to be a new wave of conservatism in the land that threatens to wash social and humanities programs up onto the sand like so much ocean debris. Not because of the paranoia produced by global uneasiness that seems to justify arming to our teeth while disarming our minds. Not because of the economic recession, interest rates and energy costs, or the other fiscal maladies that somehow end up robbing fifth graders of their art teacher.

No one of these conditions in itself determines whether cultural institutions will thrive or starve in the immediate future. Yet all the conditions, collectively, produce a new danger: an intellectual recession—a willingness to disrupt or replace the continuity of myth, music, and dream with an expedient born-again political morality.

The next few years will be a period, it would appear, when support of institutions will continue to be motivated more by fear than by love; that is, priorities and dollars are assigned primarily to what scares us (foreign powers, inflation, unemployment) rather than to what enriches us. Cultural agencies in the country will be increasingly affected by this fear and will be obliged to make adjustments accordingly. They're happening already.

The battle for the buck in the 1980s, for instance—fund-raising for arts operations and endowment—will be more intense than ever, and will require innovative and collaborative strategies. Agencies, furthermore, may have to relinquish their cherished independence and seek ways to form new alliances with other agencies of like spirit and goal. Sadly, the 1980s will see the demise of several agencies, victims of the Catch-22 economics of the arts. Finally, the 1980s will have to see the leadership of cultural institutions become serious, articulate, and well mobilized lobbyists, prepared to use known and new strategies of pressure to sustain the existence of their agencies and to preserve a civilized life-style in their community.

We will learn to coexist, and not for the first time, with the brier patch. Despite everything, we'll survive—spartanly perhaps, convulsively sometimes, sadly mostly—without compromise, rancor, or fear. Cultural institutions will not be destroyed by social madness, political aberration, or economic gastritis. They are needed too badly—in the 1980s and beyond—to provide the dollop of sanity that leavens life.

When Gandhi was asked: "Sir, what do you think of Western Civilization?" He replied: "I think it's a good idea." Good times or bad—so do we. The only real danger we face is to forget that the definition of civilization is the function of art.

Pollyanna in the Brier Patch

1

Do The Arts Cause Cancer?

The anxieties, achievements, and ambitions of arts agencies are sustained by a single and awesomely simple notion: The arts are an integral part of common experience, and are an elemental source of much wonder, celebration, and practical value.

The pieces that follow may appear to be dealing with valium, puppets, and copper disks. They are actually dealing with the search to rediscover the taproot that feeds and illuminates the behavior of all arts agencies.

Do The Arts Cause Cancer?

Of course they don't. And now that we're thinking about it, there are a lot of things that the arts don't do or cause.

Like wars. Fistfights, catcalls, and occasional high dudgeon, maybe; a critic slapped in the face with a kid glove; a hapless backer with homicidal feelings toward a bankrupt producer, perhaps. Things like that. An artist may record the blasphemy and ugliness of war—a Goya, say—but he's never been known to start one.

Or like air pollution. It's rare to find a double bass violin or a slide trombone giving off noxious fumes. (Sound, maybe. But not fumes.) Or dirty water. There may be a Sunday painter or two who might rinse the water colors out of a brush in a murmuring moun-

tain stream. But there have been no reports of cattle being poisoned at downstream watering holes.

And as for poverty—that baleful and ancient crippler of society—the arts are innocent. Considering the legendary image of the artist starving in his garret studio, or the actor lining up (again) for unemployment benefits, or the musician whose low wage constitutes a form of self-subsidy, we can certify that the artist spends more time escaping from poverty than creating it.

And the mountains of garbage that seem to be dominating the landscape. Not guilty. Critics have sometimes alluded unkindly to an exhibit of contemporary art as if it were solid waste, and certainly some stage performances have elicited olfactory comparisons, but the arts are simply not responsible for the dumping, shredding or burning dilemmas faced by American communities. All too often, in fact, "junk" produced by some artists gets sold, unfortunately, and not burned.

The arts are not responsible for garish strip developments along our highways, or for monotonous housing tracts, or for sterile shopping centers. There are enough developers around for that. Or for the decline in church attendance, or the increase in the divorce rate, or the drop of faith in government, or the rise in number of women and child beatings.

Yet for all their innocence, or perhaps because they work quietly and intensively to capture and preserve life, rather than damage or destroy it, the arts continue to be penalized by being assigned low priorities on economic and educational totem poles.

Maybe if we could, by some sneaky manipulation of scientific data, declare conclusively that egg tempera, greasepaint, or toe shoes were the causes of cancer, abandoned families or the continental drift, more money would pour in from governments, corporations, and foundations.

Unhappily, the only mischief the arts cause is pleasure.

In 25 Words or Less:
We Should Support Our Symphony Orchestra Because...

"They play nice music. It is loud sometimes. Sometimes it is soft. If I close my eyes, I can see pretty things when they play." (A fourth grader)

"We tell prospects it's a town with everything—including culture. Even if they hate classical music, they admit it gives the town a lot of class." (A business developer)

"They owe us money." (A banker)

"I have to make payments on a mortgage, orthodontia work, a home repair loan, and college tuition. Why do they think I'm different?" (A symphony musician)

"It sustains the spirit. Nourishes the soul. Celebrates the triumphant marriage of passion and form. It restores our faith in the sanity of man." (An unpublished poet)

"We're an industry of skilled workers. Why is making autos more important than making music? Music doesn't pollute." (A union business agent)

"They owe me money." (A printer)

"Every dollar spent by the orchestra or for concert tickets usually doubles or triples in value as it moves through the community. The multiplier lives." (A graduate economics student)

"Constituents in my district tell me a lot of people love the symphony. If they love it, I love it. I run again next year." (An elected official)

"It helped him. For the first time, he moved his hand. After three years. He moved it to the music." (A therapist)

"It's a perk—like club membership, a car. Two concert tickets in a box for the season. Makes a tasty package for top execs. And VIPs." (A corporate president)

"I owe them money. I feel guilty for not honoring last year's pledge. If you don't print my name, I'll pay it right away." (A dentist)

"Every concert night my business goes up 30 percent." (A bartender)

"My heavy taxes support the needs of other people—the poor, unemployed, handicapped. I need music. I demand that my taxes satisfy my needs, too." (A high school teacher)

"I think I'd rather not return to the caves." (A retired broker)

The 12-Inch Copper Disk

Imagine taking on the perplexing and outrageous task of describing the whole human experience on Earth, and condensing it

into 2 hours of sights and sounds on a 12-inch copper disk. Dr. Carl Sagan of Cornell University did it, as reported recently by John Noble Wilford in the *New York Times*. And the disk, buried somewhere in the innards of the Voyager spacecrafts as they thrust through our solar system, may one day be activated (at 16-2/3 rpm) and report to startled extraterrestrial creatures what life on Earth is all about.

I hope they get the message, because it's a good one. More to the point, I hope the message is received by, and startles, some Earth creatures also.

The problem facing Dr. Sagan was awesome: What images and sounds most truly, deeply, simply, and universally represent the nature and value of human life? If we were forced to strip down centuries of human development into its quintessential bones, what would we identify that says who and what we are, really?

A bona fide mind-boggler. But it's a question often ignored or evaded, partly because of its magnitude, and partly because questions of basic and enduring values regularly get squashed under the avalanche of society's day-to-day traumas—urban, racial, social, fiscal, and educational.

Dr. Sagan and his 12-inch disk offer us Earthlings a renewed perspective on the varieties of human races, on elemental manifestations of nature (a snowflake, a leaf), and on those phenomena of creative achievement we call art.

In fact, about one-third of the disk's story deals with the arts: architecture (examples of buildings in which we have enclosed ourselves, including the Opera House in Sydney, Australia); graphics (drawings of human and natural phenomena); photography (pictures of the Earth taken from space); and music (Bach and Chuck Berry, Louis Armstrong and Beethoven, native sounds from Mexico, Peru, and India).

Some may quibble about what Dr. Sagan put on or left off the disk; some may blink at the thought of the Voyagers taking some 40,000 years to get anywhere near a star. It doesn't matter.

We don't have to wait 40,000 years for a scaly, seven-eared creature out yonder to decipher what some of us have figured out already: What we have, what we ultimately cherish most, and what we are forever committed to transmitting from one living being to another is the desire to create the forms and the sounds that express our most deeply felt experiences. It's humanity's great gift and tribute to itself.

The outer space message of the disk—that we are human, intelligent, and creative—is the message of the arts. It is a message we should unashamedly transmit every day to inner space.

Recrearts

At first, it was very difficult to figure out why I was invited to prepare some remarks to leaders in the field of recreation. Very puzzling, indeed. Then it hit me. You must have done some serious in-depth research into my recreational activities and athletic prowess, and sensed a kindred spirit. You must have discovered that I hold the world record—2 minutes flat—for emptying and refilling trays of ice.

You learned about my obsession with hiking: in the course of a single evening, I'll hike back and forth from my armchair to the refrigerator at least four times, for a total of nearly 80 feet, a distance usually covered in world class speed.

Someone told you of my love for skiing. I can't wait until the skiers get back to the lodge to tell them so.

And in the great outdoors, I'll wander for hours enjoying the brisk, clean air searching for a cigarette machine.

I hunt—for leftover chocolate cake at 3:00 A.M.;

I fish—mostly for compliments;

I dive—into bed;

And I run—usually in circles.

But still I feel a little alien here, in the company of recreation specialists. It's rather like going to visit close relatives, and finding you hardly recognize them—as if they've drifted away from you, or you from them.

It is as if we used to play on the same team, but are now wearing different uniforms.

It's cause for a little melancholy, especially when you think it wasn't always that way.

Cultural and recreational activities (at least the athletic aspects of what we call recreation) were once indivisible. Peas in a pod. Bacon and eggs.

The idea of the "total person" prevailed for many centuries. The dashing swordsman of the renaissance, who'd slice an opponent up like salami at the drop of a woman's scented handkerchief, would

just as deftly whip off a ballad, a poem, a song, accompanying himself on the lute. We see this behavior epitomized in the character of Cyrano de Bergerac.

Even in modern times, the inseparable union between art and physical prowess still pops up. While visiting in El Salvador in 1962 as director of a student-to-student musical show, we received warnings of trouble. We were advised that gangs of tough, burly Communist youths were wandering the streets looking for mischief. They came to the theater in which we were playing, planning (we learned later) to shut off our power supply. Apparently, several peeked in first, spotted pretty American girls in leotards, ran home to get musical instruments, and called off the revolution. There was a splendid party that night—beautiful singing, playing, dancing. But the revolution? *Mañana.* Dangerous revolutionaries one minute—tender and passionate balladeers the next. And there was no evidence of hang-ups over compromising their cause or damaging their macho image.

Somewhere along this historical path, something went wrong, died out. Particularly in this country. The mind and the body got separated. Serious interest in the interplay of arts and recreation got pushed to the back burner, taken off the stove, in fact. Was this separation rooted in our early colonial heritage—in the Puritan horror of things artistic (face-painters—that is, actors—were works of the devil) and even greater horror of idle and useless play? (All efforts of the living, those first immigrants insisted, must be directed to purity, righteousness, and preparing for the next life.) Was it the country's obsession with expansion, growing, moving west, fighting the harsh elements—creating the image of daring explorers and settlers who didn't have the time to fool around with sports or culture? (The truth is, however, they did both.)

Was it the tidal wave of immigrants, crowded like sardines into tenements, so bent on surviving in the new world, they had neither time nor space for many pleasures? (To them, a recreation program was having to work only seventy hours per week, not eighty.)

When I was a kid in the late 1930s, phrases like "cultural program" or "recreational program" were a foreign language. "Culture" was a class skit we put on at Christmas time; or being told you had to sit there, with hands folded, your mouth shut, and listen, once a week for thirty minutes, to hear the late Walter Damrosch tell all his "dear children" why they should absolutely adore a symphony by Beethoven.

As for recreation, it was totally homemade. If we had a park, it was usually in front of City Hall, with a statue and large civil war cannon pointed threateningly at anyone who approached the front steps. School yards were parks—with lots of gravel and dust—but at least some open space. More often, the street in front of my house was the park. It's there we played stickball while dodging traffic. Or we threw the ball against the front steps, hoping to hit the edge of the step, making the ball fly high over the heads of the other kids who were trying to catch the rebound. If you could find, borrow, or steal some ice skates, there was a frozen swamp down at the bottom of the hill. And the only equivalent of a craftmobile was the horse-drawn wagon of the vegetable peddler (who didn't always enjoy the crafty things we tried to do to him).

As for culture, we'd *hear* about people going to the opera or the symphony—although for us, it sounded like the equivalent of going to the moon. And we'd see and hear about people playing tennis, golf, badminton, or sailing around in their yachts, but that's what rich people did on or near their fifty-acre estates in Newport—wherever that was.

I suspect that cities and towns had parks programs—somewhere—but they were well-kept secrets. And there were no community arts councils back then to worry about and encourage cultural interests. They didn't start appearing until the 1960s.

But between the time that I was a kid and my kid was a kid the world changed dramatically. It's been nothing short of a social revolution.

The revolution is fairly new—but based on an old promise that is finally being fulfilled.

Simply stated: In a true democracy, the ambitions, tastes, and needs of every citizen are important; in a democracy, people are more than social security numbers, more than taxpayers, more than demographic data. These citizens are creatures who now demand that they (unlike Rodney Dangerfield) get respect; that their unique *humanness* is recognized; that their special individuality is addressed.

(Imagine Henry Ford today trying to tell the American public that they can have any color they want, as long as it's black.)

No community, large or small, can escape the effects of this revolution. There is an electric atmosphere of change, an unquench-able thirst to discover and improve oneself, to find avenues of per-

sonal expression, to re-make one's world into a peaceful, productive, and healthy place.

It's now called "participatory democracy"—and woe to the arts or recreation planner who ignores its drum beat and power.

From what I understand, recreation and parks people not only hear the drum beat, but are actively drumming up programs ranging from aerobics to nutrition to transactional analysis.

And the upshot of this revolution, of this surging grassroots demand for personalized and democratic distribution of services? I can't speak for the field of recreation. But in the culture business, one of the best indicators is the fact that community arts service agencies have grown from zero in 1960 to more than 3,000 in 1984. In about one generation, a stunning 3,000 percent increase in community interest in the arts. I suspect that the growth of recreational services in that twenty-five-year period can easily match, if not surpass, my numbers.

What self-respecting town would *not* try to develop a sophisticated and wide-ranging recreation program, providing activities tailored to the young, the handicapped, the elderly. And equally the case, no self-respecting town could ignore the grassroots demand for the opportunity and the places to act, sing, dance, paint pictures, or make clay pots available to all the people.

So here we are—both of us victims of a massive upheaval in human priorities. And both using our unique set of tools and strategies for a similar purpose: to help people live a civilized and healthy life.

We are in fact not strangers anymore (as hinted at the start), but rather two sides of the same coin. We are—both the arts and recreation—very much in the same business, the business of stimulating people to find and develop resources in themselves they thought they never had.

We may never completely recapture the ancient Greek ideal of the "whole man." But we can, both ballet dancer and swimming instructor, restore a wholeness to our communities.

Skip the Valium

Need a breather from oppressive thoughts about the Middle East, taxes, mass murders, banana republics, and the horrors of

child molestation? Simple. Attend a performance of *Aida*. Need to get away from acid rain, nagging children, potholes, and the kidnapping of diplomats? Easy. Go see *Swan Lake*.

The notion persists, like a carbuncle on our culture, that the prime function of the arts is to help us escape, forget, find temporary respite from the disorder, lunacy, and general gloom of the real world.

The notion is not without merit, as producers of Broadway musicals will happily testify, along with other purveyors of entertaining glitz.

But the notion of art-as-escape, as a quick dip in the River Lethe, compromises the arts by being woefully narrow. It's like playing "Chopsticks" to demonstrate the full power of the keyboard. Something, clearly, is missing.

And this is what's missing:

- Art is not an escape; it is a reentry into the real and demanding world of myth, sound, color, and form—a world as ancient and as kaleidoscopic as the human race.
- Art is not an anesthetic; it is a stimulant to remind us that we are sentient creatures with a genetic appetite to respond deeply to creative images and symbols.
- Art is not a quick fix or a steam valve on our emotional boilers; it is an enduring reminder that we can indeed behave like a civilized race, and that we are ready to embrace anyone—and especially an artist—who will prove it.
- And art is not designed to show how weak we are in handling real world crises; it's designed to show that we have the strength, resilience, and emotional resonance needed to confront crises with more than a little bravery.

The arts, in sum, are not temporary analgesics like Super Strength Excedrin, Valium, or double Scotches. The pain usually comes back.

What the arts give us ultimately is the chance to balance reason against madness, beauty against corruption, and joy against despair.

And in the preservation of this awesome balance lies whatever future we may have as a humane society.

If I Could Leap Like You
One Hour Tonight

*(A personal letter to Mikhail Baryshnikov
c/o New York City Ballet Company)*

If I could leap into space like you, I would keep right on going.

I would leave behind all my childhood fantasies and follies, my adult hang-ups and handicaps, and aspire to a new vision of power and freedom.

If I could leap like you one hour tonight, I would give up pounding on the bully who kicked sand on me at the beach, or gunning down the Dalton Gang on the main street of Laramie, or miraculously guiding the crippled ship safely into harbor, or any of the other Walter Mitty-like mechanisms we mortals use to escape from our own frailties. Yes, and my stamp collection, too. If absolutely necessary, I would reduce the intake of Scotch whiskey.

If I could leap like you . . .

No more imaginary villains, no more buffeting by pretend storms. The enemies would be real: the law of gravity—that must be defied with a fluttering of fingertips and a twinkle of toes (apples can go up, Isaac!); the physical pain—endured as every muscle and every brain cell is mobilized by a tyrannical discipline. (Do you ever look down when you're up? Is the floor your enemy? Does it hurt when you hit?)

You, and all dancers like you, symbolize my greatest and perhaps my last fantasy, Mikhail. If I could leap like you . . .

I would, with very little reluctance, trade in the maladies of this half-century man—the headaches, the stiff neck, the gnawed thumbnail, the deadly effects of pickled herring or pepperoni pizza—for just one good leap. And the little grunting sounds one makes when sitting down, standing up, or bending over would certainly be muffled by the tumultuous gasps and applause by the audience.

Maybe between now and when the New York City Ballet gets here for its next performance, you'll send me instructions. Or a pamphlet on leaping. I'll practice. But if between now and then you read about a Middle-aged, Caucasian, Male, who has been apprehended on South Salina Street in Syracuse performing a grand jeté in public, you'll know it's me.

And if, with one leap on Salina Street, I could combine the grace, power, defiance, joy, arrogance, theatricality, discipline, and

sheer balletic chutzpah that you transmit, I would not have to sub-
mit to arrest. They would never find me.

If I could leap like you one hour tonight, I would keep right on
going.

Tomorrow the World

We forget sometimes why we're in this business. The nagging
preoccupation with our cataclysm of crises—budgets, deficits, pro-
gram costs, funding cuts and the host of other calamities that has-
sle us—often distorts and erodes our sense of mission and
obliterates what is, ultimately, our reason for being.

And that reason is sanity.

We boast sometimes of the impressive versatility of the arts, of
how cleverly they serve and enhance diverse human needs: the arts
are recreation; the arts are therapy; the arts are big business; the
arts are urban restorations; the arts are lifelong hobbies; the arts
are curriculum allies; the arts are aesthetic experience; the arts are
history; the arts are fun. The arts are, it would appear, a cornucopia
of good things—functions that more often reveal a sense of desper-
ate justification than convey what the arts really are.

They are a phenomenon of sanity—of rational order, coherence,
balance, and harmony. The arts are a sublime manifestation of a
forlorn notion: a disciplined form can be imposed on irrational and
seemingly disconnected experiences. Chaos, the arts proclaim, is
not the necessary and inevitable lot of society.

The notion of arts as sanity seems to run contrary to the con-
temporary tide of social behavior—a tide that suggests that nothing
can make order out of this mess.

The lamentations of crises or the boastful claims of all-
purposeness will not—indeed, have not—precipitated a deluge of
support for long-suffering arts agencies.

Maybe it's time we start selling sanity, if only to find out if the
human race still has an appetite for it. Maybe we might even make
the preposterous proposal that the arts can save us—that it can
retard the mischief, reverse the threat, moderate the madness that
afflicts the race. If the arts can rescue a single person—and awaken
in that person a skill for wrenching harmony out of disorder—why

not a family? A neighborhood? A city? A nation? Why not a global revelation that world mayhem is an as yet unshaped work of art?

Maybe the arts really can defuse, unpolarize, reverse alienation. Other institutions—the state, the church, the school system—have all offered their strategies and remedies for restoring order and harmony. For the most part, they've failed. High-principled declarations and pious pronouncements have tended, it seems, to exacerbate crisis rather than erase it.

The arts are eminently qualified and ready to take over. They do, after all, cross national boundaries. They speak, for the most part, a universal language. They have, for centuries, embodied the loftiest aspirations of entire civilizations—even when those civilizations have collapsed and vanished. The arts have never stopped wars—but they've never started one either. They're not racist. They're neither Republican nor Democrat. They have served God and humanity with distinction without ever compromising their integrity.

So given half a chance, the unique statement the arts make about a human commitment to reason, order, and—as a little bonus—beauty, put the arts in a rare position to save the world. An Art Ethic as a dominant force on the planet has got to have a better effect than librium, wars, hunger, or racial anger.

Anybody want to try it?

The Path of the Puppet

The nine-year-old black boy doesn't know it, but he's playing god. With wood tongue depressors, string, scraps of cardboard, an empty Bird's Eye juice container, and Borden's glue, he is assembling a creature—creating out of simple raw materials an object that is slowly assuming the shape of a human being. Intently, he hinges the left arm to the shoulder with string. Now both arms are attached and dangle wobblingly. The head, a crude disc of paper, is still featureless, a blank facade awaiting the few strokes that will give it sight and sound. The boy holds his unfinished miracle up to the light, which produces, on the wall behind him . . .

. . . shadows . . . from a thousand years ago . . . looming, weaving, vanishing . . . dancing on a silk wall to the beat of cymbals and incantations . . . Shapes of gods, demons, kings, and beautiful

queens reenact great battles and epic romances—dramas more an-
cient than the wizened men who cause the puppet shapes to move at
the end of long sticks. The royal Thai audience is awed by the magic
of the shapes, by the passions they evoke, by the gods who make
such miracles possible . . .

. . . but he is interrupted by a classmate, a girl two years older
and three years meaner. "You got no face, dummy! No eyes, no
mouth—nothin'!" The boy reacts swiftly, with an instinct as primal
as his genes. The wobbly unfinished miracle rises to the defense,
rushes into the face of the mean girl, and with a courage its creator
has never known, shouts in a super ogre's voice, "I will chop you up
and eat you for breakfast, you dirty snake!" The girl's puppet re-
plies by butting its head into the wobbly miracle, which sends it . . .

. . . sprawling! From a hundred years ago. The crowd shouts
with glee. "Get up. Punch! Get up, you rogue! You won't let a
woman treat you like that, will you!?" Punch scrambles to his feet,
miraculously producing a large club. Judy, with a squeal that de-
lights the farmers, blacksmiths, and wheelwrights of the British
village, begs for mercy. But too late. Punch swings, misses Judy, but
strikes the passing Constable. The crowd, seeing a dream come
true, roars its approval. Punch sulks . . .

. . . and returns to his crayons and paint to create flesh, color,
eyes, and mouth. In a few minutes, it's finished. The inert creature
now waits for the passions of its creator to infuse life, voice, move-
ment. The boy stares at it—at its listless eyes, its unkempt hair, its
mottled black face. Suddenly, the boy hurls it to the floor, steps on
it, crushing and dismembering it. He runs from the room . . .

. . . crying. In this Boston clinic, that's not unusual. Here, today,
most of the children cry or are eerily silent. Except, that is, when a
sock with a funny face is slipped over their fists. And through the
protective alter ego of their cotton friend, they will sometimes vent
the darkness and fears that cloud the mind.

Puppets conjure spirits. They invoke and open other worlds—
most of which are trapped inside us.

The Rescue of Robert

(A True Story)

Mozart knew how to reach Robert better than anyone else could.
Robert is now seventeen. He lifts weights to stay lean and mus-

cular; his sense of humor ranges from subtle to raunchy; he is an honor roll student; he enjoys escargot and buffalo steak.

He was diagnosed, when very young, as learning disabled. Uncommunicative, fearful of social contacts, and disruptive under stress, Robert, as a child, was in danger of slipping into an interior twilight world from which there might be no return. The professionals—psychologists, psychiatrists, counsellors, tutors, classroom teachers—tried to prevent his inward drift. So did his parents. Lifelines were thrown, strategies suggested, exercises carried out—all aimed at combatting the sense of frustration, failure, and disorder that were eroding his ego.

Then, an ancient remedy was tried: a dose of the arts. Piano lessons were started. A patient teacher and an explosive pupil slowly began to communicate. The language—music—was a different language, it offered a special order, and it was addressed to a primal impulse not yet threatened by normal adults, educational bureaucracies, or medical conundrums. Slowly, the world widened: the teacher spoke to the pupil, the pupil spoke to the piano, the composer spoke to them both, and all of them began to speak to the listener.

The piano playing improved. It may never be at Carnegie Hall recital level, but it doesn't matter. Music offered Robert the chance to "speak" with assurance, to reach tentatively back into the real world, to tackle other problems with a restored confidence.

The rescue of Robert by the arts is, fortunately, beginning to be less unique. *Inside Education* (September 1978) reported the findings of several noted researchers: B.H. Bragg established that a deaf child's sense of failure with written words can be overcome by creative drama; children with cleft palates can improve their verbal and social skills through dramatic activities, according to Irwin and McWilliams; mentally retarded children, Marie J. Neale found, significantly improve their speech and language skills through arts programs.

It would be a dangerous oversimplification to say that music saved Robert, or that the arts are panaceas for all child disabilities. But when I hear Robert play the piano, I think less about the arts and the quality of life and more about the arts and the value of life.

A Fishbowl Theory of Culture

The theory which I am about to describe is little known. That's not surprising, when it is realized that it was just thought up. There are, no doubt, many fallacies therein; but as a wise man once said, never let the facts get in the way of a good theory.

It is called—albeit immodestly—Golden's Fishbowl Theory of Culture. Its title is derived, as one may guess, from the lore of gold-fish fanciers. They claim that fish grow in direct proportion to the size of the container in which they live. Big bowl—big fish. Little bowl—little fish. I have not seen scientific documentation of this phenomenon, and I don't think I want to. It might lend further invalidity to the GFTC.

If, as an act of patient courtesy, you accept the theory as it applies to fish in a tank, you might also, as a greater courtesy, apply it as well to human beings in a city. For a human, however, the "swimming space" is both physical (size of living room, distance to work) and psychic (amenities, stimulation, resources)—elbow room for the soul, if you will.

The temptation to pursue the analogy between fish and people is very strong. It's especially tempting in view of how human organisms are encouraged by education, income, travel and community pride to seek wider and deeper pools in which to swim, to expand their intellectual and emotional terrain. If the theory is right, a fish, a person, or a whole community will respond to the stimulation of more generous and enlightened dimensions by adapting to the new possibilities for growth.

Well, that's the theory.

Where the issue is cultural growth of the American citizen or community, however, the theory hits a few snags. The first snags are historical.

There was, it appears, no room on the *Mayflower* for the arts. The cramped quarters were filled with religious conservatives and freethinkers, political renegades and misfits, artisans, indentured servants, and land speculators who quickly established their own narrow and insular enclaves in the New World. All small fish living in tiny bowls, creating a climate antithetical to artistic growth. As a direct consequence, the "cultural lag" developed, resulting in episodes of self-exile by artists who did surface here (from John Single-

ton Copley to Ernest Hemingway to Irwin Shaw) and who found no
swimming room. Indeed, they found no bowl.

There were lingering effects of this cultural lag of an early soci-
ety that left a strong imprint of no-nonsense conservatism. Despite
subsequent improvements in political and economic stability, the
simple notion that the cultural confidence and appetite of a commu-
nity will strengthen naturally as cultural opportunities and hori-
zons get bigger, continued to encounter snags. The legacy of the
original immigrants, combined with the devastating pragmatism of
a tumultuously growing country, made culture a dirty word, and
the arts a frivolous pursuit. Coveted and nourished by an affluent
minority, the arts became alienated even more from the popular
experience, making culture a phenomenon of social discrimination,
of snobbery, of exclusive "in" groups. Culture became something
vaguely effete, impractical, smacking of an arcane form of Un-
Americanism. The arts, like exotic tropical fish, were diverting but
not universally affordable.

Up to this point, I haven't done a very commendable job of prov-
ing or applying the Fishbowl Theory. Early settlers and later work-
ing classes had little taste for widening the dimensions of their
world to admit the beneficent influence of culture.

Yet another reason why my theory may be in jeopardy is that we
seem to have devised, as a society, a number of cunning means to
violate the aesthetic rights of human beings. Violate their civil,
political or legal rights and riots erupt, protests are staged, and
angry court actions taken. There is, however, no court of appeal for
aesthetics.

Years of exquisitely bad taste in the visual and psychic
environment—ugly signs, cheap "strip" developments, unbelievably
monotonous highways and housing tracts, smelly subways, abrasive
street noises, banal and redundant TV shows—have left the eye, ear,
and mind no choice but to activate defense mechanisms. Blot it out,
don't see, refuse to react. A dreadful desensitizing has taken place.
Not because aesthetic perceptions have vanished, but because the
environment expresses such contempt for these perceptions.

A final hitch in my theory is the persistent struggle to identify
a rational system of national priorities. What's important? Where
should the energies, monies, and commitments of government (na-
tional, state and local) be directed? The body politic is staggered by
the proliferating crises over crime, unemployment, poverty, hous-
ing, social justice, and the dozen or so wars that pockmark the

planet year round. Where do we squeeze in culture? Should it be squeezed in at all? Will it ever hold a high enough place in the hierarchy of social imperatives to make the Fishbowl Theory work?

In view of the several snags impeding my Fishbowl Theory of Culture, the theory surely seems naive, perhaps even inadmissable. But I don't propose to abandon it. On the contrary, it is *because* of these snags that I think my theory is more relevant and vital than ever.

It is because the arts have always been, and will continue to be, a manifestation of the most rational and disciplined acts of man, and serve as the kind of model for sanity, and control that can inspire imitation.

It is because the arts deal with those elemental commodities that—willy-nilly—are the natural inheritance of all humans.

Indulging in myth, understanding through symbol, responding to color and sound, and finding pleasure in form are phenomena of the genes and need space to grow.

It is because the arts—as a creative *process,* not as objects hanging numbly on a wall—offer a stunning presumption: that the skill of one person, engulfed by a multitude of events and impressions, transforms clatter into serenity, extracts order out of chaos, and reveals to us with terrible precision who we are and what we can become.

So I don't think that my theory is wrong; it simply needs to be tried. And because the general public is the victim of historical flukes, perplexing dilemmas, and twisted priorities, it is an urgent duty of community leadership to create the environment that encourages latent creative energies of people to grow to bold new dimensions.

Clever Cousin Lester

My cousin Lester ("the famous eye doctor" his doting mother would endlessly proclaim) decided, at age fifty-two, to play the cello. He'd never had a shred of musical training prior to that decision, or even talked about it. He came home one day with a cello under his arm and an appointment with a teacher. His mother was distressed: "Music?? What for? You're a famous eye doctor. And at your age!" Music study, she insisted, was for kids.

Lester produced one of his soft, enigmatic smiles, and assured his mother that he was neither adolescent nor senile. He proceeded with the lessons, applying the dexterity of surgeon's fingers to the cello strings. A few years later, he was creating the lush, resonant sounds so characteristic of that instrument. His mother never did understand her son's mad impulse for the arts.

But Lester understood.

He knew that his antiseptic career as an eye surgeon filled only half of his spiritual cup. There was a vacancy in his life, a longing not only to repair but to create. He could deftly pierce the human eye with laser blasts, but he could not penetrate the human heart with beautiful sounds. The cello was for him an emotional scalpel, an instrument for cutting through the blandness and routine of everyday existence and exposing the heart.

He's about seventy-five now. He's still playing the cello, joining other musicians in living room recitals, and is happy as a clam. (His wife, not to be outdone, and in self-defense, started taking piano lessons at age fifty-five.) He has never received an invitation to play at Carnegie Hall, but that doesn't bother him. He's already found his greatest audience, his most satisfied listener, his most severe critic—himself.

There are a lot of Lesters in this world—people who carry into older age the baggage of unfulfilled appetites, vague disappointments, frustrated desires for creative release they never had the chance to satisfy.

The arts are immune to age. They are forever young, endowing the person who enjoys them with a creative satisfaction akin to youthful discovery. They won't reverse the ageing process; they will enrich the living process.

Lester was smart. Despite his mother.

2

Dear School Board President

*L*ike zealous matchmakers, arts agencies throughout the country are laboring to bring about a happy union between the arts and the classroom. The brokering, an effort lauded and supported at the highest reaches of the National Endowment for the Arts, has taken on the aspect of a Major Concern. No self-respecting arts council—state, regional, or local—can escape the new momentum to integrate the arts into the school curriculum, to make the arts an inseparable element in the total cultural experience called education.

Some fuzziness prevails, however. Does the arts in education mean the occasional visibility by a poet "in residence"?; a bus trip to the local concert hall for a healthy dose of classical music?; a K-12 curriculum that offers formal learning in music, painting, and theater?; academy-like training in playing a trumpet or a piano?; a heightening of perceptual skills that produces a higher degree of aesthetic literacy?; or a strategy that makes the study of mathematics or history more provocative and palatable?

Arts in education probably means all these things. But overriding all of them is the notion of the child possessing an inborn aptitude for the arts—an aptitude that schools have been more often guilty of squelching than fostering.

The twelve short pieces that follow are really a plea to protect our most important natural resource—kids.

Dear School Board President

I've learned that the District Board of Education is seriously considering plans to reduce, if not totally eliminate, arts programs in the public schools.

If this information is correct, I would urge the Board to move with the utmost caution on this matter and to study carefully the educational consequences of removing from the curriculum a discipline that is universally characterized as one of the cornerstones of a humane society.

I admit to a strong bias on this subject. But as the director of a cultural agency for twenty years, I've observed the phenomenal growth of arts activities in this city and elsewhere in the country. I've noticed the enormous investment of time and dollars by people searching for the kind of personal fulfillment that only involvement in music, theater, visual arts or crafts can provide. In the world outside your meeting chamber, the society is actively exploring new ways to celebrate—vocationally and avocationally—the creative energies that all human beings possess.

Given this milieu, it seems odd and indefensible for a public school system to consider retreating from its responsibilities to provide a civilized and civilizing education—an education that has as much real world application as any other subject taught in the schools.

Any decision to drastically curtail or eliminate arts programs would be insupportable at best, and discriminatory at worst. It would directly punish the hundreds of young people who possess a genuine aptitude for the performing or visual arts. If this occurs, the Board may wish to extend this budget-cutting to inflict the same punishment on those kids with an aptitude for math. Because where is it written that an algebraic formula is more sacred than a beautiful melody? We should at least discriminate equally against all students.

It's a curious truth: long after the child has forgotten the formula, the child will remember the melody.

It would be discriminatory in a larger sense as well. A decision to reduce or eliminate art programs is tantamount to saying to a child that his or her appetite for sound, color, movement, rhythm, dream, emotion, fantasy, taste, imagination, discrimination, communication, creativity, and pleasure are useless commodities in a world apparently obsessed and weakened by budget fevers. There

has never been a time in recent history when this appetite needed more encouragement and feeding.

Nor has there been a time when more information—formal studies, surveys, etc.—has been available on the sheer practicality of the arts as innovative instructional tools, as therapy devices for adjustment to difficult social situations, and as beginnings of professional careers. Would these practical applications of the arts get swept away, too?

The arts are a language more basic and ancient than the 3 Rs. It is the language of human perception and feeling. If we are prepared to tell kids that their perceptions and feelings are unworthy of instruction and development, we are inviting a return to a new dark age of cultural illiteracy that will populate the planet with robots.

The fiscal constraints you face are real. We know that. But surely there must be—to borrow a term from the arts—creative solutions to the issue that will prevent the school district from cutting out a kid's heart while trying to fill a kid's brain.

It is my earnest hope that the Board of Education will not permit this to happen.

Message from the Genes

The recent headline read, "Students must learn arts, sports." The article, picked up from the AP wire by a Syracuse newspaper, measured one-column by 4". It was datelined Linthicum, Md.

Encased in the 6 square inches of news copy was an acre of importance: The Maryland Board of Education has, it seems, "approved a proposal requiring students to develop leisure skills in sports and the arts in order to graduate."

Reaction: Bravo! Alas . . .

The Maryland State Board deserves, at the very least, a standing ovation for the enlightened arbitrariness with which it asserts the importance of athletics and culture in the school curriculum. It has an oasis-in-the-desert quality about it; a beacon in the darkness; a raised banner we can rally to. A state bureaucracy has boldly invoked the ancient Greek concept of the unity of body and spirit. As a consequence, the arts in the public schools of Maryland can happily eschew the label of "frill." The trombone player can become at least as important as the quarterback. Bravo, Maryland.

Also, alas. However nobly motivated and educationally sound the proposal may be, it raises several onerous implications: the arts are now a "required" subject—and we know the attitude students adopt toward subjects they *have* to take—putting the arts in the league with all those other worthy hurdles and estimable obstacles mandated by state boards and regents; the arts are now certified as a "leisure skill," a sociological gambit that ignores the history and demeans the professional utility of the arts; and the implication that a diploma can be withheld for failing to enact a scene or draw a picture well—by what or whose standards, for heaven's sake?—suggests a punitive response that is antithetical to the personal pleasure that a young person ought to derive from creative explorations.

But, we love you, Maryland, for being tuned to the message from the genes, for beginning to hear the coded signals from the DNA. A child's need, aptitude, and taste for the arts are as original as sin and as basic as blood.

Children hear the message clearly: and it is reinforced by their first experiences on earth: sound, song, color, movement, rhythm, symbol, mime, and powerful dramatic contrast.

Children are already graduated to the arts. It's really, therefore, not so much a matter of requiring them; it's a matter, from day one in school, of releasing them.

Little Roger's Fancy

It's not hard to imagine the delighted reaction of parents as their little son enters the room, toy stethoscope at his neck, and announces, "I want to be a doctor."

It's also not hard to imagine the reaction of parents as junior walks in wearing skin-tight leotards with toe slippers slung over his shoulder, and announces, "I want to be a ballet dancer."

Horror, embarrassment. The kid needs a good beating, a good psychiatrist, or a good laxative. That sort of thing is all right for Susie. But for Roger? And if Roger persists, and his parents can swallow their humiliation enough to let the kid enter a ballet school, Roger may find himself the only boy in the class.

Certainly one of the least logical and most pernicious of middle-class myths is the notion that any boy who wants to be a ballet

dancer is almost automatically weird, queer, or effeminate. The prejudice directed toward boys with a yen to become ballet dancers is about as rational as the old-fashioned prejudice directed toward girls with a yen to become doctors.

Every ounce of historical, social, and anthropological evidence the world has produced demonstrates that a man's skill as a dancer is as much a part of his natural manly aptitudes as hunting, using a tool, or eating.

The Bible, for instance, is loaded with references of ancient priests, prophets, and peasants who expressed joy, sorrow, or religious zeal by dancing.

Try questioning the manhood of a dancing African tribal chief. For an answer, you're likely to get a spear through your head. Or snicker audibly as a group of American Indians perform a sacred rain or corn dance. They may not scalp you, but don't slow down long enough to find out.

And we don't have to reach back into ancient cultural traditions to illustrate the importance, relevance, or naturalness of the dance to men. When we hear a sports commentator describe the "fancy footwork" or the "dancing around" prize fighters are performing, the terpsichorean and pugilist combine. When we watch a slow-motion version of a pro football team in action, we see leaps and turns and dips that would be the envy of the American Ballet Theatre Company. (A number of big college teams as well as some of the pros are actually given dance training to improve their speed, suppleness, and precision on the playing field.) Or watch a hockey player, or a skier, or people who fence and depend on their dance-like nimbleness to keep themselves from being run through.

There is scarcely a single, rigorous sports activity that does not, at its very essence, demand the discipline, concentration, and intense physical energy of the dancer.

If this is the case, then why are so many boys embarrassed by or reluctant to become professional dancers? Probably because we've all been brainwashed by the delicacy and frothiness—the prancing elves and the flitting swans—of traditional ballet (forgetting that classical ballet is only one of many dance forms) and knowing little about the ferocious length and toughness of dance training.

You don't have to start preparing to become a doctor until you're in college. You have to start preparing to become a dancer when you're about twelve.

So, if little Roger begs you to let him be a dancer—say "no." Not because it may strike you as a silly, unnatural, or unprofitable profession. But because he may not be able to survive the stiff discipline. It's about 40 percent tougher than Marine Corps boot training.

But at the same time, please don't underestimate little Roger.

Lox, Bagels, and the Arts, or, Why Johnny Can't Sing

We're not quite there.

Despite the idealistic and impassioned rhetoric, the ballet dancers scattering pliés all over school gymnasia, the locust-like swarms of kids descending on a symphony concert, we haven't quite made it. The reintegration of the "arts and education" remains a peripheral, occasional, and low-priority issue in the American populist mind and is relegated to a position substantially below that ultimate symbol of interdependence, lox and bagel.

I hear colleagues grumbling at this assessment, especially the ones whose zeal for reinjecting the arts into the bloodstream of curricula and school kids may actually have converted anemic administrators and school boards into robust apostles of beauty.

But they are the exception, the ones who prove the rule. For all our planning and proselytizing over the past decade, the arts in America remain in a perilous state; audiences for good art, music, and theater remain essentially static (are we mistakenly equating availability with popularity?), and the knee-jerk reaction to fiscal crises facing school systems is to dismember, or at least disembowel, the arts program.

Herding kids into an auditorium for a chamber music "informance" may have a salutary effect—at least on the teachers who get 45 minutes to unscramble their brains over coffee. But it is a band-aid, a cosmetic, a quick fix. Most of all, it doesn't confront the enormous gulf that separates the arts from education and thwarts their reunion. It is a gulf produced by several forces.

First, Culture (capital *C*, of course) is still perceived as the imprimatur of a distinct and isolated social class, one that zealously protects its turf, and one that is not, as a rule, represented on school boards.

Second, art remains the antithesis of the utilitarian/industrial/
technological obsession that dominates American society, and that
views the educational system as farm clubs that produce trained
bodies for their major league enterprises.

Third, efforts at reunification of the arts and education are
often thwarted by both teachers (who lack the training to sustain
the art education process in between bouts of culture) and artists
(who can usually talk about their discipline but often lack the
"gift" to unlock and stir the creative power trapped in the children
themselves).

And fourth, the gulf is widened even more by the earnest arts
administrator who, while perched on Olympus one day, was in-
vested with the moral duty to "educate them," and sets about the
task with a ferocity that would subdue Atilla the Hun and a piety
that would put a pope to shame. There's a poorly veiled arrogance
in this duty; it usually translates to mean: they've got to be brought
up to *my* level, to my special perception of taste and quality.

There are few better barometers of cultural shifts and expecta-
tions in America than its public schools. And if they're not yet ec-
static about throwing open their classrooms, their purses, and their
minds to the arts, it may be because they haven't yet received any
universal and convincing mandate to do so. Not even, ironically,
from the arts establishment itself.

Perhaps a clue to discovering this mandate lies in a keen obser-
vation by John Dewey. Works of art, he said, "idealize qualities
found in common experience." If we forcefully address this common-
ality of experience—the aesthetic of the genes—and prove that it
truly exists among bureaucrats and laborers, corporate heads and
bookkeepers, and even the dress store owner who just got elected to
the school board, the gulf can begin to be bridged. And the long-
awaited reunion of arts and education can be celebrated.

The Big Red Schoolhouse

Call us pedants, schoolmarms, didactic worms—anything you
like. And we won't be embarrassed or angry. In fact, we'll be
thrilled.

We'll consider it a triumph to stand accused of having unsubtly expanded the personality of a cultural center, enlarging it from a playhouse to a schoolhouse.

The alteration in the psyche of our Center was no accident. It goes back to the prehistoric days of the late 1960s when the two original champions of the Center—one an ex-professor, the other an ex-social worker—crossed their fingers and delivered a bold declaration: A primary role of the new Center will be to serve as an educational force, an instrument for teaching, an environment for learning. Not in the pedestrian, mechanical sense of jamming nuggets of information down the throats of an unwary clientele. That's for computer or auto repair schools where cold fact is essential.

But given the staggering number of hours for planning, designing, and constructing the place; given the huge commitment of taxpayer dollars; given the attractive spaces, sophisticated equipment and skilled personnel, it would be nothing short of obscene *not* to view the Center as a crucible of experience, a lab for testing our aptitude for expanding ourselves.

If it doesn't educate, we felt—that is, enlarge our capacity to experience, manage, and enjoy the confrontation with our inner and outer selves—it doesn't deserve to exist. That was nearly fifteen years ago. Nobody screamed. Nobody said no. So we plunged on—treating every program and project generated by the Cultural Resources Council as an educational experience, direct or oblique.

The Festival of Nations offers a lesson in ethnic harmony; the Jazz Festival and High School Theater Festival rub rough beginners against the polishing stone of professionals; On My Own Time encourages closet artists to come out and learn from one another; the Youtheatre live shows hone the emotional skills of young people; the Salt City Folk Festival teaches that "down home" traditions must be cherished; the Saturday Creative Dramatics and Teen Acting classes stretch the dimensions of youngsters' imagination potential; the Production Planning Seminar bluntly offers the how-to of mounting a public event; and the Institute for the Arts in Education invites area school teachers to plunge into their own creative wellsprings and discover the language of the creative process which they, in turn, can transmit to their students.

The notion of the cultural center as schoolhouse is slowly gaining respectability around the country. And although we didn't invent it, we pursue the notion with a passion that borders on the psychotic.

It's an ego trip, really. You see, we're presumptuous enough to believe we can endow the next generation, the next century, with a wonderfully durable commodity: a greatly enhanced sense of self-worth.

Isn't that what education is all about?

Thanks, Donald

Don't be embarrassed if you've never heard of Donald Coker. He's a sixth grader in a local public school, and I wouldn't have heard of him either except that I got to read a letter he wrote to us after he saw a show in our Youtheatre series—a ballet version of *Alice in Wonderland.* Such post-show letters come in frequently, usually in large batches, and are invariably dubbed "cute" or "charming" and embellished with "pretty pictures."

But not Donald's. Donald saw both the truth and the dream of the performance. It cranked up his brain and opened the pores of his imagination. He understood what he saw and was unafraid to let it do things to him. And he reported it all, in an ingenuous free-verse style, with an accuracy and zest that would put adult critics to shame.

So I happily relinquish the balance of this space to Donald's earthiness, joy, and fantasy.

> I think it is amazing
> How the ballet dancers stay on their toes
> I know when they get home
> They must be soakin' their feet in epsom salts and water
>
> It takes a lot of practice
> to be that well balanced on their toes
> The minute they walk into the ballet school
> they start walking on those toes
> They really stay there all of the day
>
> They have to watch what they eat
> because they can't put on too much weight
> They might have to drink skim milk
> to keep those shapes
>
> I wonder . . .

How do the men feel running around
in those tights and stockings
I know they look funny
But the men dance good
But the women dance better

They have to stay limber
in order for them to dance so good
It must feel fun out there
Dancing on your toes

It must have been fun when Alice
fell through the mirror
And the rabbit
came to life

I wish I was playing
and I had a car
and it fell through the mirror
and my car came to life

I would get in it and drive all around
And if the red guard tried to catch me
I would run him over
And if the queen tried to chop my head off
I would run her over

Then I'd go back into the mirror
and I would tell all of my friends
and my parents
about the adventure that I had
when I fell through the mirror

And my little car turned back
into a little toy.

A Hen-Scratch Theory of Aesthetics

 The tenth-grade history teacher from Brooklyn was sprawled on
the floor, absorbed in drawing what looked like cryptic symbols on a
large sheet of paper. Circles, squares, arrows appeared. Her concen-

tration on her task was so intense, she must not have been aware that her upper teeth were gnawing rhythmically on her lower lip.

She was surrounded by about two dozen other men and women, also schoolteachers, who were equally engrossed in making arcane hen scratches on their own sheets. Except for the slight squeaking of marking pens on paper, the room was silent. Another ten minutes passed.

The young man standing in the corner moved forward and broke the silence. "O.K. Time's up. Louise, why don't you show us how you'd arrange the stage setting for this play." The Brooklyn history teacher who, like everyone else in the group, had never designed a stage setting in her life, stopped chewing her lip and moved uneasily to the center of the room. She arranged benches, chairs, and tables as her sketch dictated. She finished, and waited expectantly.

Hands shot up around the room. From a Long Island English teacher: "Too neat! The Playwright says 'messy,' 'crowded.'" Another, Social Studies from the Bronx: "Doorway's on the wrong side! You can't get to that part of the house!" A biology teacher (laughing): "The audience has X-ray vision? How they gonna see through that refrigerator?" Louise, recognizing her gaffes, nodded solemnly and began pushing the chairs and tables around again.

In what sort of bizarre enterprise have public school teachers of history, English, social studies, and biology become engaged? Aesthetic Education, it's called—training in stretching the senses and the brain far enough to begin touching the primordial laws of artistic creation. Although unskilled in theater craft, the school teachers are discovering that, given some clues to the mystery of the aesthetic principles that govern and illuminate art, they possess eyes that can be trained to see rather than look, ears that can hear rather than listen, and hands that can feel rather than touch. They discover that time, space, form, tension, rhythm, balance, and repetition are not the filmy and esoteric province of critics and esthetes, but are real, solid, useable keys for unlocking a totally new dimension of delight in the message of the artist. What a revelation.

And, with a little planning and luck, they'll share their discovery with their students. And why not? There's Science Education, Math Education, Language Education. In a world drenched with color, sound, and motion, a person untrained in Aesthetic Education can only respond to life with the zeal of a robot.

Which is why we launched the first two-week workshop of our Arts in Education Institute. Modeled on the successful program at New York City's Lincoln Center and funded by the New York State Education Department, several school districts in Syracuse and Onondaga County send contingents of teachers to the workshop, where they discover the joy of experiencing and reaching aesthetic goals, of opening their sensory pores, of unlocking the secrets of an artist's mind.

The discovery changes them.

And it only takes a few hen scratches to make a start.

Benevolent Brainwashing

I have been accused of being a child molester. A benevolent child molester, let me hasten to add, if it will deter you from informing the police or the District Attorney.

I'm not interested in their bodies. It's what is inside their heads that fascinates me, that I want to grab, squeeze, and alter. It's what their *minds* are capable of learning, seeing, hearing, and feeling that I love to attack—and do regularly, as will be discussed shortly.

When I'm asked to reflect, therefore, on future generations, and to propose a "framework for the future," my crystal ball fails me. I am hung up, you see, not on *later*, but on *now*, and on whether or not today's six- or seven-year olds are being encouraged to discover and develop their potential to the degree that will make a difference in the world they will inherit.

Which is why the seeds of the future lie in that massive concentration of cells called the brain.

And the brain, like a computer, will spew out in the future what we feed into it today. Kids are living models of the computer trade cliché: "Garbage in, garbage out."

To construct a relevant framework, one that will make the future a civilized and humane experience, we need to ensure that all our faculties *today*—our ability to feel, think, and to transmit ideas clearly and strongly—are stretched, tested, and enriched. The future will be promising and manageable only if it is shaped by a resilient, optimistic, and informed set of brains. And the brains that need the most attention are inside the skulls of kids. The resources

we need to determine the shape, size, and strength of that frame-
work are, in short, in our hands *now.*

The future, a mystery that evokes a mixture of enthusiasm and
dread, is not "down the road." Just look at our futuristic technology
already in place: artificial hearts, computers that think, death rays,
laser beams that generate three-dimensional people singing grand
opera in your living room, and magnets that decipher and analyze
every bodily function.

It boggles the mind, creating a sense of "future shock" that is
sometimes very difficult to digest.

But while there are people playing with atoms and computer
chips and tapping the molten core of the earth for a source of new
energy, a few of us are concentrating on brainwashing kids—on
making them aware of the enormous creative energies they possess
and providing the pathways along which this energy can be chan-
neled.

The waste or misdirection of these energies can be disastrous.

Among the greatest personal tragedies of life is the flower
within us that never bloomed—the aptitude that atrophies, the mel-
ody sung that nobody heard, the powerful feeling that we were
afraid to express, the beautiful words we wanted to speak or write
but didn't. Someone might laugh.

Most of us go through life feeling vaguely unfinished, incom-
plete, unfulfilled, slightly cheated, or robbed of some taste, some
need, some seed of ambition that didn't germinate.

Most adults simply learn to live with the appetites and needs
we suppressed a long time ago. It sometimes has an unhealthy ef-
fect, producing resentments and frustrations that lurk just below
the surface for the rest of our lives.

But with kids we have a chance.

A chance to open some doorways that let the mind explore ave-
nues of talent and skills—to discover their own strength before
someone weakens it. And by exploring and discovering their own
strength, we offer them a precious gift: A sense of personal identity
and worth.

"I am me! I can create and accomplish something! I know how
far my mind can reach! I have the capacity to see, think, under-
stand, feel, react, and be unafraid to test myself on new ideas."

If I were to construct a framework for the future, I would want
the help of people whose identity and worth were secure, confident
in the knowledge that their innate talents were discovered, nur-

tured and shared with the rest of the world—people who are, in the popular jargon, "all together."

All these remarks are just a way of explaining why the agency I serve, Cultural Resources Council, is up to its eyeballs in programs for young people. There are ten programs, to be exact, covering pre-schoolers to college kids. Three more are under development.

None of the programs, I hasten to assure you, has anything to do with trying to overpopulate the universe with dancers, actors, film makers, or saxophone players. We have an ample supply of all these types, operating in a job market that is wickedly competitive.

The ten programs don't reach every child in the county. We admit we're only scratching the surface. But if we infect some, maybe it'll spread.

And what's the "bug," the "virus" we're trying to spread? Simple. That the arts are one of the most powerful mechanisms for deepening and strengthening the way we perceive and deal with the world around us.

In the course of a season, we directly expose more than 60,000 children to this arts bug in the ten programs.

1. We offer a Saturday series of "classic" films—"Treasure Island," "Secret Garden"—to show the kids that there is an alternative to TV and that they have the capacity to grasp and enjoy an experience of a more complex structure than "The Smurfs."
2. We provide live professional theater, music, puppets, and opera on selected school days, with youngsters bused in from fifteen counties. Special study guides are prepared for teachers to help them creatively involve the students before and after the show.
3. A separate series of live performances take place on Saturday afternoons, giving parents the opportunity to join their children.
4. On Saturday mornings, the Youtheatre Institute offers classes—from creative dramatics to teen acting.
5. The annual High School Theatre Festival & Competition attracts over a dozen schools. Being older, the students are subjected to the criticism of professional adjudicators who underscore the toughness of the craft and the control and discipline needed in the theater.
6. Our Jazz Education Day gives young musicians with a serious interest in a music career the chance to mingle with, and be tutored by, working jazz pros. This interaction with profession-

als happens very rarely in the public schools, notwithstanding the fact that jazz is one of the purest and most indigenous forms of American music.

7. We take this a step further with our annual Jazz Festival & Competition. The young musicians—some who travel several hundred miles to attend—perform before a demanding panel of professional jazz artists. The premise on which the youngsters are judged is that accuracy and excellence cannot be compromised.

8. We launched an Arts in Education Institute—with the help of our State Education Department—to reawaken in *teachers* the excitement of discovering how this thing called art really works, and to share their excitement with their students.

9. The annual Festival of Nations has a special time set aside for kids—the Youth Concert in which they display their own pride in their national origins and submit to arduous training to get right the complex steps of their ethnic dances.

10. Occurring regularly are master classes and workshops for young dancers, conducted by visiting dance artists. The youngsters learn, sometimes painfully, that there can be no tolerance for error, that the body must be turned into a tough, resilient instrument capable of enduring great stress and even pain.

All ten of these programs have a double purpose. The first is purely pragmatic. We not only want to give solid, practical training to talented kids, but also to build future audiences—those who would rather watch than do, but watch with a keener understanding and satisfaction.

The second is purely theoretical. We want to convey an idea: the arts are uniquely able to teach that discipline is a form of freedom, that commitment is a source of strength, and that imagination is the real motivator of human growth.

And we will grab, lasso, brainwash—whatever is necessary—to give kids the chance to develop discipline, commitment, and imagination.

We've Come a Long Way, Kiddies

My theatrical debut was overwhelmingly inauspicious.

I played a postman in a sixth-grade Christmas skit in 1942, delivering messages about Christ's birth to an assortment of elves, gnomes, reindeer, and good children. In retrospect, the skit was a piece of absurdist comedy, the recipients of the message being largely the children of Jewish immigrants. But Miss O'Brien, the teacher, saw nothing amusing in it, except when Sammy Cohen's antlers slid off his head.

The episode is noted because it illustrates the substance of the cultural diet offered to public school children in the late 1930s and early 1940s. The occasional skit, a 30-minute weekly encounter with the recorded voice of Walter Damrosch exhorting us to love classical music, and sing-a-longs of patriotic tunes during school assemblies, constituted the bulk of our exposure to the performing arts. It was bland, sterile, and unmoving.

It is no longer bland, sterile, or unmoving. In the 45 years since I broke into show biz with my mail (pillow case) pouch slung over my shoulder, a small revolution has taken place. Inside school rooms, as well as out, it's been recognized that children are bundles of creative energy, that they have powerful and innate sensibilities for the arts, that they more completely learn the 3 Rs when the big A opens pathways to their minds, imaginations, and bodies, and that they are a great market for good cultural products.

These years saw children's theatre become respectable, thanks to the pioneering of playwrights Charlotte Chorpenning and Madge Miller; saw the arts sneak in by the side door of school curricula, from K to 12, with classes that range from pre-school fingerpainting to high school courses in play production; saw the formation of professional acting companies committed exclusively to playing for kids; saw television discover young people via "Sesame Street"; saw the formation of "magnet schools" that draw together young people of like talents in the arts; saw state and federal agencies create programs, provide dollar support and otherwise encourage the pumping of creative juices toward children; saw psychiatrists, psychologists, and social workers achieve startling results when the arts have been used as tools to penetrate the special world of the disturbed or handicapped child; saw major artist agents in New York City include events for children in their catalog of national attractions; and saw professional, year-round resident companies and sponsors of children's entertainment become established in Atlanta, Seattle, Detroit, Washington, D.C., Portland, Maine, Syra-

cuse, and elsewhere. Anyone not hitched to the kid wagon these days has not come out of the caves.

And the revolution continues with Showcase 87, scheduled for March in Cleveland. As part of the strong and continuing surge toward providing young people with experiences that are entertaining, sophisticated, and entirely professional—the era of the charming "kiddie show" having passed into a deserved oblivion—the Showcase will bring together sixteen of the best theatre, mime, puppet and opera companies from the U.S. and Canada, and put them on exhibit for prospective sponsors.

The Showcase is not the climax of the on-going revolution, but it represents yet another leap, a large effort to move theater arts up to the levels of perception that kids already possess. The unsecret message of the Showcase is: if you want high-class adults to run our world, give them high-class stuff when they're kids.

It makes a lot more sense than watching the antlers slide off Sammy Cohen's head.

The Arts and the Little Kid

It's the day before Christmas. An appropriate time to suggest an appropriate gift for the children in your house—especially the ones still in elementary school.

No, it's not what you think. I'm not about to recommend a beginner's painting kit, or toe shoes, or a three-ton block of granite that your seven-year-old darling will chisel into a 10-foot high statue of Peter Rabbit. What I have in mind is something much simpler, more permanent, more personal than anything you can buy in a store, decorate with pretty wrapping, or put under a Christmas tree.

Before I name it, consider for a moment the kinds of experiences a child has shortly after he or she is born: consider the kinds of aptitudes the child is born *with;* and consider how, in the first two or three years of life, the child learns to understand the world around him.

Put a book in front of a one-year-old, and the baby will chew on it. Give the child a column of figures, and he'll crumple it up. Talk to him about history, geology, or government, and he'll go to sleep.

But what if you clap your hands rhythmically in front of the child? Maybe she doesn't know how to walk or talk yet, but she knows what to do and how to respond to that. What if you put a piece of colored paper in front of him, and stuck a crayon in his hand, he knows what to do. And put a bunch of blocks in front of him and—without even knowing what it is or even having heard of one—he'll build a castle.

And when toy-buying begins, chances are it's a toy that spins, flicking off bright colors; or a toy that pulls, playing music on a little bell; or a toy that he colors in or draws on. And when the child is a little bit older, he'll hardly ever report on what happened in his day without "acting it out." And chances are he'll learn the alphabet by singing it out. And he (or she) will express their terrific pleasure in the arrival of a friend or the receiving of a gift by "dancing with joy." And until the child learns to write, he'll communicate vigorously and colorfully by "drawing you a picture." The language of a child is the language of the arts.

Psychologists, sociologists, child guidance experts—as well as children themselves—have known for a long time what some parents and board of education officials seem to forget very quickly. Namely, that a child is a natural, spontaneous, intuitive artist. It comes with the territory—in the genes, in the blood, in the brain. And as a result, the child—like the artist—sees and hears and feels with terrific clarity and intensity—and is compelled to express it with all the creative instruments at his disposal: the hands, the voice, the eyes, the body; with a stick beating on a tin can, with a hand puppet made of old rags.

It's when the child gets older and starts formal schooling that most of his natural creative juices start being drained off. Parents want children prepared for "practical" careers, and so play down their artistic hungers. School officials often label creative pursuits as "frills" and reduce or cut from the curriculum those "unnecessary" things like music and art; and society itself, especially American society, hasn't quite matured enough to assign to the professional artist the same dignity and importance that it assigns to doctors and lawyers.

A form of homicide is committed—death by strangulation of the creative spirit. (It's sort of ironic to note that when the human organism is in trouble, when the physical or mental world of a person is deeply disturbed, the experts rediscover the arts and call it ther-

apy as a means of restoring a sense of stability and accomplishment to the disturbed person.)

So what gift am I recommending? Maybe you've caught on. The local school district is considering "freezing" or cutting back on music and art programs next year in the elementary grades. In those very years when a child is straining and testing every one of his resources to find the measure of his own emotional capacities and imaginative skills—not because he wants to become an artist, but because he wants to become a person.

The good old bedrock three Rs and all the school subjects that are fed into a child are certainly essential to informing a young citizen about his world. But it's just as essential that the natural artistic aptitudes and appetites a child possesses be sustained in order to inform the young citizen about himself.

And the gift? A note to your school board advising them that you'd like your child to grow in every way. And that the arts—surely one of the great fertilizers of the human imagination and soul—are vital to his growth.

Tap Dancing on Thin Ice

It's no wonder that sometimes they're viewed as dodos, blithering lambs, or aesthetic *kvetches*. No surprise that they're often sublimely exploitable and vulnerable. No shock when their naked innocence needs to be hastily and expensively clothed by lawyers, insurancemen, bookkeepers, and managers. The only thing remarkable about their behavior is that they display it as if it were a Medal of Valor, an Emblem of Purity, a comfortable Crown of Thorns.

The "they" are graduates of the schools and academies that teach music, theater, dance or the visual arts—many of whom are pumped into the real world with enough chinks in their professional armor to make them look like slices of Swiss cheese.

What provokes this frothing began (of course) at home. A son spent four years at a reputable school of art learning about brushes, palettes, pigments, the legacy of the Masters, and that elusive play of light and shadow on the nude model which the novice painter struggles to capture. So far so good.

He can mix colors like a magician. With a few strokes of a charcoal stick, he can evoke an image of sylvan delight. His portrait of a younger brother resonates with the melancholy that was devouring the subject at the moment. Wonderful.

But for all its splendid and intensive training, the school never introduced him to a mitre box, so that he could properly frame his pictures. They never annoyed him with the issues of "artists' rights," establishing "fair market value" of art works, commercial gallery operations, or otherwise coping with the world outside the academy cocoon with a weapon any mightier than a tube of burnt sienna.

And it's not just schools for painters or sculptors that behave more like seminaries than academies. Serious students of music— vocal or instrumental—are so engulfed by matters of pitch, cadence, and tone, it's evidently considered immoral to ruffle them with pedestrian issues of performance and recording rights, the role of music licensing agencies, dealing with agents and managers, the logistics of touring, or anything as banal as artist contracts.

There are exceptions, of course. A few special programs have begun to surface that, without threatening the integrity of the art form, introduce the student musician or actor to the fact that there's an industry "out there."

But real world preparation remains sparse and flimsy in most arts academies, producing students who are marched into the industry jungle equipped with hardly more to protect them than toe shoes, palette knife and dreams of glory.

I'm not proposing that artists—of whatever ilk or discipline—be obliged to become canny arts administrators. Being an artist is enough of a load. But to dispense and receive a diploma without inhaling at least a whiff of real world imperatives—politics, business, law, and minimal strategies for self-reliance—is both unconscionable and hazardous.

It's like asking the artist to tap dance on thin ice.

Ballet and Botany

There's an ominous report out of West Genesee High School, a development so unorthodox, so alien to the mind set of public school bureaucracies as to be downright scary.

The Fine Arts Department at West Genny has introduced to the school curriculum—are you ready for this?—training in dance. You read it correctly—dance. Bends, extensions, *pliés,* and *grand jetés* are now interwoven with Biology, American History, and Math. As far as I know, it's the first public school in the county to offer dance, maybe in the state.

What makes this development very sinister and serious is that they've gone and hired an authentic, professional dancer/choreographer to teach the classes to the hundred students who have signed up.

A well-designed dance curriculum could have an awful effect on those innocent kids. The intense physical exertion dance requires might keep their bodies limber and healthy. The training might sharpen their creative sensibilities as they learn to integrate vision, movement, and music into a coherent statement. The severity of dance training might teach them something about such dangerous values as discipline, muscular coordination, and respect for the potential of the human organism. They might even be contaminated with a sense of poise, balance, grace, and personal demeanor that will plague them for the rest of their lives. A few—heaven forbid—might acquire enough of the basic skills to inspire them to pursue a career in dance, having discovered that the human body—a unique instrument of communication—can transmit images of human experience in a beautiful form, experiences that cut right through to our nerve endings.

Never mind all those silly arguments about dance being the most elemental, spontaneous, and personal vehicle of expression, or that people joining together in dance—for joy or for celebration—constitutes the most powerful *communal* experience known in our society.

Well, it appears that there are some folk at West Genny who actually *believe* in all those values and arguments. They seem to espouse the notion that the traditional 3 Rs don't address *all* the appetites and expectations of young people. Heresy!

What scares me most, however, is the terrifying thought that this little curricular innovation at West Genesee High School might spread, might seduce administrators of other school districts into introducing a similar dance program at their institutions.

I hope it does.

And quickly.

3

The Grass Roots Are Getting Greener

The insurgency of grassroots arts agencies—cultural councils that struggle to pump the arts back into the mainstream of a community's life—is a stunning phenomenon of mid-twentieth-century America. There were a handful of such agencies in the 1960s; there are more than eight thousand in the 1980s.

The startling growth rate has produced an assortment of growing pains: the scramble to find an identity and role, the struggle to acquire an instant credibility, the ordeal of winning new converts to the arts in order to build a strong and diverse base of support, the obsession with day-to-day survival tactics, and the strain of articulating a genuinely long-range plan to serve as a road map to the future.

These and other stresses of growing up are the subject of the several essays that follow. They were written in the hope of easing the passage through adolescence toward the mature and influential force these agencies deserve to be.

The Grass Roots Are Getting Greener

While in D.C., the mist lifted long enough over Foggy Bottom to reveal to me a startling national development. Evidence compiled by the National Endowment for the Arts suggests that, for the first time in American history, there is a widespread, bona fide, and culturally potent arts movement at the grassroots level.

From Hana, Hawaii (sixty miles over twisting mountain roads from absolutely nowhere) to Atlanta, Georgia; from Ortonville, Minnesota (population 2200 on a warm day) to Houston, Texas; from Springdale, Arkansas (deep in Ozark country) to Syracuse, New York, community arts agencies have been established, taken root, and now constitute a nationwide network of organizations that support, foster, encourage, house, coordinate, produce, present, sponsor, and lobby to raise money for the arts. They operate out of living rooms (Sault St. Marie, Michigan), recycled jail houses (Clay County, North Carolina), one-time textile schools (New Bedford, Massachusetts), multi-purpose arts centers (Temple, Texas) and Civic Centers (Syracuse, New York). In many American communities these arts agencies are about the only beacon and rallying point for culture in an otherwise bleak landscape.

Some numbers might give a perspective to the movement; in the early sixties there were just over 100 arts councils in America. In 1974, the last time an "official" count was made, there were 1,840. By 1990, it is estimated that well over 3,000 will exist.

The implications of this new grassroots movement are considerable. Arts councils have become firm and persistent advocates of the importance of the arts in a community; councils are creating new environments—physical and spiritual—to give local artists and arts events a greater visibility than they've ever had before; audience hitherto denied access to arts events—because of age, infirmity, color, or economic status—are discovering that arts councils are opening new doors to them; decaying urban centers are becoming, through organized arts council effort, the targets for rehabilitation by painters, sculptors, and preservationists; training in the arts and crafts—both by "artists-in-residence" at public schools and by programs offered at hundreds of "arts centers"—has become big business; and, as a result of all this, elected officials (local, state, and federal) and corporate leaders are beginning to develop a sensitivity to the social, political, and economic value of the arts.

The Messiah has not yet arrived; the Renaissance is not quite upon us.

But the arts at the grass roots are getting greener.

The Arts Scene: Is It Really Copeless?

There's a spectacle going on in the country right now that

would outdazzle a performance by the Metropolitan Opera.

It's the spectacle of hand-wringing, breast-beating, soul-searching, and fist-shaking that has roared onto the arts management scene as a direct consequence of the budget-cutting actions taken by Gonzo's friend in Washington, and by all the henchpersons of the friend.

The spectacle is all the more poignant and agonizing because we were so ill-prepared for the shock. Having spun ourselves into our own isolated local cocoons, many of us are finding it painful to have our cocoons torn open, and to look forward to the 1990s with the joyful anticipation of complete cultural dehabilitation.

The spectacle raises the question of our ability to cope, to survive, to adapt—as our primordial ancestors did—to a dramatic change of climate.

The spectacle, with all its fiscal and philosophical implications, is real enough. But have we truly been flattened? Is it all really copeless?

Not at all.

There are a variety of strong actions we can take, some of them distinctly anti-social.

We might riot, for instance: Smash windows of ticket agencies in Seattle, burn the Eaves Costume Collection in New York City, or overturn mobile stages in Dallas.

We might engage in guerrilla warfare: Tamper with the Ticketron communication network to make it double-print every ticket, or ambush the New York City Ballet and steal their tights.

Terrorist tactics are sometimes very salutary: Rip the marquee off the Ohio Theatre in Columbus, hold a senior citizen arts and crafts class hostage until we get a "Meals on Wheels" getaway truck.

Or simply go on strike: Darken every concert hall, every gallery, every theater, air only static and occasional Emergency Defense messages on FM stations, spin records that make no sound, or hold a clothesline art show that displays nothing but a clothesline.

Nothing. No song, no color, no story, no movement. Total paralysis.

Absurd, right?

We arts managers are too genteel and civilized to riot, terrorize, or strike. It would be too much like a Terry Thomas or Peter Sellers movie.

But what do we do, how do we cope, with Reagan-itis or the

Stockman Syndrome? As a partial answer, let me share with you "The Parable of the Dinosaur and the Tiny Hopping Things."

The dinosaur blinked several times into the endless sun. Objects were moving across the sky he had not seen before, creatures that his golf ball mind could not fathom.

His feet, now sunk twelve inches into the mud that was once his exclusive and deep pool of water, were not easy to move. He tried, but couldn't remember how. So he had been standing there for three days, wondering what to do.

As he lowered his head to avoid the burning rays, he could dimly perceive small moving things on the earth around him. They were strangely shaped and behaving oddly—wrapping themselves in leaves, burrowing into crannies between stones, sucking into their balloon bellies deep swallows from the thin sheet of water that still floated in tiny pools on top of the mud. There were a lot of these hopping and crawling things now that were exploring, improvising, adapting, surviving. "I would do that," thought the dinosaur, "if I could just think of what to do."

His four huge feet sank another six inches into the mud as the earth suddenly trembled, and huge red plumes of fire spit vertically on the horizon.

The dinosaur thought the rumbling was a sign of hunger, so he swung his head toward the only tree he could reach. Instinctively, he went for the leaves on the top of the tree. They were gone. Lower down there were still a few; and a hundred yards away in three directions there were trees with a lot of leaves. But the dinosaur, his legs now two feet into the rapidly baking mud, didn't know how to reach them.

The dinosaur thought that it might be time to think about getting worried. The competition for the little water and few leaves was getting tough; new creatures were devising clever ways to survive in the red sun, to search for different ponds, other trees, deeper crannies. "I think," thought the dinosaur, "that I will try to think about doing the same."

With great effort, he tried to move his left front leg. But the mud was now touching his large underbelly. The leg didn't move. In confusion and frustration, he lifted his head to prepare for a defiant roar. Nothing came out. He couldn't remember how to make one.

The only sound was the cracking of the baked mud.

The sun is indeed burning. And the pools are drying rapidly. And the rumbles from the Potomac, from state capitals, and from over-solicited donors have never been more ominous.

Our most traditional and trusted methods of coping with the threat of dramatic change in our climate—the impassioned chatter about "quality of life," the frenzied letters, phone calls, and visits to legislators, the flaunting of data and impact studies, the canonizing of the artist, the view of the arts as a device for urban revitalization, the arts as educational or therapeutic tools, the arts as the last bastion of sanity—all are virtually obsolete. They're prepared to accept the homage of the people on its own terms.

We've heard it before; a thousand times, *ad nauseam.* We hear it at conferences where we solemnly nod our heads, go home, and remain singularly uncreative in trying to build the bridges, coalitions, and linkages with the hundreds of other service or business enterprises in our communities.

And it's not money that handicaps us. (Bridges and coalitions *reduce* cost.) It's *thought.* It's a new way of perceiving our role vis-à-vis the rest of that special complex of universes called our community.

The dinosaur in our parable was content, a bit smug, and not very bright. It mistook its weightiness for relevance; its height for stature; its appetite for curiosity. It couldn't adapt to violent change, and it died. The facile, quick, and inventive survived.

The same can be said of arts agencies—whether councils, presenters, or theaters. Promoting the arts is not enough. Not in an era when the National Endowment for the Arts is being slashed, the PBS massacred, Medical Trauma Centers demolished, Legal Services to the Poor butchered. And when federal subsidies for grain are cut, we've got a problem. We never did have the clout of farmers.

"Coping" doesn't mean merely "putting up with" or "dealing with." It has to mean a readiness to *alter* the way we think about ourselves, our agencies and the many other institutions that surround us that constitute the matrix of total community. It means an aggressive *search* for new relationships. An arts program, for example, built into a local police department has a better chance for survival than a program done in collaboration with the local quilting club. There are relationships that begin making us an integral part of a community's *other* major needs and ambitions. It means developing a new *relevance* for our programs and goals—to move

steadily toward the image of arts as an "essential service" to a broad and diverse spectrum of citizens.

It's all very sad. Many of you have already succeeded in achieving traditional goals: opening or operating a theater, establishing an arts festival, or getting a good sponsoring season started. And now you hear: It's not nearly enough.

Incidentally, the process of searching and adapting does not imply compromise. There is no wish to water down the arts, to sell them out, to abandon them to the rabble. What *is* implied is the need to begin learning different tongues, a different language, so that we can translate the arts—without patronizing—into the jargon of the urban developer, the youthful offender officials, the social service agencies, the labor unions, the Kiwanians. The arts agency that does not, in other words, emulate the octopus in the eighties and nineties will follow the path of the dinosaur.

The situation is not copeless. If we wish to both see and shape a future, we'd better get our feet out of the mud before it begins to harden.

Ten Terrific Ways to Become Obsolete

What follows is the product of thorough and painstaking research carried out over the past twenty years. There is, as we know, substantial literature on the hallmarks of successful cultural agencies. There has never been, lamentably, any methodical study of the means to ensure the failure of these agencies.

The motive for this research is simple. Responsible arts leaders must not rely on instinct to achieve failure; they should, in fact, be carefully schooled, and know precisely which strategy of collapse they are using. Blind, unsystematic failure simply has no challenge, and therefore no drama.

Some arts managers make lifelong careers out of failing. I know a young woman who studiously applied her skills in doing everything wrong and brought about the demise of two dance companies and one opera group. She was later associated with a small symphony orchestra in Florida. In three months it went Chapter 11 of the Bankruptcy Law.

It is no easy task to diminish, demoralize, and painstakingly dismantle an arts organization. But when perpetrated with deftness and panache, there is something awesome in the spectacle of

collapse. There is no accident about it. The killing is carried off with the icy precision of one of gangland's professional hit men.

If what follows in any way facilitates or accelerates the process of decline and decay, I will experience a sense of deep reward.

Some of the ten tips I will offer—actually ten delightfully malignant strategies for making arts agencies trivial and useless—may sound a bit familiar. If they do, you are to be congratulated. You are well on your way to making yourselves obsolete or extinct.

1. Keep Your Wagons in a Circle. Be very clubby and elite. Resist all temptation to admit the untutored, unblessed, and unwashed creatures into the protected circle of your cultural encampment. Protect to the death the arcane interests of the 1–3 percent of the population that are art-lovers against the insinuations of the do-gooders who proclaim that the arts are as inherent as genes and as basic as blood. (I sent a congratulatory telegram to the President of an arts Board who fired the Executive Director for letting the Barbershoppers use the theater. Bravo, Mr. President! Imagine—Barbershoppers!)

 Be insufferably discriminating toward people, programs, and art forms. Maintain gallery hours that are maximally inconvenient, ensuring that working-class rabble can be kept out. Keep your mailing lists lean and small, unsullied by names of Rotarians or Visiting Nurses who can't fathom your program anyway. Hammer away, with tasteful arrogance, at the themes of "enrichment" or "quality of life" and never feel you are obliged to define them.

 Remain stolidly indifferent to regional and national trends, reports, and analyses of the new insurgency at the grassroots of cultural democracy, of shrinking and competitive dollars. All these rumbles will merely muddy the waters.

 Above all, keep your orb and sceptre polished, ready to use to dazzle and intimidate the populace. We do, after all, want to keep them in their place and at a safe distance.

2. Shun the Smoke-Filled Room. If you feel disdain, impatience, or discomfort with the political process, you are merrily sliding toward extinction. Let the National Rifle Association, the Moral Majority, the National Education Association build powerful constituencies. It's a tacky and bothersome process for esthetes. And who, after all, has the time to build files on

elected officials, develop dossiers, form coalitions, mobilize campaigns, especially if under pressure to organize the Clothesline Art Show that is scheduled in two weeks; or that significant seminar on "Multi-Racial Arts in Suburban Schools."

It dirties the hands, trying to convince those political squash-heads of the value of the arts, particularly when the persuasion has to go on incessantly, interminably—every day, every week, all year long. Skip it. And when you awake one morning to discover that your agency has been decimated by an act of the legislature, simply smile, stretch, and go back to sleep. You have triumphed.

3. Never Look Out the Window. Industries may be moving in or out; elementary schools may be closing; the population may be shrinking or expanding; some minority tensions may be percolating briskly; a bond issue on a new secondary treatment sewage plant may have the natives in an uproar; four retail stores may have closed on Main Street; drumsful of PCB may be leaking into a public swimming pool; and a band of wild English short-hair pussycats may be terrorizing school children. Remain calm. Go ahead and plan your season as if nothing were happening, as if the subtle or dramatic shifts in a community's economic, social, or environmental climate were just raucous newspaper headlines.

It is wise to be suspicious of those devious creeps who secretly pore over demographic studies; or who insist, a bit pretentiously, on receiving updates on 1980 census findings, who keep in touch with local urban or economic planners and developers; who sit in on community improvement meetings, who know union officials as well as they know school superintendents; and who inhale deeply the essence of the thoughts and actions that alter their communities. What's all that got to do with *culture?*

4. Make 2 + 2 = 5. This is a strategy with real substance. It could, alone, guarantee your extinction. And it's simple to use. Merely preserve that beautifully blurred distinction between earned and unearned income, that fragile fuzziness between debits and credits; that *je ne sais quoi* air about bookkeeping procedures, cash flow, or internal controls. Treat budgets like bouquets of daisies, randomly plucking and discarding the petals. Cast off your 501(c)(3) status like a childhood romance. Forget to report

withholding taxes or, juicier yet, spend the withholding tax money on flashy posters.

The ominous noises from the IRS regarding the fiscal liability of you and your board is so much bureaucratic garbage, perpetrated only to intimidate the masses.

Lose no sleep over it.

The real virtue about this pathway to oblivion is that it's fast and provides the masochist with exquisite humiliation.

You'll be notorious for weeks. You could even become a guest of the state in one of its more isolated institutions.

5. Remain an ethnic and social virgin. You may suffer some small criticism from those cranks who take the "melting pot" notion seriously. They are probably the same crackpots who endorse Fair Employment Practices, the ERA, and Equal Opportunity.

The ethnics claim they possess and preserve a rich cultural tradition—but who can learn all those weird dance steps or want to wear the funny skirts?

And the blue collar labor force—the bowling, beer, and TV crowd—should be conspicuously overlooked. The fact that in Syracuse we happened to find extraordinarily talented painters, sculptors, photographers, ceramists, wood carvers, and musicians working on factory assembly lines should not influence us. They were probably planted there by the State Arts Council as Fifth Columnists.

The fact that the labor unions represent, potentially, a delicious source of hard cash for programs should not deter you from any compulsion—latent or active—to ignore them and become obsolete.

Minorities—the elderly, half blind, retarded, Black, Hispanic—are nervy types who presume to possess strong creative energies and who demand an equal share of the cultural pie. Do everything possible to suppress them.

You won't stay in business for long, but your flag-draped, virginal body will be lowered to its final rest unblemished.

6. "I Gave at the Office." This is closely related to the virginal technique just offered. You may, from time to time, receive overtures from social and civic agencies—that infrastructure of morally upright organizations that deal with social, educational, medical, or penal problems.

They may, occasionally, sing the siren's song, trying to seduce you into a false heaven of public service—that is, form a

drama club for emotionally disturbed children, send the pianist you have in residence to the county jail, or, as my wife did, go to the orthopedic rehabilitation ward and sing to a young boy with a severe concussion while squeezing his hand rhythmically, hoping the words, melody, and pulse will bridge the unknown distance between his world and ours.

These links and connectors between the arts and social service agencies are dangerously beguiling: they might not only do good things for kids or adults, they might also generate good press, produce good support dollars, and might even make the arts agency as necessary as garbage disposal. They can also become an awful burden, distracting you from the planning of your forthcoming gala benefit featuring the "Stars of the Boston Ballet." You just can't worry about champagne punch and learning disabled kids at the same time.

And God forbid you should make overtures *to* these social agencies. Don't you know that you work with the *arts,* not with people??

Stick to that and the earth will gape.

7. Avoid kid stuff. This is a good one. It will stir the heart of every hassled parent.

The objective here is to flaunt, defy, or forget every social or educational principle regarding the needs of children and their developmental potential. Nothing so clearly identifies the self-destructive arts administrator than the act of throwing cultural scraps to kids—the occasional Youth Concert (Shari Lewis and Lambchop?), the once- or twice-a-year play, the art classes that spend a lot of time with paper and string. These are, without doubt, activities that make us feel *good* because we're "doing something for the children."

That's enough. Don't spoil those noisy, jam-encrusted little rotters. Not unless you want to survive, of course—and that's utterly contrary to the objective of this essay.

Besides, it's much more fashionable to stand around at cocktail parties, wringing hands and beating breasts, lamenting the lack of an informed, supportive and generous audience—the one we didn't create because of our unswerving commitment to self-elimination.

The failure to address the needs of kids vigorously, comprehensively, consistently, and creatively is the hallmark of an agency's death wish.

8. Look through the wrong end. This strategy guarantees positive results. Simply keep your pragmatic telescope focused on the single planet—and to hell with the constellation.

To illustrate:

A lady I know was gurgling with joy over her artist-in-schools program. It covered two third-grade classes. The rapture she exuded was stunning; her vision of impact the program was having on the kids was staggering.

I applauded her and advised her that she was well on the road to extinction. That puzzled her.

I asked: "What about the others?"

"What others?" she said.

"All the kids in the first, second, fourth, fifth, and sixth grades?"

She frowned.

"And what about the other schools?"

"What schools?"

"The private and parochial schools. The high schools. The day care centers, the technical schools. Where does the board of education fit? The superintendent? The parks and recreation winter and summer programs? The senior citizen center, the church baby-sitting programs? The teachers' association? The whole bloody educational establishment?!"

She blanched and gulped.

"All of it?" she lamented. "I couldn't possibly!!"

"Not even with a long-range plan to gradually insinuate yourself? Not even by phases? Not even by recruiting key people and agencies to help? Don't you want to brainwash *all* the kids and change the world??"

Tears began to well up in her eyes. And I knew then that she had mastered the technique of self-annihilation.

9. Stay nitty, stay gritty. This technique is delightfully subtle, but quite deadly and effective. And it's very simple.

All it requires is that you get so deeply preoccupied with the grundgy hassles of everyday survival (budgets, staff, application forms, gallery walls that need painting, theaters with broken seats, a heartless city council) that you forget the guy with the paint brush, or the lady in toe shoes, or the boy with the flute.

With any luck, the bureaucratic/administrative process has diverted your attention and respect away from the creative process—away from the *artist.*

It is usually so gratifying to perceive oneself as being up to the armpits ("busy" and "productive") in alligators, it is easy to forget that our paramount and inexorable commitment is to the *artist,* and to creating the atmosphere and environment needed to transmit the artist's statement to the widest possible audience.

You, as the arts manager, are the pathmaker. And when the path is congested with the rubble of yesterday's unfinished annual audit, or tomorrow's meeting with the stony-faced executive committee, your organization becomes a suitable candidate for the unmemorable arts agency of the decade.

In the beginning, it is said, there was "the word." And the word was uttered, I suspect, by a poet. The moment you stop hearing it, start putting up the shutters.

10. Mangle the mandate. The best has been saved for last. This strategy is so comprehensive that it makes the previous nine suggestions virtually obsolete. And it has a wonderfully austere simplicity to it.

 The objective here is simply to *forget, weaken,* or never really *understand* the mandate that brought you into existence in the first place. If you don't, at least once a year, whip out of the files and re-read the "statement of purpose" that explains and justifies that existence, you are two steps from the edge of the cliff.

 The further you stray—for reason of convenience, accommodation, or personal preference—the more you blur your reason to *be,* and the sooner you will be rewarded with oblivion.

There you have it. A handy and tested catalog of techniques for making yourself obsolete.

I strongly recommend that you try a few of them, if you haven't done so already. (The arts administration field is getting crowded anyway, and needs thinning out.)

But I devoutly hope that when you try any of these techniques for self-destruction, you fail.

2088 Is Today

I confess to what some may view as a small heresy. Increasingly, I'm finding it more rewarding to read the *Wall Street Journal* than *American Arts, Business Week* rather than *Arts Reporting Service, Forbes Magazine* or *Popular Science* than a Newsletter from the Association of College, University and Community Arts Administrators. Not that there's anything bad about these respected arts publications, but they don't often help me cope with a question that's becoming, for me, obsessive: what will be the shape and function of arts institutions one generation from now; or two; or three? How far ahead are we thinking or planning?

The preoccupation by the arts establishment with crises, personalities, and field activities in 1988 offer neither clues nor guidance to the inevitable adaptations and modifications in the delivery of arts services in 2088.

The twenty-first century is an eyeblink away. And it's arriving in an atmosphere electric with signals of change—technological, political, economic, sociological—that will radically alter our perception of and need for the arts. Will our revered institutions—symphonies, museums, dance and opera companies, big performing arts centers—be capable of anticipating and responding to the changes, or will they persist in focusing their energies totally on the day-to-day horrors of budgets, fundraisers, deficits, season brochures and combat with Foggy Bottom officials?

Arts agencies may be in heavy trouble if they neglect to raise their antennae higher to intercept and translate the signals of the future that are flooding in on us right now and fail to explore their destinies in relation to robotics, infrastructure collapse, mounting unemployment, acid rain, cable tv, nuclear dangers, corporate transfigurations, international tensions, the deepening cries of the impoverished, minorities and handicapped, or the imminent prospect of laser-generated three-dimensional holograms in stereophonic sound filling one's living room with a complete performance of *La Traviata.*

Which is why, more often than not, *Business Week* tells me more about where arts agencies might be twenty-five, fifty, or one hundred years from today.

Looking far ahead is really a matter of staying in touch with and studying the wider world that engulfs the arts, of developing a

readiness for resilience, and of believing that we have something to pass along to future generations of more value than a large deficit.

2088 is today. Futurists know it, and they know it's a way of managing the future. The temporal crises facing the arts are the best inspiration for polishing the crystal ball and peering deeply.

Lobbying: Staying on the Premises

There are three inevitabilities for the arts administrator: death, taxes, and lobbying. The first is a mystery, the second is a misery, and the third is a maddeningly persistent obligation.

Effective lobbying—the sustained effort to modify perceptions and alter the priorities of the political purse-string holders— operates on seven very elemental premises, the multitude of published "how-to" tactics notwithstanding.

Each of the seven premises evokes a specific action.

Premise 1

Lobbying is a right guaranteed by the United States Constitution—"the right to petition government."

Action

You have a right to enjoy that right without reluctance, embarrassment, or fear.

Premise 2

Government at all levels is becoming increasingly responsive to the demands of special interest groups. ("America is no longer a nation. It is a committee of lobbies," says Charles Peters of the *Washington Monthly.*) Interests that were once disparate and loose-knit have formed powerful coalitions—more than 2000 now operating in D.C. alone.

Action

Form coalitions, even at the small community level. An arts council alone is a fragile fighter. In concert with a Parks and Recre-

ation Department it gains strength; it becomes stronger yet when the coalition widens to include the Junior League; more powerful still if the roster is expanded to embrace a Chamber of Commerce, an Association of Retired Persons, a Manufacturers Association.

Premise 3

The "law" of primacy and frequency is paramount in lobbying: be the first to present and argue the case, and argue the case often, vigorously, and doggedly.

Action

Obey the law.

Premise 4

The arts are a unique phenomenon in that there are no groups organized specifically to combat or destroy them; that is, there is no anti-culture council as there is, say, an anti-abortion group.

Action

The field is remarkably clear. There are no land mines in it or snipers waiting in ambush—except those that we place there ourselves.

Premise 5

Divisiveness among arts groups is a cancer. It can kill us. Jealousies, rivalries, and discord—occurring all too widely in the field— are cripplers. Exposing to the public the kind of soiled linen that reveals dissension, ambiguity, or schizophrenia is an invitation to disaster.

Action

Work toward the kind of coherence, discipline, and integrity of the arts community that you would expect to be inherent in the art forms you celebrate. The most delicate fissure in the united front can be easily transformed into a major chasm by priority-setters

and budget-makers. These persons will, in self-defense, grasp at any visible flaw, any irregularity in the structural integrity of a suppli-cant in order to validate cutting.

Premise 6

There is a tacit understanding between elected official and cons-tituent: we are both engaged in an ancient and well-regulated game. We both know that. You respect my need to preen and puff and promise, and I'll respect your need to beg, cajole, and lobby. But we play by the rules.

Action

Learn them. Play by them.

Premise 7

Lobbying is an honorable and intellectual adventure in persua-sion. It offers, apart from its obvious long- or short-term objectives, a delicious opportunity to match wits, to dramatically change per-ceptions, to win converts. It is a form of cerebral warfare, rather like chess—a warfare that produces, happily, no casualties.

It is the brokering and re-directing of power in quest of a ra-tional society.

Action

Do it.

Lobbying with Alphabet Soup

They get the meat and potatoes. I get alphabet soup.

They know exactly where to go. I wander in a funhouse maze of acronyms.

They get organization, militancy, and change. I get newsletters—telling me how badly we need organization, militancy, and change.

They get action. I get invoices for dues.

The "they" are, of course, the Teamsters, or the Moral Majority, or the National Rifle Association or the National Education Association, or the host of other fiercely myopic, zealously single-issue lobbying agencies that accurately translate the gabble of their constituents into lucid demands for attention and change.

We who fancy ourselves humanists, however—writers, artists, administrators, or all-around culture nuts—have, by and large, a lousy track record as effective lobbyists. We persist in viewing the process as distasteful, puzzling, something done by crackpots or paid professionals, an activity that somehow sullies the purity and threatens the autonomy of "The Arts."

There are exceptions, of course—witness the dramatic rise in appropriations for several of the State arts councils. (Witness, also, how *low* the appropriations were in the first place.) The occasional success in an arm-twisting contest locally merely accents the flaccidity in mobilizing nationally to build a continental constituency as powerful as, say, the AFL-CIO.

To aggravate the matter, we proliferate agencies—thus dissipating service effect—rather than consolidating agencies. We continue to move, like kids forming clubs, away from a central and influential mechanism and toward a multitude of turfs. Each of the old, new, spun-off or remodeled arts service groups insist that they are needed to service a specialized clientele with highly specialized problems. Appropriate and commendable.

But while each is fussing over symphony musicians, dancers, arts councils, presenters, or auditorium managers, who the hell is fussing over the climate for and condition of the arts in America? Who's far enough out of the trees to see the forest? If the mighty AFL can wed the mighty CIO, might not several marriages be arranged with the less-almighty arts groups for the purpose of producing one or two very strong visionary kids?

Presently, I hold membership in at least six organizations. (I say "at least" because there may be others I'm forgetting.) The six, *collectively,* lack the political clout of a Steamfitters Local.

You'd think that with AAE, AASCH, ACA, ACAE, ACC, ADG, AFA, ASOL, ATA, AADC, ACUCAA, AAA, BCA, COAA, COS, FEDAPT, HAI, ISPAA, IAAM, NACAA, NASAA, NARB, NMC, OA, PCCC, TCG, TDF, USITT, VLA, YA, PAMI, M-AAA, NEFA, WESTAF, SAF, GLAA, NEA, NEH, we'd radically alter national priorities.

Forget it.

It's alphabet soup.

Saturday Night and Next Century

To tell you the truth, this is less a piece on arts management than it is a public confession. I am compelled to admit, finally, that I'm utterly paranoid.

After more than twenty years in the arts administration racket, I've earned the right to this affliction. My paranoia was not, however, an overnight achievement. It had to be carefully cultivated. It had to be practiced every day—like scales or the fourth ballet position, in order to get it right. In retrospect, I attribute my success as an arts administrator to the rapidity with which I learned to feel threatened by nearly everything and everybody, by all those sinister and arcane forces lurking out there in the darkness waiting to pounce on me.

The arrival of a newsletter from a national arts agency, a published statement by the National Endowment for the Arts Chairman, two concert-goers whispering in a corner of the lobby, plunge me into a rapture of gloom and fear.

Also the Reagan Administration. I'm convinced that the proposed cut in the federal arts budget was directed solely and cunningly at me. "Let's get Golden," Ronnie said to his staff "and watch him squirm." They know I don't give a damn about the money. But I do give a damn about threats to our national purpose and values.

Like the fundamentalist groups in Maryland, Delaware, and Iowa that have lately begun to infiltrate school boards urging that student productions of "Death of a Salesman," "Inherit the Wind," and "Grease" be banned. This doesn't fool me for a second. It's a conspiracy to demoralize me. Knowing my taste for creative freedom and discovery, they lurk in ambush behind trash cans waiting for me to innocently stroll by.

Like technology. Here's a real boost to my paranoia. Knowing my addiction to live performances, the electronic wizards of the world are conspiring to shut down concert halls and theaters, muffle into silence the breathing, laughing, applauding audience by substituting the big screen, three-dimensional stereophonic, laser-generated holograms—right in my living room, with a reality that

makes you think you can smell the pancake base on the actors' faces. And while I'm reeling from that personal attack, out of the corner of my eye I spot the deadly parade of the TV cable companies, offering a promised land of cultural delights, smugly whispering in my ear that I'd better be ready to convert my art gallery into a laundromat.

No less a cause for my paranoia are my colleagues—especially the ones who, out of peevishness or ego-starvation, like to form new clubs and associations. They do it for spite and malice, knowing how deeply I feel the need for coalition in our field, rather than proliferation. But that's not to be. They single me out, it appears, for torment. So far over three dozen associations have emerged—AAE, AAM, AASCH, ACA, ACAE, ACC, and others. With every mail delivery I quiver: There'll be an announcement of the formation of yet another acronym that purports to offer a glimpse of a cultural Eden.

There are many other causes for my paranoia, but they all seem to coalesce into the biggest cause of all: I'm already feeling persecuted by the future.

The federal government, the technocrats, the play-banners, the colleagues who seem to relish splintering the field have really gotten to me, to the point that I can find respite only by watching a Japanese sci-fi film like "The Monster that Ate San Francisco" or a re-run of "Mr. Ed." Indulging in the narcosis of trivia might delay, perhaps, turning into anything to keep me from the kind of basket case I may become—if I were to live that long—in twenty-five years, in fifty, in a hundred.

There is only one faint glimmer of hope, one vagrant ray of salvation to keep me from being utterly sucked into the Slough of Despond. That salvation is you. I should say *us:* the arts administrators and managers at the community level—the people who mobilize talent, focus creative energy, alter community perceptions, and have the power to forge individual links into an invincible chain of cultural priorities that will have, although emanating from the grassroots, a *national* relevance. Accept it or not, national wars are being fought on Main Streets, U.S.A.

It is us—the original, and maybe the final line of defense against bureaucrats, censors, and electronic nuts, among others; against the people and institutions that hold the discovery and liberation of the creative spirit as an irrelevant, dangerous, or godless enterprise. And we can be sure that they're out there.

And being the paranoiac that I am, I'm even a little nervous about us.

We're a curious lot, we arts administrators and managers. We seem to thrive on paradox and contradiction. It gives me the willies, sometimes making me feel like the character in the Steig cartoon, cringing in the corner of an empty room, declaring "mother loves me, but she died." Those paradoxes and contradictions need brisk unraveling or we may not have to worry about twenty-five or fifty years from now.

There are two things that are unsettling.

First, there's a nagging irony. Here we are, institutions that depend heavily on the interest, good will, and support of an audience—we certainly labor mightily to woo, cajole, seduce them— but that tend to make transient, sporadic, and short-term efforts to invest seriously in the propagation and expansion of that audience. We do sometimes pay solemn homage to "outreach" and even occasionally go *to* the people (by turning two blocks of downtown into a once-a-year "Arts and Crafts Carnival," complete with balloons, clowns, and indigestible pizza). But we shouldn't kid ourselves. These strategies are timid and have less to do with a long-range, strategic plan to modify a community's perception than it has to do with improving revenues, filling seats, attracting more bodies to an exhibition opening, or proving how socially responsible we are in order to justify our funding.

The second, and related, paradox is even more puzzling: we represent disciplines that are rooted deeply in the past (inherited traditions, styles, artists) and we display great reverence for the past. We often, however, reveal an astonishing casualness toward the *future*— to the generations just being born, and the many that will follow them. (How many arts councils do you know that have a co-op program with the obstetrics and pediatrics departments of local hospitals and try to influence what children see and hear from moment of birth?)

We tend to be, in other words, so preoccupied with the concert we've got scheduled for Friday, March 26, 1988 (and the infinite hassles it is generating), that it becomes awfully hard to worry about who's going to be occupying the seats at the concert on Friday, March 26, 2088. Or if there'll be a concert at all. Or a 2088.

Parenthetically, I offer a modest proposal and useful exercise. Start a campaign in your community to build a new, multimillion

dollar arts center, whether you need one or not. It is a refreshing experience. By far the greatest ordeal I faced in planning the Civic Center of Onondaga County had nothing whatever to do with fundraising, architectural design, labor disputes, or equipment. It had to do with riddles of the future. Given all the information we could gather, all the trends, signals, signs, clues, hints, and profound prognostications by any expert who dared speak them out loud, could we plan a facility that would be relevant and useable three generations from now? Given the experiments in dance, music and the video arts, would artists and audiences in the year 2061 praise me or curse me? Well, I don't know. Whatever they say will have to be transmitted through a spiritualist.

This preoccupation with the here and now is really not difficult to understand. Whatever temptation we might have to play at being futurists—to forecast and thus manage the future—is often thwarted by our egos and our mandates. These are powerful forces, compelling us to want to accomplish something *now.* We tend to measure our purpose, progress, and goals by the specific time span of our own working commitment, by the impact we will have during the useful years of our life. If we are going to pour our time, money, and sweat into the survival of our local dance company, we logically crave some satisfactions in the form of immediate and tangible results—a 10 percent increase in subscription sales for 89-90; a $25,000 decrease in our accumulated deficit; the streamlining of board and staff operations; raise the sale of banana bread at the symphony bake sale by 50 percent; run the most successful benefit gala *ever.* Why not? These are delicious and exhilarating goals. We want to feel that we contributed *something* during our brief strutting across the community's cultural stage.

But it's a mixed blessing. The impulse to accomplish good things is motivated as much by the desire to be applauded and remembered, as it is to alter the future, to endow coming generations with an irrevocable and militant passion for the arts.

Perhaps it's because our cultural institutions are so young, our sense of tradition—the preserving and passing along of great ambitions and achievements—is so short. Perhaps it's because the nation itself, like an amoeba, is still floating, changing, dividing itself, and dividing again.

Perhaps it has something to do with being victims of a "real time" world, manifested by an obsession with day-to-day problems and crises—get the season announcement out sooner; get the sing-

ers under contract; remodel and expand the gift shop; replace the carpeting in the foyer; fix the leaking toilets; get that bloody funding application. (Lord knows, it is enough to keep our noses, elbows, and knees to the grindstone.) The battle, often enough, is to get through the week, make the payroll, and see that the board gets enough stroking.

In fairness, many cultural agencies *do* look ahead. They develop "long-range plans" or commission "five-year studies," often with the help of expensive consultants. These are useful exercises, to be sure, although they more often emerge as institutional ego trips (where will *we* be in five years), rather than where the world will be in five years, or fifty, and what social, political, or technological forces are at work right now that might drastically modify the public appetite for our product.

Long-range studies are good, but they usually (a) don't look far enough ahead, (b) are done by the wrong people, (c) ignore many of the crucial imperatives about America's changing life styles, and (d) are read by very few people.

It's a curious thing. The long-range studies I've read commissioned by community arts agencies have universally ignored a fact that's dangling right under their noses: This wildfire explosion of populism in the United States—the "I'll-do-it-myself-in-my-own-community, if you please" movement that's been spreading over the past twenty years. It's a movement that could, by the year 2000, put major orchestras and museums on the path of the dinosaur. They are being crippled partly by the weight of their own bureaucracies and fiscal crises, and partly because communities are doing their own thing, for a lot less money and for just as much satisfaction. There may simply not be enough room for behemoths any more.

Will we be ready? If the big guys are knocked out by the year 2000, can we shoulder responsibilities for the distribution of cultural services at a level three times greater than today? What will we need in dollars, staff, facilities, public understanding? The burden of sustaining the cultural matrix of the country may come to rest on arts administrators in hundreds of small communities across the country.

Is it altogether foolish whimsy on my part to believe that we can plan ahead—really *ahead*—and by planning, actually *control* the future? (The paranoia is beginning to surface again.) The answer is: of course. But it will call for a reordering of our priorities, of tuning the brain to a longer wave length; it will depend on a better

balance of emphasis between getting our agencies through tomorrow and, at the same time, battling for the cultural prerogatives three generations down the road.

I'm suggesting a deliberate and measured trade-off, proposing that we need to assume yet another burden.

The formula for managing this burden already exists; we simply need to borrow it from the church of colonial America. Reactivate the notion of tithing, the giving of 1/10 of one's personal wealth to the church, as a way of guaranteeing access to heaven and a place in eternity. Let's translate church into cultural heritage and contribute 1/10 of our energies and resources to building future audiences, to developing new loyalties (among labor, ethnic minorities, children—to name just a few constituencies) that will transmit, on our behalf, the dream of the civilized and humane society that is synonymous with the arts. We're getting awfully good at bequeathing massive deficits to future generations; we ought to try to be just as successful at providing a legacy of relevance and value.

I wonder what the results would be if every arts agency in the country assigned one person, from either the board or the staff, to the task of being the conscience of the future, the surrogate for two generations ahead, the chairperson, if you will, of the crystal ball department. The person would be responsible for studying the signals, smelling out the trends, reading the demographics and regularly proposing strategies that would ensure the relevance of that agency fifty years from now, making sure that the agency remained resilient and responsive. It will be someone who wasted no time reading the "arts and entertainment" society pages of the local press (looking for pictures of the Opera Guild ladies modeling costumes in preparation for the grand ball). Rather, it will be someone who *did* spend time wondering what effect the "population bubble" in 1990 projected by Health and Human Services will have on future programming; what effect the cuts in student loan programs may have; what the failure to enforce clean air standards will have, especially if you're coated by acid rain while attending an open-air concert. Someone who ponders what the introduction of robotics into American industry will do to the labor force in twenty-five years (and thus to the economy; and thus to sources of arts support). It will be someone who reads, not *American Arts,* but the *Wall Street Journal.* It will be someone who is unafraid of developing the loftiest, most futuristic strategies by proposing that the arts be shared with the cosmos aboard the space shuttle. (A seasonal bro-

chure? A subscription order form? Who knows who's out there?)

A little crazy, maybe, but the future is now. We are both shaping it and being inundated by it every moment. Essentially, there's nothing crazy about being ready to manage it. Futurists are at work everywhere, knowing that national survival could depend on it.

As human beings we know that we're not immutable, we're not invulnerable. We take cogent steps—insurance policies, investments, estate planning—in order to be comfortable in our old age and to protect those we care for long after we're gone. We should do no less for those arts institutions that we serve as temporary trustees, the institutions that we proclaim help mankind discover reservoirs of beauty in themselves and in the world around them.

If you think that a board president will collapse in a paroxysm of hysterical laughter at the suggestion that he or she appoint a "futures committee," the president might be reminded that the exercise of looking deep into the future is really an exercise in looking hard at today, at the events and changes taking place in the total real world around us *right now.* If nothing else, the exercise can help reduce the cultural myopia that sometimes plagues arts agencies—that narrow contemplation of one's own artistic navel, the cocoon-like existence that sometimes immunizes us against the total society we're supposed to serve. The exercise can have a very salutary effect—maybe open some eyes and some minds. If that happens, perhaps I will be spared from becoming the quintessential paranoiac.

And why bother inflicting on me an even deeper persecution complex? The hell with me. There is something more important to protect *now* and to be protected on into the unimaginable distances of time and space.

Splat

That's the sound that Arts Impact Studies seem to be making lately when they hit the wall of legislative chambers or the walnut paneling of corporate board rooms. They don't even ricochet a little; they just go splat and slide down the wall to form a small puddle on the carpet.

These studies—very chic in the arts agency business nowadays—are not *supposed* to go splat. They're designed to assault, stun, amaze; to make eyes pop in wonderment; to make palms

rub together in glee and itch with a little avarice. They're *supposed* to demonstrate how, like alchemy, the arts are transformed into dollars that circulate, multiply, and produce—albeit obliquely—an improved community economy. By whispering a few statistical incantations over some raw data, the arts emerge as "big business," vital contributors to a healthy fiscal climate. Didn't the recent study by the Port Authority of New York make clear that the arts have a $5.6 billion impact on the New York City metropolitan area? Didn't we recently demonstrate that even in modest Onondaga County, New York, the arts are a $33 million industry? Shouldn't these revelations be enough to knock the socks off and win over any elected official who may be wavering in his or her decision to infuse the arts with money?

Evidently they're not enough. It is the very obliqueness, the indirectness, the ephemeralness of those "multiplied" and swelling dollars that makes these studies splat instead of stun. The notion of "ripple effect"—an invention of economists, not artists—is often too slippery to handle, too abstract for the bread-and-butter, tax-harassed, constituent-intimidated mentality of public officials who, in an unintentional parody of Gertrude Stein, believe that a buck is a buck is a buck.

The arts *do* trigger the "multiplier effect." They do go forth and stimulate spending and tax revenues. But so does the Aid to Dependent Children program, the Community College, the Highway Department, the Zoo and the Americanization League. They all get public or private dollars and use them to meet payrolls, buy goods and services, and pay taxes. Anytime money moves, it mounts.

The high intentions of Arts Impact Studies tend to get neutralized, however, because (a) they can't make a case different from any other community enterprise that makes bucks bulge; (b) they tend to be couched in fiscal hyperbole that often raises a skeptical eyebrow if not curls a sneering lip; (c) they deal in a mathematical mystique—especially the very esoteric jobs—and smack of a voodoo that eludes the hard-nosed pragmatism of public or corporate officials; and (e) they are often viewed as panaceas, as a quick fix to produce the instant credibility that will change the public perception of the arts from clique to cash.

Should we abandon impact studies? Certainly not. Indeed, more should be done. In the arts' meager arsenal of defensive weapons, these studies have the potential for igniting a few firecrackers, if

not large bombs. And better a pop than no bang at all. But in a climate of aggravated fiscal conservatism and of legislative surgery that mercilessly lops off jobs, programs, and services, Arts Impact Studies have to speak in brisk and familiar tongues, a language and methodology that articulate convincingly how *people* benefit, not merely "the economy."

Otherwise the sound of the splat will still be heard in the land.

The Dream Client

The Dream Client, like the myth of the Dream Girl, is a will-o'-the-wisp. It is a fantasy indulged in by consultants to amuse and comfort themselves during dreary layovers at airline terminals, while being toured through an unheated crafts center in January, while waiting several extra months for City Hall approval of a travel invoice, or while doodling to kill the time that had been set aside for interviewing the President of the Bent Elbow Crafts & Culture Club, who forgot.

The fantasy, after many years, threatens to escalate from an idle diversion to an unhealthy obsession. As a therapeutic exercise, therefore, and in the hope of providing benchmarks against which clients may measure their passage from Actual to Ideal, I offer a small catalog of traits that create the profile of the Dream Client. The list that follows is not altogether whimsical; it is based on experiences and observations assimilated while working with arts councils, facility planners, and arts presenters in Newport, RI, Pontiac, MI, Charleston, WV, Cleveland, OH, Athens, GA, Aspen, CO, Poughkeepsie, NY, and a couple of dozen other communities.

Remembering, and enlarging upon, the good things, the Dream Client is:

A Discreet Skeptic—a person who tactfully suppresses the nagging suspicion that all consultants are snake oil salesmen bent on fleecing members of the Mayor's Task Force on Cultural Progress; or that the consultant, if sent by the state or the feds, is the visible symbol of waste in government. The client who tastefully disguises his or her contempt for the consultant who must perform the ultimate dodge—getting on a plane—is always appreciated.

A Saintly Spirit—who eschews jealousy, scorn, or suspicion of those "other"—unfriendly—arts groups, stays aloof from warring

factions, and even finds something kindly to say about the board president of the local symphony. There is no tribute too great, short of canonization, for the client who remains serene and charitable while dodging the crossfire of frustration, ineptness, insularity, and ambition in the cultural combat zone.

A *Gracious Host*—who recommends lodgings closer than twenty miles from the client's headquarters, uses the consultant as an excuse to try that "special" restaurant, and schedules appointments to allow for brief recuperative periods and other biological requirements. The ultimate act of graciousness is to hold a large dinner party in honor of the consultant *after* he has left town.

A *Living Data Bank*—who can recite demographics like a catechism; who knows who's got the clout and under what conditions it can be used; who is a reservoir of statistics, covering a ten-year period, on fund-raising drives, audience development projects, attendance figures, and projected costs of expanding the stage house of the venerable movie palace downtown; and whose grasp of community gossip and dirt is impeccable.

A *Diligent Pupil*—who has completed a massive amount of homework on the structure and operations of the community's arts institutions, made wide-ranging inquiries of how other communities handled their cultural service problems; read the literature on planning, fund-raising, and administration; and even, by a number of discreet inquiries, carefully checked out the credentials of the consultant before hiring him.

An *Astute Mathematician*—who can perform numerical wizardry; that is, deduct the 84 nights that the committee projected that the new facility would be used from the 365 days of the year and come up with 281 nights of darkness, emptiness, and no revenue; who can then multiply the 84 by the average per night income, compare the result with the estimated annual cost of amortization of loans or bonds, personnel, utilities, maintenance, security, insurance, promotion, and program, and conclude either that the committee had better abandon its pointless euphoria and start scratching for more customers, or that the project is a rotten idea.

A *Canny Politician*—who is deeply sensitive to the subtle interweaving of personalities, issues, and money that constitute the backdrop to the development and survival of any arts project; who knows the jargon of the streets, the argot of urban redevelopment and the metaphysics of financing; who is not afraid to be a pest at a city council meeting and a pal at the pub after the meeting;

who can cajole a board into real advocacy actions; make a hero of the mayor; cause a newspaper editor to dream of a Pulitzer Prize; offer the prospect of eternal life to a major donor.

An Unshakable Chauvinist—who truly loves, is proud of, has confidence in, wouldn't trade with anyone for, and believes deeply in the future of the community; who will suffer the label of Pollyanna if it will help to repair the eroded ego and refocus the diffuse pride of his or her community—knowing that the revitalizing of a community's values is inextricably linked to a community's cultural ambitions.

A Herculean Worker—for whom there are no clocks, no days of the week, no light or darkness; for whom Christmas Day at home with the family comes as a delightful surprise; who is—because no one else has either the stamina or commitment—the community's two-legged workhorse for the arts, the symbol of the lunatic dedication required to dramatically and permanently alter a community's perception of itself.

An Elegant Pluralist—who, in a rational and persistent manner, espouses the notion that the cultural distinctions that characterize a community are important; that they are, in fact, critical components in any arts planning process that tries to identify and satisfy a community's need for cultural services, programs, and facilities.

The ten characteristics of the Dream Client outlined above are hardly a complete profile. There are others; but these are the ten that most often percolate through the brain while waiting for the President of the Bent Elbow Crafts & Culture Club.

At the moment, we consultants need not feel threatened. Dream Clients are not proliferating. Our breed and our income are not endangered. But a few clients are rapidly approaching Dream status. And when they arrive, one of them will surely be invited to publish an article on the Dream Consultant. I hope we're ready for that.

Three Little Pigs Revisited

Not too much heavy symbolism has been ascribed to the story of The Three Little Pigs. It may come as a surprise, therefore, to learn that the story is virtually a metaphysical evocation of the arts ad-

ministration phenomena in the United States. Each of the three little porkers, in fact, represent the three prevailing philosophies of arts management.

It may be further surprising to learn that the three had names, although deleted from most published versions.

The first was called Curly; the second was named Larry; and the third was christened Moe.

Curly, the first pig, is the consummate jerk. An utterly naive creature, he believes, as many arts presenters and producers do, that security can be achieved through the use of frail and ephemeral materials. This is not unlike the way some of us cling lovingly to the belief that all those glittering and seductive platitudes about "art" and "culture" and "enrichment" and "quality of life" are sufficient unto themselves, are justification enough for our existence, and will provide adequate protection against those hairy philistines who'd like to sink their teeth into us.

Pig #2, Larry, is the pious optimist; his eyes atwinkle, fingers crossed, counting on a few hastily nailed together boards to ensure a life of contentment. There are a lot of Larrys among us who believe that by tossing in a few socially responsible planks ("Have we stroked the disadvantaged today?") or by hammering on some outreach programs ("Didn't those retired folks *love* the Scarlatti?"), our house will be immune from danger.

Then there is Moe—the ultimate pragmatist—methodical, practical, far-sighted. Moe carefully piles and cements brick on brick, knowing that the world out there has dramatically changed in the past generation, and that the wolf can come from many directions and take many forms. One wishes for more Moes in our business— the ones who meticulously construct new, even bizarre, coalitions of artists, presenters, and audiences; who scrupulously search for fresh strategies to market attractions; who painstakingly put together and launch audience development programs based on, for example, the long-term and brazen commitment to assaulting the minds of kids from the moment they leave the womb and indoctrinating them with the arts.

We are all, like the three little pigs, immensely vulnerable. The buying and selling of art (a product which, alas, the American consumer finds easy to forego) at the community level is hazardous at best—an enterprise that could vanish overnight from our communities, leaving 95 percent of the population unmoved and unruffled. And the greatest source of our vulnerability comes from forces—

human, economic, and technological—that we didn't foresee; that we see now; and that we're not always sure how to deal with.

These forces represent a new type of wolf, intimidating enough to convince three smart pigs that it might be wiser to relocate than to build.

It wasn't always that way. It used to be easy to identify the wolf—the "enemy." For the producer, the villain was the presenter—that slippery devil, who had to be chased, cornered, cajoled, contracted with, extracted money from, and remembered venomously for housing the artist in a private home inhabited by two cholicky kids and an incontinent dog.

For the presenter, the enemy was "them"—the gang who prefers "Dynasty" to the erotic plucking of Ravi Shankar on his Indian sitar; the cruel and stupid editors who wouldn't use the second news release or who captioned the photo of your piano artist with the name of the town rapist; the manic printer who ran a thousand programs with the wrong date; the vengeful God who madeth the heavens to open and produced the second flood on the opening night of the artist series.

For the artist, the enemy was *everybody*—producers, presenters, audiences—those sinister and unscrupulous types who underpay, underuse, underpromote; who allow customers with bronchial asthma to sit in the front row; who keep dressing rooms at a bone-chilling temperature intended for Alaskan Huskies; who force pianists to play the keys with their chins because the bench keeps slipping down; and who provide floors for dancers with the hardness and density of a missile silo.

As for the audience, the enemy would appear as the ticket seller, a hatchet-faced volunteer who says he never heard of your reservation, or *you* either, for that matter; or the three ushers at the head of the aisle who won't seat you until their exchange of cookie recipes is completed; or on stage, where an over-zealous dancer gets his sword stuck in the prima ballerina's tutu.

The wolf did, indeed, take many forms. But they could be tolerated. After all, these flukes, aberrations, and mishaps were all "in house"—all part of what we romantically called "show biz."

But the wolf, like a reckless amoeba, continues to divide and multiply. In the familiar children's story, the wolf was simply hungry. He no longer only huffs and puffs, however. He paces outside—coldly and indifferently. He no longer attacks. He lays seige. He

doesn't have to blow the house down. He simply has to be patient and wait for the occupants to weaken and surrender.

It will take dramatic changes in attitude and tactic to fend off the wolf of the 1980s and 1990s. These will be discussed shortly.

The wolf poses new threats, more sophisticated and pervasive than ever before. He represents, for one thing, a new breed of consumers, who are behaving with maddening unpredictability. They have become picky, selective, even unimpressed with those red-hot season discounts we love to offer (which were never the prime reason for buying a series anyway), or with that ravishing array of artists you sponsor (many of whom they probably never heard of). They are beginning to wield and enjoy their consumer power by withholding the bigger dollars we are demanding to see certain attractions (is it because they can see most of them "free" on cable TV?) with the exception of the hard-core loyalists—"the Chamber Music crowd" or composer Philip Glass aficionados—they are expressing impatience both with classical tradition and modern innovation. They frazzle the nerves by refusing to conform to the comfortable old stereotypes of social and economic class. (Has cultural democracy—the legacy of the identity revolution of the 1960s—become a bigger experience sooner than we thought?) Culture nuts have begun showing up from zip code areas once seemingly indifferent to the "fine" arts. And audiences, drowning in entertainment options to a degree unrivaled in the history of global culture, are more and more embodying Sol Hurok's profound philosophical insight: "When they're not buying, there's no stopping them"—as many of the major artist agencies in the country will sadly testify.

If customers are turning balky and prefer to sniff rather than devour, the escalating costs we are encountering are like a wolf in vampire's clothing. The point does not need laboring. Although inflation has slowed down, the surge in dollar cost for everything from transportation to ticket printing, from artist fees to marley non-skid dance floors, from two cases of Chivas Regal (for the thirsty soft rocker) to advertising space has been steadily upward. A case in point: three years ago we engaged a young piano artist for two days. The contract fee was a total of $1,200.00, which covered his transportation, hotel, and food. For that money, we got an evening concert, performance/demonstrations at two neighborhood centers, one prison and one Rotary Club, plus several interviews, and the agree-

ment to attend a wine and cheese party after the recital. This year his fee is $5,000.00, no frills or extras allowed. I'm sure he's matured and ripened as an artist over the past three years—but $3,800.00 worth? He's 317 percent better? I doubt it. We can imagine the screams of concert-goers if ticket prices were raised 317 percent. Well, maybe our talented pianist has wolves howling at his door, too.

The money issue facing us isn't just how *much* everything has gone up, but also how the supply of money from other sources has gone down. Cities, counties, states, the federal government, and foundations continue, by and large, to confine us to our niches at the bottom of their totem pole of priorities. Their commitment to giving money to the arts continues to be governed by a policy of artificial dissemination.

The Business Committee for the Arts in New York City will publish staggering figures to illustrate improved corporate support for the arts. The committee will also neglect to mention that the bulk of those dollars are poured by Exxon, Mobil, and Arco into prestige specials on PBS, leaving very little to filter down to community enterprises.

Ironically, our frustration—and sometimes anguish—over the rising costs and lowering support really has little to do with money. It has, rather, a lot to do with public policy—or the lack of it—relating to the arts. And by public policy I mean the arts being recognized and declared critical to the health, stability, and survival of a society. Government, local or national, has no problem in proclaiming that education, transportation, medical services, communications, and national defense are urgent matters of public policy. Why are the arts not on the list? Isn't the celebration of sanity, of beauty, of civility, or humaneness as important as city buses or killer satellites? What's wrong with those dingbat officials?

We must also ask: What's wrong with us?

The consumer base is erratic and not growing with the gusto we dream about, and the ability to scramble after and catch up to rising costs is uncertain. What is not uncertain is the magnitude and power of the newest wolf on the block—competition from the veritable revolution in electronic media. Let me quickly assert that I'm not looking for excuses or scapegoats. When I book a mediocre attraction and promote it poorly, the results at the box office have nothing to do with the electronic media. I simply did a triumphantly lousy job.

On the matter of electronic media, I claim a certain advantage. (At least I think it is.) Within the span of my lifetime, I've been witness to the growth and steady encroachment of the electronic media. As a kid, I got my kicks from radio, listening to the "Fred Allen Show" or "The Shadow." There were only three networks then—the red, blue, and mutual. And if I wearied of "Our Gal Sunday" or "Inner Sanctum" I could get some jollies by going to a movie to see Chapter 6 of "Red Devils of the Purple Sage" or to a real, live show—a play or musical. What a treat!

Then a mysterious thing called an image orthicon tube appeared (one of the few inventions for which a Russian could really take credit). And the glowing, hypnotic rectangle of glass began to illuminate living rooms. The same three networks operated, but with different names. The impulse to go out slackened a bit. After all, who wanted to miss a new play written by Paddy Chayefsky or Rod Serling?

Disgruntled by the brain-numbing pap of commercial TV—at least were told we should hate it, although I did enjoy sharing Captain Kangaroo with a young son—the fourth network appeared, PBS, as an antidote to the garbage thrown at us as an excuse to sell deodorant. PBS cracked open some new doors. At first, there were a lot of very tiresome "Talking Heads." But not for long. With products like "I, Claudius" and "Live From the Met," the impulse to stay home—not have to grunt while putting on galoshes or drive twelve miles in rain or snow, only to have one's wife grumble about the long walk from the parking garage to the concert hall—got stronger.

Then the new tremors began, erupting in the phenomenon of cable. A dozen channels. Forty. Two hundred on the horizon. Making decisions about what to watch could induce a nervous breakdown, if not family warfare. It got harder just to remember that there was a live concert in town. (When Disney Productions and Playboy entered the cable market, I knew we were doomed. They were grabbing the kids at one end and the dirty old men at the other.)

The hottest topic of conversation, and groaning, at a recent annual professional meeting was that villain, TV. Presenters of classical attractions moaned over the easy availability of Pavarotti, Domingo, and virtually every major dance company in the world at the push of a button, and without the $30-50 top for tickets. Even popular attractions are not immune. One presenter told the melan-

choly story of promoting Barbara Mandrell. Tickets were going very well until the local press announced when "The Thorn Birds" would start. Ticket sales plummeted.

Our electronic revolution doesn't stop with cable. Around the corner is high definition television. Within the next decade, hotels, motels, restaurants, and movie houses may become the community concert hall, by offering big screen TV shows with a clarity and vividness we can scarcely conceive, transmitting live performances from Broadway houses or the Los Angeles Music Center.

And in about the same eyeblink of time, the holograms will be here. The technology is already in place. We needn't stir from our living rooms (the ultimate electronic prophecy) to enjoy *Tosca* performed by laser-generated, three-dimensional singers performing in multi-track, hi-fidelity sound.

It's all very real, the diodes and grids and mixers are with us and their presence will increase. I'm not sure if even the little pig in the brick house is very safe.

Consumers, costs, and competition have always been with us. I'm certainly not trying to make a new case for old villains. But they've grown larger, and their influence has accelerated. And I'm not sure if our strategies for counteracting have kept pace. If unchecked, the local presenting of live artists could become an anachronism—the two-wheeled dog cart in the Cadillac showroom. And the greatest casualty is likely to be that cherished and radiant myth that has sustained us for so long: the notion that nothing can replace the excitement of experiencing a live performance. I'd check the odds before putting any money on that. When a machine no larger than a portable piano keyboard can fake an entire symphony orchestra, can a dark concert hall be far behind?

One of the pleasures and terrors of living in the twentieth century is the awesome velocity of change, the threat to establishment ideals, the assault on revered beliefs. As artists and administrators, we're not immune. Not even the relative isolation of a small community ultimately offers much of a shield.

I know that I'm inviting the ire of the apostles by suggesting that our noble enterprise may not yet be up to facing and dealing with some formidable dangers.

No gloom is intended, but I do believe, however, in shedding innocence; in loosening the stranglehold of nineteenth-century cultural piety; in trying to make objective assessments of who and what we are, why we do what we do, and what's trying to thwart us;

in searching for collective strategies that make our role more relevant to our communities, our states, our nation. There's just no room for rosy optimism and no time for bitter pessimism. But there is room and time to become savvy opportunists.

There's a delightful definition of the three attitudes that, again, involves a wolf.

The pessimist spends all his time worrying about how he can keep the wolf from the door. The optimist refuses to see the wolf until it seizes the seat of his pants. The opportunist invites the wolf in and appears the next day in a fur coat.

How do we skin the wolf?

A rather distasteful thought, actually. It sounds rather messy, but appears to be rather necessary.

And the step that can be taken—at least as a first step—to keep the wolves from our door, is to apply a concept borrowed from nature. It is a term not commonly associated with the arts. The term is symbiosis—the notion of mutual interdependence as a condition of survival. Frankly, I know of few other enterprises that need it more than we do.

By symbiosis, I *don't* mean merely "helping each other" or "working together." That's too simple. The concept is deeper. It recognizes the elemental imperative to nurture and protect one another, because if any single unit in the interdependent life cycle of several organisms is injured or dies, all units are threatened. And if the concept is good enough for Mother Nature, it ought to be good enough for us.

The point of introducing this notion is largely to underscore the need to rediscover and restore the unity, the oneness, of the A, B, C of our business, of the Holy Trinity of the arts: the artist, the broker, the consumer.

Never before in the history of American culture has there been a greater urgency to identify the bond that holds us together, to speak to each other and to the world in the same tongue, to reforge the union that helps us resist the howling that's going on out there. That's why we shouldn't skin the wolf. He may be a blessing in disguise. He is at least a splendid opportunity.

Symbiosis in the business of arts producing and presenting can manifest itself in several ways, for instance, in the way that the artists and broker do business together—business that needs to be conducted in a professional, courteous, sensitive, and insightful manner, a manner inspired more by empathy than by emnity.

Is the artist prepared to deliver the product promised? Does the presenter have a facility that will properly enhance the product? Does the producer regularly supply an ample choice of appealing, attractive and varied promotional materials that help sell the product? Can the presenter actually and effectively use all the materials provided? Does the producer supply a specific and current list of technical requirements? Will the presenter reciprocate with an accurate description of the technical facilities and spaces available? Will the artist arrive on schedule and be ready to go on in a timely manner? Will the presenter be ready for the arrival with a trained crew, clean stage, heated dressing rooms, running water and a genuinely warm smile? Has the artist specified clearly how payment of the fee will be made? Does the presenter have the check ready (a good one, preferably)? Will the artist participate in the fun and frolic of an after-the-show reception or party? Has the presenter gotten approval in advance for the artist to attend the bash? Is there, in other words, a sense of honor, anticipation, and high professional regard for one another? Are the two conspiring deeply and intimately to make sure that a performance turns into an event?

And finally, will the object of all these questions—the audience—be received in a civil manner, be protected while in our house, get delivery of the product it was promised, and be honestly and promptly advised of any problems?

A "yes" answer to all of the above means we've started to have a lovely symbiotic experience.

On a more personal level, symbiosis can be even lovelier, especially if we can lay down our weapons and put aside our obsessions with the pieces of turf we try to protect.

More than once I've had the unsettling feeling of being locked in combat with artists and audiences, rather than being locked in an embrace with them. These obsessions are a nuisance, counterproductive.

For the artist, it's the quest for the best deal, in the most number of places, in the most friendly atmosphere. For the presenter, it's the myopic frenzy of wooing buyers, seducing the media, trembling at the thought of deficit. For the customer—who doesn't lose any sleep over the fees we pay or our technical riders—it's deriving the maximum bang for the buck, while being stroked like minor royalty.

It creates the impression of different planets, spinning in isolated orbits.

Am I indulging in fantasy, or is it possible that the artist, broker, and consumer might share the same ambition: to induce a humane and satisfying climate in a community through the medium of a memorable art experience?

It is not really a pipe dream. Many years ago, as a novice presenter, I was about to plunge in and book my first attraction. The artist representative—who has since moved on to his celestial venue—shocked me. He didn't salivate and whip out a contract. He sat me down and gently cross-examined me. All I wanted to do was buy an artist; what the rep wanted to do was find out about me: my background, my tastes, my motives for choosing the artist in question. He wanted to know about my town: who lived there, what did they do, what did they teach in the schools, what was downtown like, who else promoted attractions in town, and whether the arts got as much newspaper space as obituaries. I'd never been asked those questions before. I didn't know they needed to be asked. The upshot of the interview was that he declined to sell me the artist I wanted. "You'll die with it," he said. He recommended a different type of attraction. We did it. We didn't die with it. Four years later, I booked the one I'd wanted in the first place. We died with it. I'd forgotten to ask myself those questions.

The interview was symbiosis at work. The questioning, the probing, the caring, the reluctance to sell, willy nilly, in favor of some ulterior motive: to make sure the arts succeed.

When the arts in a community are in jeopardy, it's often because the artist, broker, and consumer don't talk to one another. So I ask again: is it naive to imagine that a vital working partnership can be forged among the three? To assert that all three have a profound stake in the success and satisfaction of each other?

The partnership need not be casual. A practical manifestation of symbiosis, though it's hardly been tried, is to consider creating coalitions of people that don't usually sit together, a tactic widely practiced in government and politics. The "bipartisan commission" is often an effective strategy for exhibiting strength and defusing future criticism. Where is bipartisanship in the arts? We seem to be fleeing from one another, forming a hundred clubs to keep each other at arms length. Everybody's got a club: chamber groups, choral groups, symphony groups, dance groups, arts councils, presenters, artist agents, magicians, harmonica players, bell ringers and kazoo blowers. We sometimes share the same turf, but it's usually to conduct the business of selling and buying. That's fine. But it

would be intriguing to sit down together, as equally ambitious and vulnerable peers and explore how, collectively, we can strengthen the *industry.* To examine the accommodations, trade-offs, strategies, and rationales affecting fees, scheduling, promotion, changes in the economic climate, and a dozen other topics. And what if this sitting together was extended to include the consumer—creating a three-way exchange, a triad of shared concerns, a mini-congress of the arts?

It happens sometimes; informally, as a rule, over a few Scotches usually. But only insofar as the presenter acts as a surrogate for the audience, is the consumer present. This is bad because consumers are the largest, most volatile element of the three, the ones we court and woo so zealously, the ones without which the presenter and the artist would be as useful as deck chairs on the "Titanic."

Finally, there's a high-tech form of symbiosis. The application of computer technology to the development of a national booking exchange. It warrants close study because it's very likely that a computer terminal will be our booking agency in the very near future.

How might an artist use this technology? He or she would ask the machine about the size and location of the venue, how to get there, its technical equipment, its acoustical properties, sound system, condition of the floor, the kinds of attractions that have played there, the audience they drew, what newspapers are in town, what overnight accommodations are available and at what cost—and a host of other details.

To satisfy a presenter's curiosity, information would be available in milli-seconds on every artist who's played in a specific region in the past five years: where they played, the size of audience, ticket prices, excerpts from local reviews, artist behavior, length and content of performance, types of encores, name of agent, fees, and more. There might even be—and why not?—the ability to punch up a three-minute audition tape. All this as close as our local library or community college.

The technology is certainly not a magic solution to our universal dilemmas. And certainly there are intangibles that can't be computed. But if the electronic toys can reduce guesswork and risk by 15 percent, we're 15 percent smarter and stronger. And we need all the smarts we can get—in all the candid, abundant, and freely shared detail we can get.

Which takes us full circle back to the metaphor of the three little pigs, and the obvious question it raises: can the three parties

in this great celebration of the mind and spirit we call the arts learn to live compatibly under the same roof of a sturdy brick house? Can we—through a unique (even daring) kind of mutual reliance and candor, abandon the flimsy straw and the frail wood, and build a solid and attractive structure? Can we, collectively, respond to the precarious position the arts hold in America with a unity of voice and purpose that transcends the clatter of bargainings, bickerings, and lamentations that often passes for arrogant martyrdom?

We had better learn to live that way, or we'll be blown away. The comfortable certitudes and platitudes that used to sustain us are gone, or maybe never really existed. The ground under our feet has turned from rock into thin ice.

If, in fact, we honestly believe all the lofty pronouncements we're so prone to utter about the relevance, universality, impact, and delight of the arts; about their ability to transcend social and linguistic barriers; to satisfy the innate hungers in all people; to represent order, discipline, beauty, and sanity—then we have no other goal, no other mandate than to indulge in a little symbiosis and transform ourselves from three little intimidated porkers into one big powerful pig.

Star Dust and Grass Roots

I won't try to disguise it. I'm a blatant, compulsive, dyed-in-the-wool civic chauvinist who happens to believe that an extraordinary amount of creative talent exists—indeed flourishes—at the grass roots, in one's own backyard.

In backyards all over the United States, in fact.

The wealth of theatrical and musical skills—some learned, some innate—that enriches a community partly helps to explain the surge of "do-it-ourselves art" that has swept throughout the country over the past twenty years. An American community that cannot boast of having a little theater group (or several), a musical theater company (probably two: one for *Annie*, the other for *Pinafore*), a choral society, and an opera appreciation something, is a community that hasn't yet heard of rural electrification.

The popularity and quality of homemade culture lie in the unique gift it offers—the chance to live two lives: as the 9-5 breadwinner, engaged in a perpetual war with the real world; and as the

8-11 P.M. dreamer engulfed by the illusions and rhythms of a fantasy world. Or is it the other way around? Is 9–5 filled with illusions, evasions, deceptions, and 8-11 a time for discovering certain truths about the human condition?

Yet despite the abundance of local talent, a nagging reservation is often heard: it's all very nice, but it's not Broadway, it's not Hollywood. We've been inhaling star dust so deeply and so long as it blows off the silver screen, oozes out of the TV tube, or leaps off the theatre section of the *New York Times,* that perceptions and value systems get distorted. Star dust is a narcotic—easy to get hooked on. It makes a heavy user stand in a trance-like state, staring up at the stars, never bothering to notice the flowers growing around the feet. Those addicted to star dust think "local" means "provincial," "amateur" means "second-class," and "community theater" means an "artsy" little club that keeps frustrated performers off the streets.

The star dust habit needs kicking. The therapy I'd strongly recommend is a heavy dose of Summerfest—the five weeks in July to August when we celebrate the extraordinary, sophisticated, and versatile theatrical skills that grow in our own backyard.

There's no controlling star dust. It even lands on the grass roots.

Doin' the Survey Scream

My coat of arms, if one were designed for me, would depict a Questionnaire rampant on a field of Pain.

I have been deluged with questionnaires, surveys or data request forms from trade magazines, state agencies, researchers and book writers, lobbying groups, community and municipal planning commissions, and assorted college students.

Not being prone to primal screams, I will find release in a different fashion by offering to similarly survey-ridden administrators:

A Questionnaire on Questionnaires

Name _____ Date _____

Agency _____

Address _____

1. *Frequency and Length*
 A. In a 12-month period the number of questionnaires I receive is:
 _____ 0–50 _____ 51–1000 _____ 1001–500,000
 B. In length, they run: _____ up to 5 pages _____ up to 20 pages _____ about the length of the Koran
 C. To complete a "quickie" form requires: _____ over 2 hours _____ over 10 hours _____ an Alaskan winter
 D. Translated into dollars, completing a form costs: _____ over $10.00 _____ over $50.00 _____ No dollars (I throw them away)

2. *Format*
 A. The cover letter: _____ admits desperation _____ threatens reprisals _____ promises eternal redemption
 B. The questions asked are generally: _____ ambiguous _____ redundant _____ perplexing _____ all of the preceding
 C. The space provided for long answers is usually: _____ microscopic _____ minuscule _____ infinitesimal
 D. The return envelope: _____ is never provided _____ is provided but carries no postage _____ carries postage but is too small for the form
 E. Response to the form is usually requested: _____ in 1 week _____ in 3 days _____ by yesterday

3. *Emotional Response*
 A. A questionnaire arriving in the morning mail inspires: _____ revulsion _____ despair _____ homicide
 B. When finished, I feel: _____ naked _____ exhausted _____ righteous
 C. When *I* prepare and issue questionnaires, it is to: _____ seek vengeance _____ inflict punishment _____ alleviate boredom

4. *Impact*
 A. When promised "results of the survey" I have received them: _____ 0 times _____ 1 time _____ 0 times
 B. As a result of all the information collected by questionnaires, I have noticed: _____ a major increase in arts funding _____ a major drop in arts funding _____ fat files

5. *Agency Service*
 Indicate the number of times you have been asked to identify the racial, cultural, ethnic, social or national groups you serve: _____ White _____ Black _____ Hispanic _____ Etruscan _____ Pre-pubescent kids _____ Post-pubescent kids _____ Mohawk Indians _____ Second generation Italian stone masons _____ Retired army colonels _____ Jewish Orien-

tals _____ Laplander Doctoral candidates _____ South American dicta-
tors _____ Saudi Arabian orthodontists _____ U.S. Presidents _____
Lincoln Center ushers _____ Mothers _____ Viola da gamba players
_____ Known criminals _____ Miscellaneous minorities

6. *General*

In the balance of the space provided on this page, feel free to comment at
length on the questionnaire mania obsessing arts administrators and
others.

The Feasibility Study
or, How Big Is the Iceberg?

In the beginning there is, as a rule, a feasibility study. In the
end there is, presumably, an arts facility. What is done at the begin-
ning will, inescapably and irrevocably, influence what happens in
the end.

A feasibility study can be, therefore, both an illumination of a
community's* creative ambitions and a lethal instrument that can
frustrate and damage those ambitions; it can be the alchemy that
transmutes base data into a community's golden dreams or trans-
form the dreams into a rubble of bitterness and ambiguity.

Launching a feasibility study should, ideally, imply that arts
facility planners have a genuine appetite for assembling—in a ra-
tional, meticulous and empathic manner—a body of information
that will produce not only a faithful assessment of the legitimate
desires and needs of the community but also serve as a pathway to
the attainment of those desires and needs.

Simple, really. Just find out who, when, what, why and how.
And from this accumulated data—statistics, charts, projections, ta-
bles, lists, *pro forma* budgets—a sharp three-dimensional vision will
surely emerge of a cultural temple, ready for ratification by the
citizens, translation by the architects, and implementation by the
wealthy.

Well, perhaps not so simple. Many feasibility studies are, un-
happily, content with a concoction of names and numbers; such as,
what groups will use a new arts center, how often, at what cost,

*As used here, "community" is any definable concentration of people and institu-
tions such as a neighborhood, town, city, county, or campus.

requiring how much space, operating under what magnitude of annual costs and with how many bodies to run the place.

That's fine. When this occurs, however, the study is suspect. Having limited itself to quantitative phenomena, it offers only the tip of the iceberg, keeping invisible and undocumented the great mass of community ambition, potential, and energy that floats just below the surface.

Complicating matters is the fact that a feasibility study is not only the first, but also usually the *only* major document prepared by a planner that attempts to consolidate public testimony into a document of faith—a veritable bible from which chapter and verse may be recited for months or years to come. As such, it carries an inordinate amount of influence. It should be, therefore, inordinately complete.

Objectives

Accomplishing this completeness requires an altered mind set, a different way of seeing the purpose of a feasibility study. It demands a catholic view of a community, a wide-angle shot that encompasses the people, the institutions, the anxieties, and the psyche of the community. Within this broad purview, a feasibility study can begin to address not only the appropriateness of a facility, but also the capacity of a community to understand, accept, sustain and participate in the realization of that facility. A feasibility study has value, in other words, only insofar as it attempts to equate collectable data with community destiny.

Achieving this equation may not be easy. But it begins to be possible if a feasibility study is informed by some or all of the following five objectives:

1. To document the creative energy that permeates every sector of community life: artistic, social, educational, industrial, religious, ethnic, fraternal, and political. The aptitude, taste and need for the arts are so widespread (although sometimes disguised) as to refute the notion that the arts are ceremonial jewels appropriate only to very special occasions and very special people. To reiterate: a feasibility study searches for manifestations of creative energy, not just performing arts groups.

2. To reveal the depth, variety, content, and number of performing arts activities—in all their incipient, amateur, and professional

forms, viewed without blinders or preconceptions—and a professionally drawn profile of the people who support these activities. The findings, of a magnitude that often can be startling, are likely to provide at some future date a potent instrument of persuasion in the business and political arenas. To reiterate: a feasibility study must document, fairly and unequivocally, all phenomena of the arts, in whatever scale or purpose.

3. To catalog accurately the identity and number of a facility's prospective users—on stage, in ancillary spaces, and in auditorium seats. This information is critical; if nothing else, it may reveal the uncomfortably high percentage of days and nights the facility will stand empty. This revelation may, in turn, inspire the wish to take another look at the manifestations of non-arts activities (conferences, meetings, lectures, etc.) in the community, and how they might translate into regular events in a facility. To reiterate: a feasibility study must develop an extensive inventory of activities—theatrical and non-theatrical—that expresses the breadth of public-interest events that can be accommodated in a new facility.

4. To strengthen, through coordinated program planning, the impact of the arts institutions on the community. Having amassed a formidable amount of information on the activities and problems of the music, dance, and theater groups in the community, planners may find themselves able to recommend ways to facilitate and improve the health and prospects of many organizations. To reiterate: a feasibility study can offer new strategies for cooperative and efficient operations among local arts organizations.

5. To act as a unique and powerful catalyst in the community. Intending to or not, a feasibility study process can inspire a community to reexamine its value systems and, thus, to reassess its capacity for survival. To demonstrate that the resources and power exist in a community to raise a temple can be a compelling antidote to those with the power, or cultural ennui, to pull the temple down. Cities wither, decay, and sometimes die because nobody succeeded in focusing on what was worth saving—cherishing, in fact—and passing on to others. To reiterate: a feasibility study can stir community desire to confront itself, to reexamine its human and physical resources, to reassess its image of itself.

Essentially, a study may be viewed as a critical exercise in communication. It is an exercise that is highly specialized (the goal being the creation of a specific type of facility) and, at the same time, very general (the substance of the study being the universal experiences and aspirations embodied by the human beings in a community).

It is communication that expands its value as it becomes condensed into a body of distinctive community ambitions.

It is communication not merely for the purpose of collecting information, like so many postage stamps or sea shells, but rather to establish, perhaps for the first time, channels through which can flow ideas, feelings, and attitudes about the arts held by a broad spectrum of a community's people and institutions.

Whatever the final value or application of the study, it will, at the very least, establish that someone has prepared thoughtful questions about the cultural matrix of the community and is willing to search for answers.

If organized properly, a study may unavoidably create a lively public forum for the exchange of views, a forum that may generate a hitherto unimagined synthesis of community wisdom, myth, and experience.

If nothing else, what can be communicated by a study is that the arts interface with a total community, evidence of which can be of great value for reasons other than fund-raising rhetoric.

To accomplish its communicative mission, a study will have to be carefully structured, impartially conducted, and utterly comprehensive. These characteristics are critical if the study is to produce the good will, cooperation, and trust that become passports to the community mind. The planning process is inextricably bound to the democratic process (the meeting house notion of people sharing and determining their own destinies), to the political process (the building of a constituency that will support the plan, and the arts, for a long time), and to the marketing process (whetting the appetite of future users and buyers of your product). Ready or not, the process will impinge upon and animate a multitude of community perceptions and expectations.

Implications and Dangers

The terrain over which the study process must travel can be riddled with traps, making the wish to explore the bulky underside

of the cultural iceberg highly vulnerable. This is suggested not to dishearten or discourage planners, but to alert and forewarn. The trip is unquestionably worth it, but planners might watch their step for the following:

1. Who is doing the study? If local people, are they—like a good jury—reasonably free of personal biases or cultural blind spots regarding what is "good art" or who are the arbiters of "quality of life"? Are they socially uncalcified enough so as not to preclude certain strata of a community's structure?

 If consultants are engaged to do the feasibility study, are they prepared temperamentally and professionally to look at the total community without preconceptions, impatience, or a hand reaching for an off-the-shelf, ready-made solution? Whoever they are, local or imported, can they reserve judgment until all the facts are in? (Most say they can, but watch for the tell-tale ripples of ego, favoritism, or glibness.)

2. The study team needs to be alert to local arts agencies (the symphony, the ballet, etc.) that either conceal information like thieves, do not have it organized and documented, or cannot find it. Many arts groups, despite their uphill struggle for credibility and survival, sometimes tend to adopt a cavalier attitude toward record-keeping, making tenuous at best both their fiscal and programmatic projections.

 Budgets, attendance figures, accounting practices, deposits for withholding taxes, maintenance of good subscription and mailing lists, relationships with state and federal exempting agencies, and operating projections, among other management concerns, are often in shambles. Discovering this, the researcher may pry, beg, or be obliged to conduct crash courses in arts administration and agency management. The fiscal health and administrative tidiness of a facility's future constituents bear an obvious relationship to the success or failure of an arts facility project.

3. Planners should be wary of emotional, ethereal, or rhapsodic responses to their requests for study data. A researcher is likely to hear: "There is a real love for chamber music in this town!" There certainly may be such a love affair going on. But the figures (using a hypothetical example)—average attendance of 270 over the last three chamber music recitals, which represents an increase of 4 percent over the last five continuous years, and a

program deficit of $1,400.00 despite the volunteer nature of the sponsoring agency, and the fact that the performance hall used by the recitalists, a university chapel, is rent free—may temper later recommendations to an architect that a space be created for the exclusive use of chamber music performers. The siren songs may need to be resisted. To invoke Jack Webb's shimmering one liner "Just the facts, m'am."

4. Planners should also keep in mind that the study instruments devised for gathering information may be a source of real anxiety. These are, typically, questionnaires, cast in many different forms depending on the kind of organization being studied or the kind of data required. Long forms, short forms, evaluation check lists (to assess existing facilities), profiles, multiple choice, impressionistic or subjective—a wide assortment of research devices can be, and have been, constructed. What should concern researchers is not altogether a matter of the structure and objective of the study instruments; it is also the matter of subjecting small or medium size organizations to the numbing effect of lengthy and complex questionnaires—an ordeal that can sometimes produce messages scrawled across the returned, uncompleted forms: "We have not the time, staff, or inclination to complete this lengthy document" (a county historical museum); "are you crazy!??" (an antique instrument ensemble); and "Crap!" (a private music teacher).

An effective research instrument is one that presupposes intelligence, cooperation, and a modest amount of effort on the part of the respondent; it does not presume that the respondent is a binary computer system capable of instant print-outs of titles, dates, names, attendance figures, dollars, or who can, with confidence, prescribe the "aesthetic qualities" of a proposed auditorium. Good questioning devices will deliver the grist; the researcher remains the mill. Those conducting a study may have to be extraordinarily patient (to allow time for information to be retrieved), persistent (to ensure that it *does* get retrieved), and pedantic (in the old classical sense of one who runs beside you while teaching you what you need to know). In the long run, a good research instrument can be a learning experience for an arts group, offering the group an opportunity to methodically assess and perhaps refine its own systems and goals.

5. The feasibility study process will very likely cause some perplexity among many of the amateur organizations that are invited to

contribute to the study. Conceding their non-professional status, they may find it hard to understand why they are being pestered for information: the PTA that sponsors an annual fund-raiser talent show, the Jewish temple that conducts twice-a-year forums on Middle East problems, the Missionary Zion Church that mounts an Ebony Fashion Show to raise money for the Negro College Fund, the Police Benevolent Association that promotes an annual Roy Radin Vaudeville Night, and the hundreds, maybe thousands of other clubs, societies, associations, guilds, and leagues that are—in theater parlance—occasional presenters. They may suffer from a modesty complex, believing that their meager efforts in show business disqualify them as important information sources or as potential users of a large and complex facility. They are wrong, of course, and a feasibility study process should address the need to change the attitude of these occasional presenters. They do, after all, collectively represent a major programming resource, one that could account for 25-50 percent of a hall's utilization capability, and constitute a powerful political base of good will and support.

Some Results

A faithfully executed feasibility study, one that explores widely and probes deeply, can produce several positive effects and minimize the risk of a debilitating myopia. The study should produce:

1. A community that has been put on notice—insofar as it is humanly possible to do so—that it is deeply involved in the planning of a performance facility uniquely its own, bearing its own style, character, and goals; that input from the community has been genuinely invited and heard and has been faithfully recorded.
2. A power structure (corporate, political, and social) that will not be surprised or unpleasantly disarmed when the news breaks or the project moves into high gear. A leadership structure that is on intimate terms with the process becomes a key part of the integrated circuitry of the planning.
3. A considerable amount of quantitative data. It is data that not only underpins the later formulations of a facility's program, spaces, and services, but also vigorously demonstrates that arts

activity in a community is a major industry, one that merits respect and attention; one that would, if diminished or thwarted, seriously weaken the community.

4. A fascinating, and maybe embarrassing, revelation of the major gaps that exist in the spectrum of cultural options and opportunities in the community—those pockets of unsatisfied interests or of unchanneled creative energy—that perhaps begin to hint at the kind of facility needed, and the kinds of service roles it may have to play.

5. A tentative—*very* tentative—image of the facility itself may begin to emerge: a hint of its size, of the number and type of audience chambers, a feel for the kinds of ancillary spaces it may require, a suggestion of who or what the regular users will be, maybe something of its operating philosophy. But it must be re-emphasized: a *very tentative* image, an amorphous concept, something that bears the same relationship to the final product as the first rough scenario does to the finished and produced play. The temptation for the planning team at this point to make some hasty architectural and financial judgments is often very great. It is a temptation that should be resisted.

Summary: The Complete Iceberg

A feasibility study identifies a community's facility needs within a framework of a community's total needs. To accomplish this, it must perform five functions simultaneously.

The first is the most familiar: it is a synthesis of data and opinion that generates certain specific recommendations. The variety and quality of activity, the track record and future prospects of arts organizations, the demonstrable level of audience support, the potential for finding money, the availability and suitability of likely construction sites, the character and limitations of existing facilities, the annual operating costs, and a host of other palpable factors are made to coalesce into a factual report on the feasibility of creating a new, or different, facility for the arts.

Unquestionably, this is a vital function. Unfortunately, many studies stop here, unwittingly leaving a community grasping for a rationale that transcends bricks and mortar, that outlasts the novelty of a new concert hall, that make large construction costs and annual deficits tolerable.

Which brings us to the second function of a study: to articulate a philosophy, a *raison d'être* for the massive enterprise, a credo that is more substantive than a piece of real estate.

Simply put, a philosophy is the amplification of a community's belief in what it can become, what it must accomplish, and how a new facility will, in fact, facilitate cultural, educational, and social goals. Will it intensify the relevance of school arts programs? Will it, in any manner, enhance a community's urban environment? Will it enliven the architectural character of the community? Will it improve the climate for new business development? Will it bring about beneficial change? In what? Why?

A facility—new or remodeled, large or small—that is raised as an insular monument, as a phenomenon unrelated to the nagging imperatives of a community's appetite for survival, will be built on sand.

It is the philosophy of service—centrifugal in nature, spinning outward to embrace, assimilate and reinforce other community needs—that constitute the real foundation of an arts building.

A feasibility study should, thirdly, attempt to serve as a community's thumbprint—a configuration of creases, lines, and swirls that is entirely unique to the spirit and ambitions of that community. The history, landscape, location, demographics and cultural patterns of a given place are loaded with clues that planners need to discover and try to embody in the study. For example, the question of the distinctive architectural profile that has evolved in a community—the size, scale, age, and texture of the buildings that will be neighbors of a new facility—needs to be studied with great care. If, as another example, a community happens to have a variety of ethnic heritage groups that are stronger and more entrenched in a community's psyche than is, say, the local symphony, a feasibility study would be remiss if it failed to address the "international" character of the town.

Most feasibility studies, unhappily, reveal an obsession with "models"—that is, here's what they did in Denver, or tried in Tampa, or settled for in Syracuse. (A cultural and civic leader on Long Island boldly declared recently that he wants a "mini Lincoln Center for the Island.")

We forget sometimes that a community has, like a human being, a distinctive appearance, style, and character—all molded by the genetics of history, geography, and luck. A good feasibility study will shower as much analytic affection on the *ethos* of a community

as it does on determining the number of seats that local promoters insist they need for bus-and-truck shows.

A feasibility study will constitute, as a fourth function, a promise. However tentatively reported, heavily qualified or reluctantly expressed, the data-based recommendations of the study make promises: that the facility will really be accessible by designated organizations; that the expense and revenue projections are valid; that the proposed management system is the most viable; and that the community can, in fact, expect to undergo a metamorphosis from wasteland to oasis as a result of a new arts facility.

If the promises turn out to be hollow or impracticable, the ensuing disenchantment will be extraordinarily difficult to erase, and subsequent efforts to revive interest are unlikely to provoke much confidence or credibility.

The fifth and concluding function is to clearly establish the foundations of a facility program. These foundations are, typically, interpreted as a catalog of events—public and private, arts and non-arts—that may be accommodated in appropriate spaces, that will occur with a particular frequency, in a particular sequence, and will require special equipment and services to conduct. Important enough. But this interpretation represents only half the meaning of "program," the half that relates to the mechanics of night-filling.

The other half is more elusive but equally important. It relates to the sensitivity of response that planners display toward the "other" audiences, the other 95–97 percent of the population whose interests and needs are not normally reflected in the data results of formal surveys. These audiences—youth, minorities, blue collar workers, ethnic groups—have as much right to expect (if their tax dollars are in any way helping to pick up the tab) programs and activities (a morning arts day care center? a senior citizen acting company?) that address their needs directly as do the white collar, affluent, highly educated culture buffs.

A concern for the "others" pays off. It legitimizes an outreach posture, justifies massive expenditures, and helps to generate a base of constituents that can have substantial political clout.

A feasibility study is, in sum, the revelation of a total community, out of which may emerge the philosophy, size, and program of an arts facility.

This article first appeared in *Student Activities Programming 14,* No. 4 (October 1981): 34-38. Reprinted by permission.

4

How Sweet It Was, Mrs. Murphy

In the days when a Sol Hurok announced the debut performance in
Carnegie Hall of a "pianistic genius," it was a cultural event of
cosmic magnitude. It was invariably a gala event, redolent with
glamour and excitement, with radiantly dressed women, with
flowers, with champagne.

Mr. Hurok did not, fortunately for him, have to fret over thermo-
stat settings, access for the handicapped, stiffened copyright regula-
tions, union rules, fair employment practices, the viability of
tax-exempt organizations, or, above all, the eruption of grassroots
demands—a legacy of the 1960s—for an equal share of the cultural
pie.

These demands, and the surging cultural democracy they repre-
sent, have produced a startling phenomenon: the replication of Sol;
thousands of mini-Huroks operating in cities, towns, and villages
throughout the United States. These hometown entrepreneurs may
lack the sizzle and panache of a Hurok, but they share the same
goal—make the live performing artist the centerpiece of a dramatic
community event.

The proliferation of Hurok-like presenters has produced a paral-
lel proliferation of performance venues: from small church meeting
rooms to huge new cultural centers, from coffee houses to high
school auditoria, from remodeled shoe factories to renovated movie
houses. All the venues represent, however subliminally, a nostalgic
evocation of a Carnegie Hall.

The phenomenon of entrepreneurship—presenting—has become
a major activity among arts agencies across the country. State-wide

and region-wide conferences on presenting are held annually in at least a dozen states; major service agencies now operate (New England Foundation for the Arts, Middle Atlantic Arts Consortium, and others) as clearinghouses or "block booking" enterprises to facilitate the distribution of performing artists on an economical basis to many local presenters.

The collection of pieces that follow in this section try to address the sometimes uncomfortable ambivalence of today's presenters: they cherish, as they should, the myth of the glittering cultural happening in their communities during which beautiful artists dazzle and exhilarate the beautiful people; and they confront, as they must, the nagging real-world imperatives of marketing, solvency, law, and social conscience.

It is a delicate and difficult balancing act.

How Sweet It Was, Mrs. Murphy

I plan to attend all the events that we are presenting this season.

I will, that is, if the federal government and U.S. Congress let me.

As recently as ten years ago, producers, promoters, and theater managers didn't appreciate how sweet it was to have only local, mundane worries: ticket sales, promotion, printing, parking, artist fees, clean toilets, and Mrs. Murphy's lost left earring (found in Row L, under Seat 28). But then the U.S. Congress, responding to a nationwide eruption of interest in the arts, began to promote some acts of its own. The acts are not theatrical, musical, or balletic. They will, however, have a very dramatic effect on theaters and concert halls in America, one that will keep me busy and reduce the number of times I can watch shows from my seat in Box 4.

During the visit of the Rod Rodgers Dance Company in October, for instance, I expect to be poring over the parched prose of PL 94-553, General Revision of Copyright Law, 1976, to determine if we're liable for paying license fees for the music Mr. Rodgers is using.

While Mummenschanz is performing in November, I may be trying to unravel the mysteries of the Rehabilitation Act of 1973, Section 504, to ascertain if the handicapped have been denied access to the splendid mime show.

As the National Theatre of the Deaf weaves its gestural magic in February, I am likely to be engulfed by HR 1720, HR 1847, HR 2113, and HR 2498 to puzzle out what some honorable Congresspersons mean by the "cost of materials" vs. "fair market value" of an artist's work.

When the Dukes of Dixieland romp through their music in April, I will be dissecting HR 79, Postal Service Act of 1979 to calculate if rising mail costs will allow us to send out any more CenterArts to let you know that the Dukes of Dixieland plan to do their romping.

And if I observe, in April, a sense of discomfort in the audience for the gifted Chestnut Brass group, I will hurry to my desk and re-read the Energy and Conservation Act of 1975, Contingency Plan Numbered 2, trying to imagine the homicidal impulse of ticket-buyers sitting in a crowded auditorium that can be no cooler than 78°.

If our season were longer, I would have to get at the Fisher-Conable bill, HR 1785 (tax break for charitable donations), Arts in Education Act of 1978, Part C, Title III, PL 95-561 (more money for arts in the schools), the "Livable Cities" Act, Title VIII, PL 95-557 (arts projects to revitalize cities), HR 1042, Tax Checkoff (voluntary donations to the arts), and more.

I'll miss a lot of good shows, but I'll learn a lot about the machinery and machinations of Congress.

Mrs. Murphy and your earring, where are you?

Dear President Reagan

I am writing to assure you that there is nothing subversive or controversial about our season, nothing that conflicts with your personal convictions of our national policy. Quite the opposite, in fact. To forestall any possible misunderstanding, however, allow me to explain.

1. Not one federal dime has been requested or received to support our attractions. A nice model of self-reliance, wouldn't you say? We take some pride in proving that we can produce ample deficits with or without federal aid.

2. Our thwarted effort to bring the Peking Ballet in no way related to the crisis over selling airplanes to Taiwan. The company would have been here merely to dance beautifully, not to advocate reunification with the People's Republic, recommend an embargo on spare parts for tanks, or rescue a tennis player.
3. The acclaimed Vienna Symphony is our way of saluting international peace efforts—Vienna being a safe capital where world leaders can meet to defuse world tensions, stabilize oil prices, or simply enjoy great tortes.
4. Marcel Marceau probably hasn't thought too hard about the Russian natural gas pipeline that excites the French government and seems to annoy you. Marceau's an extraordinarily gifted artist, but I don't think that miming pipelines is a part of his repertoire.
5. That incredible flamenco guitarist Carlos Montoya is, of course, Spanish. We haven't had any problems with Spain lately, have we?
6. The remarkable violinist Mark Kaplan is actually good for our economy. He earns a fair amount of money playing with European orchestras and brings most of it home to the USA—a real plus for our international balance of payments.
7. Now there's Burl Ives—as loving as Santa Claus and American as apple pie—a troubadour who cherishes our national folk values. Can't argue with that, right?

See? Nothing politically or internationally threatening about our season. Quite the reverse. In fact, it's rather nice, when you think about it, to realize that one of the few places in the world where international harmony can still prevail is in the concert hall—where the only weapon is art, and the only victim is a joyous audience.

We really have to try all pathways to peace, don't we, Mr. President?

Those Were the Days

Remember the popular song, "Those were the days, my friend; I thought they'd never end?" It could serve as the theme song or national anthem of arts presenters—especially if you're old enough

to remember, or at least have read about "those days." That was when the biggest crisis was a contractor telling you he may run short of red velour or gold leaf paint for the new concert hall; when the greatest anxiety was generated by the awful thought that Mrs. Guggenheim could come up with a gift of only $3 million this season; when the most intense personal crisis was whether to wear to the concert the rope of pearls or the jade pendant earrings; or when the fat tenor stormed in anger when criticized for not tenderly lifting an even fatter soprano, and then carrying her up a circular staircase.

They were nice, comfortable, good old days. Box seats were part of a family's estate and were handed down from generation to generation; stage unions behaved themselves; and Sol Hurok was on his throne, ruling the concert world. Even out in the boonies, you didn't have to think or work too hard to organize a splendid season; after all, weren't those charming, smiling boys from Columbia Artists Management scattering across the land like locusts, stroking and coaxing those charming, smiling ladies of the Morning Musicales set into selecting the "right" season?

Those were the euphoric days when "populism"—if the word had been invented yet—would have been scorned, when "society" meant the "right people" and not the real world, when impressarios would have gagged at the phrase "arts administrator"; when "the arts" were a snugly and smugly isolated cocoon, woven of wealth, gold lamé, and privilege, insulated from the slings and arrows of outrageous taxes, energy costs, competition, minorities, the handicapped, technology, unionism, politics, bureaucracies, inflation, and the attitude toward the arts expressed by the majority of our population that is so eloquently expressed by a shrug.

Ah, the good old days. There were problems then, to be sure. And we can still find a residue of "those days" in a few urban centers—Boston, New York, Miami, Atlanta, Chicago, Denver, Los Angeles—where cliques of wealth and influence still dominate the concert scene. Mostly, however, the days are gone—battered by the storms of social insurgency of the 1960s and 1970s, undermined by new edicts and enforcement regulations by state and federal bureaucracies (facility safety, energy conservation, minority access), and threatened by a not insignificant panic as dollars and audiences dwindle, forcing us to wrestle with our cultural consciences in an effort to, as the telephone company jingle goes, reach out and touch someone—new.

It is just as well that those days are gone, and just in time. No society is static; or if it is, it dies—like our friends the dinosaurs. And culture—an integral part of our social matrix—needs to be as resilient, as adaptable as the world it shares, or it, too, will die. This helps, perhaps, to understand why several major institutions have already been blown away. Was their problem really a lack of bucks, or an inability to bend? Close analyses of agencies in crisis usually disclose that a kind of cultural *rigor mortis* had set in before someone tactfully pointed out to them that they were dead.

With the comfortable, old verities and absolutes shot full of holes, do they have to be abandoned? Do the old notions of excellence, of truth and of beauty get dumped down the drain along with mink coats and temperamental impressarios? Certainly not. We surrender nothing. We emulate the cockroach—we adapt. We emulate the worm—we stretch.

Let me share with you several examples of survival by selective adaptation. Many will come as no surprise—at least I hope they won't. And many will be illustrated by programs or strategies that my agency has adopted—not because they pretend to be quintessential models of anything. In fact, many others take similar approaches. I use them only because I know them best. And because—come hell or high unemployment—we intend to survive.

Each example will have two parts: What, it seems to me, we *must* protect and preserve from "the old days," and what we *have* to do, simultaneously, in order to take on those new dimensions of service that might keep us relevant. It is a very delicate balancing act, one that challenges both our equilibrium and our sanity.

The examples have one goal in common: to turn our operation from a shiny, flat stone into a multifaceted crystal, one that can bounce light and color off many surfaces simultaneously. And in so doing, perhaps catch the unwary eye of someone who never focused much on our product.

We must, for one thing, never surrender our position of art for art's sake. Is this perpetuating snobbery? Of course. But the discipline, beauty, revelation, and sanity inherent in the arts are too crucial to the fabric of a civilized society to compromise, and must unblushingly be cherished. We also have to celebrate, at the same time, the astonishing relevancy of the arts to other community appetites and interest: improving a community's economic health (as revealed by an impact study), moderating the stresses of a disturbed personality (a role for drama therapy), or expanding social attitudes

that are healthy (creating threshold experiences in the arts for kids who've never been to a theater before). None of these familiar and widened applications of the arts in any way compromise discipline, beauty, revelation or sanity. More likely, they reinforce them by powerfully demonstrating the capacity of the arts to influence and shape the destiny of a community or a human being.

We must also, at all cost, perpetuate the notion of elitism in the arts. Not as a club to beat off the unwashed or heathens, but as a goal—a reward for enlightenment, personal development, and a bonus of real pleasure. Elitism, if viewed rightly, is the invitation to peek in, enter and share the mysteries of the creative universe. The arts—at least the "traditional" or "classical" forms sanctioned by the best people and esoteric critics—have always been an autocratic, elite phenomenon. Toughness, isolation, arrogance, and blind dedication have never been flaws in an artist's character—but rather virtues. And the artist has a right to expect his or her audience to struggle up the ladder to the height the art demands.

We have to remember, however, that it's a *climb*—sometimes slow, clumsy, arduous—not a *leap*. It is hard sometimes to convince cultural zealots of this, especially the ones who piously and naively believe that they can "educate the audience" and get instant results.

The use of populist strategies to achieve elitist goals should be in the bag of tricks of every arts sponsor. In addition to booking that sensitive harpsichordist, or that exquisite string quartet, toss in Jean-Pierre Rampal playing jazz with pianist Claude Bolling; Shari Lewis doing a great kid show with the local symphony; Judy Collins in the same season as Marcel Marceau; a Millie Jackson ("the queen of sass and class") a few weeks after Carlos Montoya. Is it because these "pop" acts usually earn money? Of course. What's wrong with that? But much more important is to project an institutional image that comfortably embraces all forms of "serious" entertainment (and Shari Lewis or Millie Jackson are no less serious about their standards, careers, and performance than Montoya). With such an image, we can try to defeat the "Tiffany syndrome"— the presumption that our hall contains only exclusive, unfamiliar, and expensive items—financially and intellectually too dear for most people's taste. It is a syndrome that is as big a killer in the arts as heart disease is in the general population.

While still on the subject of elitism, we must continue to cherish and protect that hardy band, those devotees, the aficionados of

culture, that small army of loyal supporters who subscribe, do guild work, help keep the torch of excellence burning. They may represent only 3-5 percent of a total community, but we have to salute their dogged faithfulness and reward them in any way we can.

But we also have to keep a sharp eye on our community's demographics. Who *else* is out there? How many *different* audiences, tastes and needs are we *not* addressing among the 95-97 percent who don't subscribe to the symphony? A community, no matter how small, is a phenomenon of multiple communities, each with different identities and ambitions. Can we, as arts presenters, deal with *all* of them? Certainly not. On the other hand, to ignore all but the blessed few is inviting obliteration. So we look hard, stretch, devise, concoct and throw bridges out to them.

The Festival of Nations held annually in Syracuse—in celebration of the more than thirty different ethnic heritages—is really a way of reaching and touching nearly 60 percent of the community, a reach that has fine strategic and political implications. Our annual American Indian Pageant acknowledges the wealth of tradition we inherit as being the site of the headquarters of the Iroquois Confederacy. The annual Gospel Evenings salute the rich texture of music that emanates from our several black churches. And of course ramps, hearing loops, and wheelchair positions recognize another community—the handicapped.

Yet we've just scratched the surface. We've hardly penetrated the matrix at all. But I think our message is getting clearer: we know you're out there. The so-called arts establishment is not a private club. We respect your special talents and needs; we can work together. We see the arts not as that single, intense flame, but as a kaleidoscope of flames. There is not an arts sponsor or presenter in the world who is prohibited from casting the longer look, from reaching out and more deeply into one's own community as a way of building new alliances, of developing new loyalties. If we don't like Matt Dillon's description of being a Western sheriff, being in the arts will be "a chancy job, that makes a man watchful, and a little lonely."

Certainly we must persist in satisfying the audience we've already got in the bag. They've earned the right. They need all the TLC we can give. But what happens after them? In ten years? Twenty? No sponsor can dismiss or belittle the role as audience creator. I'm not referring to selling more tickets or to luring subscribers with wine and roses. I'm discussing an organized, consis-

tent and highly professional attack on kids. Not an occasional "kiddie show" or occasional children's matinée, or a Christmas *Nutcracker*, but a calculated assault on the mind and senses of young people—with the intent of making the arts for kids as basic as blood, as friendly as food.

We rank the seducing of children's minds on a level absolutely equal to any other major series or services. There's a touch of altruism about it; the rest is a kind of philosophical avarice. We are greedy about keeping our long-range ambitions well fed. We're hungry to produce a species of bipeds whose respect for the awesomeness and uniqueness of the creative act will be so ingrained and energetic that it will—and how's this for hyperbole?—change the world.

This hunger explains why there are Saturday classes for kids (starting at age 5) in Creative Play, Creative Dramatics, and Teenage Acting; why there's a full series of professional attractions— plays, opera, dance, puppets, mimes—that attract 60,000 youngsters a year from a fifteen-county catchment area on both school days and Saturdays. It explains why there is an annual Theater Festival for young actors and technicians, an annual statewide Jazz Festival and Competition for talented young musicians whose school administrators haven't yet discovered that jazz is a respected and indigenous American art form; and on Saturdays when there's no live show, there is a program of film classics for children.

What does this have to do with arts presenting? Nothing. Everything. By giving young people new breathing space for their latent creative instincts in the whole cosmos of the arts, and letting them actively and regularly find genuine joy in that cosmos, we are encouraging them to become part of that army that will defend the arts in the future.

A presenting series that does not include a major component for young people; that does not, if necessary, *create* such a component, is engaged in the classic fallacy of cutting off the nose to spite the face.

Ah, those uncomplicated good old days. But our efforts to accept and adjust to totally new imperatives isn't over. They affect the theaters and concert halls we use.

Certainly we must struggle to maintain a sense of decorum, the experience of the "occasion" in our performance venues. It's what makes a theater different from a movie house or a ball park. But the 1970s and 80s altered that a bit. An empty theater—a "dark

house"—is anathema, a silent shout about its exclusivity, and depressing testimony to the management's distaste for earned income.

The thought of sullying a hall with unanointed activities (nonclassical events) remains a cause for convulsions among some boards of directors.

Let them convulse.

We happen to love barbershop quartets, and bridal fashion shows, and exhibits of new machines that keep the heart pumping, and political debates, and "Hallelujah" sessions by born-again church groups, and nominating conventions, and lectures on alcoholism, sex or how to apply for a small business loan. Events like these constitute half of the 1500 bookings that occur annually at the Civic Center of Onondaga County.

More importantly, these events are a more honest representation of a community's interests, lifestyles or ambitions, involving a truer cross-section of the population than, frankly, do arts events. This fact does not go unnoticed by elected officials (who supply public dollars), or by corporate leaders and merchants (who supply private dollars).

And so far, the Syracuse Opera Company or the Syracuse Symphony has not reported any sullying of the Center by lectures on getting small business loans, or born-again teenagers.

The same practiced resiliency affects an issue very similar to the decorum of the hall, the matter of publicity and promotion. In the good old days it was often enough to print the list of attractions, issue the list, and wait for subscribers to pour in the money. Lovely. And there's still no question about the need to retain a certain dignity about our public face. We certainly are not advertising a circus, and a Bach Partita for Violin is hardly mud wrestling! However, we have to stretch our notions of advertising. I'd feel a bit foolish about alluding to needs so patently obvious as improved design, compelling visual imagery, punchy language, crisp type face— if it weren't for the three years I spent as a panelist for the Presenting Organization Program of our state council. Deep fits of depression would occur over the bland, muddy, confusing, unappetizing, and eminently forgettable flyers and brochures sent along with the applications. The arrogance of these documents (our audiences *love* what we do and will come no matter what) and the naiveté (don't presenters know we live in a harshly competitive and sensory overloaded world?) make me wonder if some presenters live

on the dark side of the moon and receive no radio, TV, films, maga-
zines, or newspapers from earth. It's a kind of ultimate and outra-
geous masochism to prepare promotional materials that in any way
generate less excitement or interest than what we expect the artists
themselves to generate.

We are fighting battles for the bucks and the bodies that Minnie
Guggenheim, Sol Hurok, or the chirping musicale groups of the
1930s and 40s never dreamed of. Bluntly put, a list of artists is no
longer enough. If they are not packaged in a format that has fresh-
ness, vitality, wit, humor, and provocative imagery, we are actually
encouraging our audience to stay home and watch Saturday Night
at the Movies.

There are other ways in which we must preserve the old cul-
tural truisms but, at the same time, adapt to a nerve-shattering set
of new imperatives. We must remain obedient and loyal citizens of
the U.S., but not hesitate to express carefully orchestrated anger
when a Circular A-122 appears, curtailing our right to lobby, when
a revised charitable contributions law is introduced that may dis-
courage donors, when postal rates for non-profits are threatened
with yet another increase. There is a time, in other words, to behave
less like Michelangelo and more like Machiavelli.

Out of all this, if there is a "message" about the 1980s and
1990s it is self-evident: bend, flex, stretch, adapt—or die. Renew.
"The person who is not busy being born is busy dying." And who
but people associated with the arts have a greater command over
strategies for innovation and creativity?

And do we think that all that stretching and flexing will cause
migraines? Will playing double and triple roles turn us into schizo-
phrenics? Will reaching and expanding produce hives?

Certainly not. In fact, it's about time. In further fact, it's begin-
ning to be fun. It quickens the pulse and tingles the nerves to have
to keep one eye on the box office and concert stage; one eye on the
acute shifts and surprises out of Washington; one eye on the na-
tional and local economy; still another eye on our social and human
service obligations; and yet another eye on the technology explod-
ing around us that has already made the future yesterday. This is
surely no place for a Cyclops.

Like it or not, we've been shoved into the real world, out of
Eden; out of that arcane, remote and cliquish environment to which
we were once exiled by wealthy patrons, esoteric critics and pam-
pered artists.

It's an awesome juggling act we have to perform and I think we're beginning to learn how to do it.

Hitting the Long Ball in the Short Park

Today's discussion begins with a simple test.

On the left, a list of ten uncommon instrumental artists currently on the concert circuit; on the right, a list of musical instruments. Match the instruments to the performer.

1. Ronald Thomas	A. Piano
2. Daniel Phillips	B. French Horn
3. Harvey Pittel	C. Clarinet
4. Morton Subotnik	D. Harp
5. Robert Routch	E. Violin
6. Donna Curry	F. Cello
7. Stephanie Brown	G. Flute
8. Richard Stoltzman	H. Electronic
9. Frederic Hand	I. Saxophone
10. Gerald Goodman	J. Guitar
	K. Lute

If you have made only two or three correct matches, you have scored miserably on the test. But don't be disheartened. Your percentile places you solidly in the ranks of the general public, art agency boards of directors, and most local critics. If you scored moderately well—with five or more correct answers—you are either a New York City artist rep or someone who gets his jollies from reading *Musical America* instead of *Playboy.* If all the responses are correct, you are a very esoteric misanthrope, a part of the .0002 percent of the concert-going public.

Despite the low or modest scores that can be expected on the quiz, we persist in sponsoring artists the likes of the ten listed above—all of whom, and others, have played in our Carrier Theatre Series. And we do so not because we scorn the juicy revenues from a performance by a Van Cliburn or a pops thing by a Mitch Miller, but because, in the long run, it's good business.

The artists are extraordinarily gifted; they can offer novelty, versatility, and surprise because they are not yet frozen by tradition or PR hype; their performance fees are still uninflated; they offer

youth and diversity to an institution's overall program; and they graciously share their talents, musically and verbally, with both the filled and empty seats. And when they "make it big" they may even remember us warmly. So there's good value and investment.

But most of all, we see them not as second string or bench strength performers; we see them rather, as players in a triple-A farm club, performers with the credentials, experience and passion either to move up to the major leagues or to become, as a few have already, long ball hitters in their own leagues.

So the only reason to feel badly if you scored poorly on the test is that you're missing some exciting games.

The Feeble Smile

Let me offer you a peek at the glamor of running the performing arts complex in our Civic Center. Everyone *thinks* it must be glamorous, even exhilarating, to manage one of the major theater complexes in the United States, especially with all those national and international artists that flood our stages like a shower of stars.

I'm looking at a copy of the House Manager's Report for October 21–27, 1985. It was a week when a lot of glamorous things happened—enough, in fact, to make a manager think about joining AARP long before he's fifty-five, or to order Gelusil in 100-gallon containers.

Entertainment-wise, it was really a great week, loaded with enough cultural glamor to stuff an elephant. The Talent Company was performing *A Chorus Line,* the world-celebrated Guarneri Quartet performed with the Syracuse Symphony, the famed Chinese Acrobats of Taiwan entertained 7,000 youngsters, the Clancy Brothers & Tommy Makem transported us to Ireland, and a film classic, "Now Voyager," was offered by the Cinephile Society. A stellar, scintillating week.

But wait. The House Manager's Report tells another story, describing the true glamor of a cultural center, the story the general public never gets to enjoy.

For instance: twelve lights in the Foyer were found to be burned out and must be replaced; the escalator, that impish devil, suddenly stopped moving as people were entering; audiences at the sym-

phony reported that the temperature in the hall was too low; the toilet in Room B5 sprang a leak when flushed; the intercom system in the Community Room decided it was time to die, briefly; the buses carrying children to see the Chinese Acrobats arrived late for the first show; a school child broke a glass container, obliging the teacher to remove the kid and clean up the mess; and someone forgot to tell us about a dozen wheelchair patrons who arrived unexpectedly, forcing us to scramble feverishly to accommodate them.

A freakish elevator or a broken toilet didn't diminish the excitement and pleasure the live performances stimulated in the audience. Everything got fixed, as it does every day, every week.

But when people tell me how envious they are about the glamorous role of the Civic Center Director, I can only respond with an appreciative nod and a feeble smile.

Walk in My Shoes: Selling the Arts to the Ageing

I wish I'd thought to write this essay ten years ago—or even five. I would have been very smug and very wise about how I, as an arts administrator, would have devised marketing strategies that appeal to "old folks." From the vantage point of a still-distant retirement, I would have offered a number of splendid recommendations drawn confidently from stereotypes, hearsay, and the glorious presumption that physical decay, isolation, and senility would never get *me*. It's lucky I didn't write it back then.

A change occurred when, a little over a year ago, I received a discreet and attractive brochure from an agency called The Metropolitan Commission on Ageing advising me that according to New York State law, I could now qualify, subject to certain conditions, for all services and benefits provided for senior citizens. That was a day! (I hasten to add that New York State is quite liberal, and the qualifying age level is quite low.) Imagine my violent shift of emotional gears, the reeling sense of revelation, the vivid re-encounter with that stunning line of verse—"When at my back, I seem to hear/Time's winged chariot drawing near." It didn't draw near; it thundered into view, and it drastically altered my view of the senior citizen as a new target as ticket-buyers for the arts. The brochure informed me that I could play checkers and learn macramé at the Ida Benderson Senior Citizen Center; I could take advantage of the

"Call-A-Bus" service to take me to my medical appointments; get a reduced admission fee to the movies; and a discount on my blood pressure medicine, among many other goodies.

It wasn't reaching a dramatic new age plateau that bothered me. I can count, and I'm in pretty good health. It was the unnerving discovery that I didn't *know* anything about getting old. My parents taught me not to steal, the school taught me to read and write, the Boy Scouts taught me to change a light bulb, the Army taught me how to type, and three universities taught me how to use a lot of footnotes—but none taught me how to grow old.

So I feel a little awkward, tentative, intimidated, ill-equipped. As a kid I knew only one old folk—my immigrant grandmother. As a model for "ageing with pride and dignity," she left several things to be desired. She crabbed a lot, was mostly toothless, emitted a musty smell, and was always shrouded in dark clothing. She had one redeeming feature: she was one of the shrewdest, nastiest blackjack players this side of Vegas. Of course, this was back in the days when "gerontology" would probably have meant a skin disease, not a serious discipline; when a "commission on the ageing" would mean a place you went to die; when a Senior Citizen Residence meant the room off the kitchen of a married daughter's house; and a "social worker" was the person who arranged weddings.

I don't know if my grandmother thought about sex after 70 (she didn't talk about it), felt deprived because the federal government didn't pay to repair her broken hip, or was angry because there was no agency to arrange for a bus tour to the Pocono Mountains.

But what a different—no, that's too bland a word—what a revolution in attitudes toward ageing in just the span of my own very young life. From the image of "old folks" squirreled away in back or side rooms, surrounded by the mouldering objects and memories of a rapidly disappearing time, to the present reality of Grey Panthers—to the highly vocal, visible, organized, even militant force that senior citizens have come to represent, a force powerful enough to twinge the conscience of a nation.

So here I am—touching the outskirts of ageing's twilight zone, along with hundreds, thousands of my contemporaries, most of us ill-equipped for the passage, with all you arts producers and sellers waiting to pounce on us as a potentially juicy piece of your marketing.

I'm using, as you can tell, a very personal perspective on this matter of grabbing the older audience (I'll very shortly qualify, and

ageing is a very personal matter), because I don't dare speak for the existing and rapidly growing supply of senior citizens. They constitute a maddeningly diverse range of ages, conditions, background, education, taste, ambition (many of them able to enjoy, according to census bureau projections of lifespans, at least twenty years to pursue their multitude of interests after retirement). And when my sunset days finally arrive, I'd hate to have presenters and promoters look at me as simply a marketing target, as "one of them," as a nameless entity in a generalized lump of greying and stooping human beings, who are obliged to adapt to a bunch of platitudes and guidelines about who we are and what we want.

Although no one has exactly asked me, I'm going to share with you anyway what I want. (I admit I can't play the total innocent. After more than twenty years in the Temple of the Muses, I'm somewhat familiar with the kinds of arts services and attitudes that ought to prevail—so I can't be coy on this matter.)

I'd hope you'd do four things for me as I approach my radiant retirement on the pathway from dotage to blessed senility.

The first is very practical, obvious and rather easy. It has to do with the kind of activities you might arrange for me, being sensitive to the conventional wisdom about us old folks.

The second is a little more complex, because it has to do with the rather special environment I wish you'd create for me if I succumb to your marketing charms.

The third request is perhaps the most subtle and elusive of all because it demands that you discover and awaken in me ambitions and revelations I had forgotten or didn't know I possessed.

And the fourth may be a little strange and disconnected, because it has nothing at all to do with me as an older audience.

As for the practical and typical services, I'd be disappointed if presenters and promoters didn't use some or all of the "standard repertoire" of baits to lure me into the theater. (And for those in the business of seducing older folks to support and attend your program who haven't heard or tried most or all of these, it might be wise to investigate a career in optical physics.)

I assume, as an Older American, that you're going to tempt me with a matinee performance, knowing that my weakening eyesight or the scarcity of public transportation in the evening might make me want to get home before dark. I hope you'll offer special discounts (I might be living on one of those crippling fixed incomes), and perhaps special seating. But be careful. I've got my pride, and

you might embarrass me if you presume that I'm poor (and even if I am, I may still have my priorities), or that I'm a physical basket case who has to be lowered into a seat. You might set up a sneak preview or open dress rehearsal for me and my eroding friends. There's something special about that little privilege. How about a theater party—dinner, a few drinks (no, I'll never give that up), a real dress-up affair. I haven't, after all, given up on feeling elegant. Or the combination job—a bridge match and show; a bingo game and show; a ski outing (I'm getting reckless!) and show. And there's nothing wrong with a few educational teasers—a little foretaste of the show, a little background, a few highlights, given at a convenient center, library, church. Or a "Grandparent Day." They're fun. Any grandparent gets in free when accompanied by a grandchild who buys a ticket. And don't forget to remind me frequently about people like Casals and Picasso and Olivier and all the other old guys whose art remained young and virile. But if you really want to get me turned on, find out if I have any talent and if I'd like to show it off. Invite me to join a senior citizen acting company, an orchestra, a choral group—or even a vaudeville troupe. (Yes, I still remember live vaudeville, although mine may be the last generation that does.)

This is hardly a complete list of "activities" that might pull me away from my warm TV set. They are all familiar, all routinely used. The irony about these strategies, however, is that they are trade devices that any competent PR or marketing person employs to reach a special constituency. The strategies, with slight modifications, could work on shopkeepers, teachers, cab drivers. There's nothing really "unique" or "special" about these devices. A modest amount of creativity and empathy, the hallmarks of any good PR pitch, is what might get me to pull on my galoshes on a winter day and arrive at your concert or exhibit.

Now let's turn briefly to my second request—to the place, the environment, you want me to go to—assuming you hooked me with your cunning strategy. You'll forgive me, I hope, if I admit I'm a little leery. I have an unsettling suspicion that you're going to make my play-, concert- or exhibit-going experience a series of subtle nightmares. Oh, I think you'll worry about some obvious things (or I hope you will) like ramps (if I'm confined), or grab bars in the johns. These basic accommodations are great for my friends in wheelchairs. But I'm arrogant as hell, and convinced that I'm going to remain vertical until I go permanently horizontal. So I remain

convinced that you might ambush me with an assortment of barriers, with a reluctance or inability to study and try to control *everything* I will encounter that might accentuate my frailties, and thus eliminate my pleasure.

In the hope that presenters and promoters are not closet sadists bent on torturing vulnerable old-timers, allow me to ask a few questions about the *place* in which your event will be held.

Will you make every effort to ensure that *all* the conditions surrounding, or leading up to, the concert or play are closely studied in order to provide a humane and safe night out for me? Will you try—*really* try—to "walk in my shoes," as the Indians say? If I'm confined to a wheelchair, will I be discriminated against and forced to sit in the "handicapped section," or will I have a choice in the matter? If I've suffered a 60 percent hearing loss, and forgot to bring my ear trumpet, will there be an inductive transmission loop or an infrared hearing reinforcement system that will help me? What if, God forbid, I become ill; do you have a secure procedure for emergencies, a trained house staff that knows CPR, that has police and ambulance phone numbers at their fingertips? Are your railings too low, your drinking fountains too high, your emergency exit hard to spot? If I'm on a fixed income, and you offer fixed and inflexible prices, should I even bother to call the box office?

And as I prepare to leave my house or apartment and venture into the night, will I be reasonably confident that the streets are safe and patrolled by visible security? Can I park my car somewhat closer than six blocks away, and take advantage of a sheltered drop-off area at the entrance so that at least my wife won't have to hike those blocks? And if I don't have a car or, as is often the case, it's being repaired, is there adequate bus or cab service? And when I arrive, can you offer me, if I need it, what the airlines call "special attention"—maybe help me avoid the crush of people at the foot of the stairs, or point out the elevator that will take me up to the mezzanine?

Please don't misinterpret these questions—or the dozen others that could be asked. I'm not characterizing senior citizens as invalids, cowards, cheapskates, or pampered brats. But with ageing comes a higher susceptibility to illness, and a lower resistance to hazard and stress that translates into a heightened consciousness of vulnerability. It can seriously dilute that wonderful anticipation of joy, enough so to encourage me to turn a deaf ear (perhaps deaf anyway) to your marketing pitch.

Even for a forty- or fifty-year-old culture buff, it can be a big enough hassle to prepare for going to a concert. Magnify that hassle tenfold, add elements of uncertainty, discomfort, fatigue, and maybe a little fear, and we begin to "walk in the shoes."

My third request has little to do with such practical matters as ticket pricing or escalator service. It has to do with the product you're trying to sell me. Marketing the arts to senior citizens will, all too often, clumsily miss the point—and thus miss the potential buyers. Presenters and promoters really goof when they try to sell me a ticket to an event, viewing me largely as a consumer of a specific concert, or dance. They forget that my needs, as an Older American, run much deeper than the transient titillation afforded by that prizewinning young fiddle player.

They forget that at my age, I am keenly, sometimes tremblingly, aware of my mortality, of my rapidly dwindling tenure. I'm searching, therefore, for a kind of gratification that comes only when an art seller helps me calm the tremble and slow the dwindle.

Please don't, in other words, sell me a ticket to a show. Offer me, instead, a passport to a living, undying world.

Sell me escape from the terrors of isolation and loneliness by reminding me that an arts event is a vibrant, social situation I can enjoy with stimulating and stimulated people. Let me know that being a member of an audience is really being a member of a special community, one that binds people together and encourages the sharing of strong feelings.

Sell me the idea that attending an arts event is a way of continuing to grow up, rather than just growing old. There is a sense of adventure, challenge and new experience that can have the effect of re-charging my low emotional or mental battery. The energy that I'll draw from that hot battery will help sustain the twenty-plus years I'm supposed to enjoy following my retirement.

Sell me security and accessibility with my ticket. I want to feel as safe and comfortable in your concert hall as I do in my home. Convince me that your people are friendly and tolerant of the disabilities that often come with ageing without ever being patronizing.

And sell me my memories. I might have, many years ago, acted in a school play. I might have played the trombone once, and was forced to store it in the attic when the imperatives of school, job, family and mortgage took over my life. I was never a Fred Astaire, but I surely did love to dance. And I have always, albeit secretly,

dreamed of being a Big Star in something. The event you want me to attend can breathe a small flame or two into some embers I thought had died a long time ago.

My fourth and final request has nothing to do with coaxing me to drag my ageing bones to the theater. It has, however, a lot to do with when to *begin* the coaxing; and it has to do with not needing to coax at all.

The issue of turning on a senior citizen to the arts makes a melancholy inference. It suggests that up to age sixty-two or sixty-five, a person was never exposed to, or seduced by, the arts. Perhaps, to a great extent, that's true.

I wish, therefore, that you had tried to turn me on when I was six, and not waited until I was sixty. If you had pursued me at age six, only half as hard as you're doing now, made twice the number of appetizing events available to me, and twisted vigorously a few more arms of parents and teachers to convince them that music was at least as important as mathematics, I wouldn't need your sales pitch at all. I'd probably be the first to send in my season subscription.

So, dear presenter or promoter, I will be immensely sympathetic to your self-serving need to fill all the auditorium seats with ticket-buyers if you will be sympathetic to the life-sustaining needs of mine. Walk in my shoes; understand the path that ageing obliges me to follow; then send me your season brochure.

It's worth the effort. By 2050, there'll be a market of 67 million persons who are 65 or older. If you want to grab us, know us.

Killing the Goose

I really like and respect you, dear Superstars of the concert stage. When you sing (or fiddle, strum, leap) I goosebump. You are all world class, top drawer, first bananas. Your years of training and experience entitle you to perform in the world's best concert halls before mobs of adoring fans and to be paid a hefty piece of change. And your agents, managers, tailors, dressers, accompanists, and barbers deserve nice compensation also.

Having any of you appear in my hall is a great privilege. I admit that your presence imbues us with real class, and that your

box office appeal moderates the terrors of my accountant. (And with your current fees, my accountant needs a lot of moderating.)

To tell you the truth, though, I'm getting a little nervous. Well, more than nervous. Frightened. It explains why I have to be tacky and ask: are your fees likely to go up as much in the next five years as they have in the past five years? It's a rhetorical question, I guess. I don't really expect a reply.

You see, when artists' fees really jump, I'm trapped; all I can do (other than ignoring the public appetite for superstars and not booking you) is to shrug, sigh and start wrestling with a lot of awful questions: how much of that increase—not being General Electric or Sara Lee—can I pass along with impunity to the consumer? how much less help can I anticipate from the dwindling resources of state and federal agencies? with a big budget item like you, plus my own production and promotion costs, do I stand even a remote chance of breaking even? and, if I don't manage to break even, where is the "profit" I need as risk capital to book talented young artists who aren't as famous as you? if I have to raise ticket prices to $40 or $50 each, should I feel guilty about supplying rare talents only for rich folk?

I know that you have your problems, so I apologize for annoying you with mine. Except that my problems *are* yours. The compulsion by artists and agents to exploit a hot market by juicy fee increases can have grim and ironic results: it can shut down the market—kill off the goose that displays the golden eggs.

At the very least, there may be fewer presenters who can afford you, thus depriving many people of the personal encounter with your gift.

The whole merciless momentum of rising artists' fees, both fed and justified by inflation, can have desolating results. Is there something we can do about it? Can we talk before your fees reach the Olympian heights of The Rolling Stones? Can we—presenters and artists—start searching for ways to restore a real sense of partnership, to startle the world by offering a model of responsible self-governance, to explore strategies that might minimize the awful cost crunch and still deliver the great artists to the greatest number of people?

I don't want to get rich on you; but I also don't want to be merely the instrument that collects the money for you. I'd really prefer to work with you rather than for you or your managers.

Possible? Or too late?

I suspect it's the latter, so you can see why I'm frightened, dear Superstars. I just don't know how much longer the cosmos can support your magnitude.

Seats vs. Souls, or,
Who's Trying to Sensitize My Psyche?

Marketing the arts is one thing. It is surely a demanding, sometimes maddening and often unpredictable adventure in the stimulation of appetite and action—the end result being (please, Heaven!)—the filling of seats, and of galleries, and of institutional coffers. The goals are clear; the effect, for better or worse, is measurable.

But marketing a community to itself is another thing. It is premised on the notion that, like an iceberg, a large mass of talent, interest and creative energy floats, mostly unseen, just below the surface. Relegated to a kind of oblivion, this large mass may not feel comfortable in the rarified atmosphere above the surface and remains, therefore, unresponsive to the inducements and seductions of traditional arts marketing techniques.

How do we get at that large mass and thereby broaden the market?

A solution would be either to lower the water or raise the iceberg. Lowering the water may be a task only the Lord can perform. But maybe there's a method of raising the iceberg. And it depends on how many marketing pathways we are willing to follow, how specifically or loosely we define marketing, how many hats we are prepared to wear.

This council wears three hats. Two of them are not very different. The first is that of facility management; the second that of a presenter of artists, both major and minor. It's not at all awkward to shift from the first hat to the second.

But it's that third hat—so radically different from the other two—that significantly alters our institutional mission and that obliges us to stretch the concept of marketing beyond its familiar parameters. We are also, you see, an arts council—one of the more than 3,000 community-based service agencies in the United States committed to sensitizing and expanding the psyches of the many

organizations and sub-communities that somehow feel alienated from the mainstream of professional cultural delights.

So while two of our heads vigorously apply most of the traditional and novel marketing strategies to get bodies into the seats for concert and theater events, our third head is fussing less with filling seats and more with winning souls, making converts, bridging the gulf that often exists between local community amusements and diversions and the more sophisticated experience of the "establishment" arts institutions; between, as it were, the beer hall and the concert hall.

We acknowledge right up front the inanity of expecting everyone in town, despite the most canny marketing strategies, to become overnight devotees of Gustave Mahler or *Swan Lake.* We acknowledge, further, the solid and intrinsic value of the avocational, ethnic and educational enterprises generated by local amateurs, most of whom extract considerable social and cultural values from their exercises. And we are compelled to acknowledge, finally, that the process of sensitizing and developing new audiences, of significantly raising the arts consciousness of a total community may extend well beyond the lifetime of this writer, or even this writer's children.

Nonetheless, one of the most profound challenges to professional arts managers is surely to penetrate and proselytize among the "others"—the 95–97 percent of a community's citizens who may appear to be indifferent to, or unprepared for, traditional marketing techniques and philosophies.

We discovered long ago, as no doubt many others have, that a player in a local amateur theater group is not necessarily a subscriber to the professional League of Regional Theaters (LORT) operation in town; or that an enthusiastic practitioner of a Hungarian Csardas dance is going to be turned on by the offerings of the local ballet company; or that a blue collar lathe operator—who is incidentally an occasional Sunday painter or potter—is a regular visitor to the local art museum; or that a zealous benefit chairman of the Jewish Community Center will have even a remote grasp of the complex arrangements entailed in booking a big star as a fund raiser.

It is almost as if the informal or avocational arts (and non-arts) community was a cluster of isolated planets, whirling in independent orbits, experiencing little or no gravitational pull toward the

major professional arts institutions that do, in fact, represent the models of excellence.

A major thrust, then, of this agency is the adoption of a marketing strategy with a wholly different wrinkle, a completely different goal: selling a community to itself. This takes the form of creating programs and showcases designed to gradually reinforce the ego and celebrate the creative energy of those individuals who view their effort as isolated from the traditional concert-loving or museum-going crowd, and who are, therefore, not readily susceptible to arts marketing campaigns, no matter how provocative or clever.

So while hats No. 1 and No. 2 worry over lease agreement details with promoters, or concoct ideas that will produce enough box office revenue to at least break even on a Vienna Symphony performance, hat No. 3 is implementing programs to enhance, teach, or salute those communities of interest that are typically viewed as remote from mainstream culture.

Four examples, described briefly, may illuminate our oblique approach to marketing the arts—particularly in the areas of community theater, ethnic traditions, "closet" visual artists, and a wide assortment of civic, social, fraternal, educational and religious organizations that will occasionally rub shoulders with the arts. We do not, incidentally, claim any pride of originality. Many of our programs are done elsewhere, although perhaps not with the same philosophic objective.

A marketing goal: attainable professional excellence.

1. *Community Theater*

Local amateur theater/musical groups offer a maddeningly complex dilemma. On the one hand—contentious, jealous, uncooperative; on the other—dedicated, energetic, and often unusually deft. They tend to operate on, and protect, their special piece of turf and are often reluctant to share information, mailing lists, or equipment, or to invite supervision by an outside professional.

Although we knew we could never suppress—or certainly eliminate—certain traits that are characteristic of amateur theater groups, we suspected that a strong dose of professional guidance and obligatory cooperation might begin to help them develop a new empathy with the community's Equity theater by imbuing the amateurs with a more mature sense of professional competence than they had hitherto experienced.

To this end, we created Summerfest—a summer season of six local theater groups packaged under our aegis, as producer. A professional technical staff, publicist, house management personnel, and box office were now deeply involved in the implementation of the summer package. Training was given in move-ins and take-outs, pre-planning sessions were held to establish lighting and sound designs that would make more efficient use of time (and thus money); tickets were ordered for the entire season, obliging each company director to think hard about scaling and income; budgets had to be prepared and submitted to the Producer, and a promotion campaign was mapped out in detail, indicating the sequence of display ads, news releases, special features and photo sessions. In other words, the local groups were induced (or seduced) into behaving like pros. We were, in short, "marketing" the idea that a higher degree of excellence was attainable by the application of some basic discipline. (By the second season, in fact, company directors were meeting privately to figure out how to share sets, props, costumes, and even a "universal" light plot, the cost of which could be divided up among the groups.)

After four years of Summerfest, the gap between them and the LORT operation was beginning to close. The operating mentality of the amateurs is slowly beginning to parallel the mentality of the pros.

A second marketing goal: pride

2. *Festival of Nations*

Ethnicity—a pride in cultural origins—has enjoyed an unusual revival over the past several years throughout the country. The revival has been no less visible in Syracuse where nearly three dozen national heritage organizations proudly retain their links with the "old country." These organizations are formidable. They are not only cohesive and strong, but they represent collectively slightly more than 75 percent of Central New York's population—a demographic factor that has more than a few political implications.

Prior to 1969, a few of the ethnic organizations—Polish, German, Ukraine, Scottish, and Italian—sponsored "field days" at different times during the year. Robust and friendly affairs, they were nonetheless isolating themselves from one another and from the community-at-large, evoking an unfortunate and

inaccurate schism between "blue collar ethnic stuff" and "real art." This distortion of value, we felt, had to be altered; a different perception of the existence and worth of traditional folk art had to be "marketed."

The strategy to accomplish this was relatively easy: invite the groups to accept being organized, under the guidance of professional directors, stage managers, sound and light technicians, publicists and others, into a Festival—a major international celebration, under one roof over a two-day period, that would create the kind of ethnic and entertainment mix with broad appeal.

The invitation was accepted. In 1986 (the eighteenth Festival year), thirty-five national heritage groups participated by displaying national dress, offering tasty edibles, performing traditional dances and songs, and demonstrating unique crafts.

That the program is successful—about 12,000 people normally attend—is irrelevant. The effect on the participants and the general community is not. Sensitive to the new level of public expectations, the ethnic groups upgraded or remade their costumes; rehearsals for their live performances became more intense, obliging many choral or dance directors to re-explore their own roots to ensure accuracy; ethnic groups that felt they were too small or too scattered—persons of Estonian, Latvian, or Macedonian descent, for example—banded together in order to share the spotlight; by encouraging organizational continuity, the Festival generated the formation of national heritage clubs— the Japanese American Cultural Exchange Society, the India Association, and others; some groups became brave enough— having tasted the heady experience of public approbation—to rent the large concert hall in town to present evenings of traditional music and dance.

And from the response of the public—through individual comment, letters, editorial statements, press coverage, and ticket sales—the notion being marketed was getting through: that authentic traditional folk music, dance, and crafts are an intrinsic part of a community's cultural texture; that bona fide ethnic arts offered a purity and historic dimension as valid as anything in a symphony's repertoire; that ethnic traditions cannot be relegated to a low spot on a cultural totem pole, but are, rather, part of the spectrum of cultural diversity, bright and luminescent chips in a community's artistic kaleidoscope. With each year of the Festival, that Hungarian Csardas dancer is per-

ceived as less an ethnic and more an artist, more the alter ego of
the ballet dancer than the opposite.

Just as we are marketing the notion that amateur theater
groups can aspire to high professional competence, with the eth-
nic groups we are selling pride of identity—professionalism and
pride being but two of the ingredients in selling a community on
the strength of its own artistic muscle—thus gradually heighten-
ing a community's susceptibility and favorable response to tradi-
tional arts marketing strategies.

A third element is discovery.

3. *"On My Own Time"*

The man who refills the bottle cap machine at a local brewery
has been—unknown to his fellow workers and bosses—dabbling
in pastel drawings for years. The pediatrician's secretary occa-
sionally escapes from the wails in the waiting room by thinking
about the glaze she will choose for the ceramic piece she made
that is about to enter the kiln. The insurance company execu-
tive, strolling to the coffee machine, frowns over his failure last
night to accomplish a secure weld on one component of the
freeform metal structure he's creating in his garage.

The bottle cap filler, secretary, and insurance executive
have three things in common. First, they are "closet artists"—
men and women who live double lives: as wage-earning 9-5 com-
pany employees and as creative artists who practice their skills
"on their own time." Second, they tend to be deferential about
their artistic efforts, accepting the role of "one who loves," an
amateur. And third—like the community theater actor or Hun-
garian dancer—they sense, and much too often accept, the gulf
that exists between themselves and the sanctioned "establish-
ment" artists who are exhibited in the community's major mu-
seum.

The three types of employees identified here can be multi-
plied many times over. There is not a factory, bank, department
store, or hospital that does not harbor, among its work force, men
and women who retreat from the unreal world of gear boxes and
interest rates into the real and fulfilling world of the visual arts
and crafts.

We felt it was both appropriate and essential that we flush
them out and make them visible; that we create a program that
produces, for both the worker and the boss, the great discovery

that authentic artistic abilities lurk in unlikely places—on as-
sembly lines, in reception rooms, within the typing pool, or at
the cashier's window.

The program—"On My Own Time"—accomplishes just that.
Now involving thirty-five major commercial, medical, and educa-
tional institutions, the program provides the tools to set up the
mechanism a company needs to invite employees to submit
works of art (in several categories), assists in the arrangement
for an in-house exhibition of the works (in corridors, employee
lounges, cafeterias—each work carefully labeled with the name
of the artist and of his or her department); provides a training
session, conducted by professional art store or gallery managers,
to teach basic techniques of matting, framing, and displaying;
organizes and dispatches to each company a panel of professional
artists/judges to identify the best works; arranges to have the
selected works put on exhibition in the community's major art
museum; and schedules a gala opening for the artists, their fam-
ilies and their bosses—many of whom, incidentally, confess that
they have never before set foot in the community's major art
museum.

The impact of the "On My Own Time" program is not yet
accurately measurable. A few developments are intriguing, how-
ever. As a result of being selected and receiving favorable com-
ment, several employees left their full-time jobs to pursue the
ephemeral career of full-time artists; companies have begun to
elevate the importance of the in-house exhibition by sponsoring
receptions, giving awards, and purchasing works; company offi-
cers have begun attending the gala opening to bask, frankly, in
the reflected glory of an employee's achievement; and company
officials admit that their *pro rata* share of the program's cost is
one of their most fruitful fringe benefit investments.

Discovery. Louis, standing at the next lathe, is not just a
lathe operator anymore. He's different now. He's an artist.

Discovery. The myth of the blue-collar worker or typist as a
9-5 drone begins to dissolve. They now possess the power to cre-
ate beautiful things.

Discovery. The local art museum is not a walled and forbid-
ding fortress. It's a place in which a lathe operator or typist are
welcome.

Discovery. Top management perceives the multidimensional
nature of many of their employees—that the loading dock fore-

man can magically transform a piece of wood into a soaring eagle.

Professionalism, pride, discovery. These are phenomena as critical to a healthy milieu for the arts and as central to the goals of a marketing strategy as the more typical objectives of increasing subscription sales for an opera company or a ten-year campaign to build an endowment.

And one final example of an indirect marketing approach: sharing with the lay audience the mysteries of theatrical skills.

4. Production Planning Seminar ("Where Do I Go From Here?")

The first three examples of marketing related to the arts—performing, visual, or ethnic. The Production Planning Seminar reaches for a totally different constituency for the purpose of sharing with them the basic (and usually theater-based) skills required to mount a public event successfully.

The cosmos of a community embraces a constellation of clubs and societies—social, civic, professional, commercial, fraternal, educational, and religious—that will, at least annually, "go public."

Read the calendar of community events published daily or weekly in the local press: the lectures, fashion shows, benefits, bazaars, pancake breakfasts, talent nights, book reviews, poetry readings, product display meetings ("industrials"), political debates, awards or installation ceremonies, alumni reunions, and a host of other occasions that call the public's attention and invite them to an event that launches, culminates, explains, or dramatizes the institutional mission unique to the agency that sponsors the event.

Comprised mostly of volunteers, these sponsoring agencies constitute a wide band of energy, influence, and diversity, qualities that are, as a rule, rarely channeled in support of arts agencies—which are, after all, just several more "clubs" in a community's human infrastructure. And wouldn't it be delightful, we mused, if some of these agencies could be sensitized to the role and contribution of the arts?

Fortunately, these social, civic, and service organizations have become increasingly aware of the need to develop basic skills, to become adept in planning, staffing, budgeting, fund raising, promotion, ticket sales, and transmitting their special message (in a space or on a stage) in an orderly, attractive, and

compelling form; in other words, to apply the principles and techniques that are the basic language of arts producing agencies.

The object, then, was to bring together the two elements—the enthusiastic but untutored community service and business groups and the veterans who were professionals in preparing for and "putting on a show."

The Production Planning Seminar has become an annual event drawing representatives from organizations as disparate as the YMCA, American Dairy Association, Onondaga Community College, Holiday Inns, United Methodist Church, General Electric, Jewish Community Center, Miller Brewing Company, Cortland Historical Society, P&C Food Markets, Planned Parenthood, and a Convention & Visitors Bureau.

The basic message transmitted to these agencies is this: the only difference between producing *Aida* and an Ebony Fashion Show is one of degree; that both need intensive planning, a realistic budget, a committed staff, a methodical and attractive promotional campaign, good internal cash controls, and an organizational structure that makes clear who's in charge of what.

Seminar alumni have reported to us on their successes and failures; sent copies of "right" budgets and upgraded brochures as evidence of their new skills; advised us of changes in the composition of their boards that has produced more fund-raising clout; and, on several occasions, proudly informed us of their successful battle with state and federal bureaucracies to become 501(c)(3) agencies. At least one took the bold step of booking our 2,100-seat concert theater to present a benefit event and (at least in this case) made money.

The object of this side-door marketing is simple: A new rapport develops between a food market chain and an arts agency, between a motel operator and a legitimate theater. Sharing with them certain basic production skills—the kind that can apply directly to their own enterprises—produces a bond, however germinal, between the arts and the rest of the world, a kinship that had not hitherto existed. The revelation that arts principles and practices can make a local GE Products Show more exciting can begin to reduce certain barriers that often exist between engineers and artists.

The four programs cited here as parallel or oblique marketing strategies are not, alas, without price tags. But the price is not dollars; each of the four is financially self-sustaining by both direct and indirect revenues. The real cost is in staff time, energy and patience. To achieve the four marketing goals—professionalism, pride, discovery, and skill—among community theaters, factories, ethnics or clubs, the Cultural Resources Council staff, in addition to their regular administrative and technical duties, must become counselors, teachers, hand-holders, disciplinarians, and cheerleaders; they must produce a series of publications that explain how, why, and when; they must maintain a library of current documents on management, budgets, and promotional techniques; they must provide one-on-one technical assistance to help novices prepare funding requests or evaluate a proposed poster design; they must somehow squeeze out a few extra minutes or hours on stage to give neophyte groups a sense of security and confidence, and they will accept an invitation to critique a final run-through of a PTA Follies.

These are the price tags. And we are willing—indeed, as an arts council, obliged—to pay the price. But we believe it to be a profoundly good investment, recognizing that any measurable return on the investment may be a decade or a generation down the road.

We are, as alluded to earlier, marketing a tenuous product—a reinforced community ego; and by such reinforcement to gradually create a climate in which a community's perception of the arts is sharper, deeper, and more hospitable to the products of arts institutions.

We contend that the best way to market the ego and to create the climate is to demonstrate to as many people as possible—especially those who are, or seem to believe they are, alienated from the traditional purposes of the arts—that they possess (or can cultivate) the intuition, taste, skill and critical judgment that are basic to a flourishing arts scene.

If understood, trained and rewarded, it is possible to win the souls of the amateur theater actor, the Balalaika player, the lathe operator, and the motel manager, and to count them as allies in the battle for the survival and growth of the arts.

In sum, the more a total community can be made aware of the depth and diversity of its "hidden" artistic resources, the sooner will the people of that community become more willing targets for traditional arts marketing strategies.

Heaven Hype Us

The newspaper ad promised a great evening of musical crime, madness, and violent destruction.

For $3.50, one would be assaulted by Joe Whiting and the Bandit Band, driven to lunacy by the Locoweed Band, and demolished by Short Fuse and the Explosives. And with three 12-oz. drafts of beer offered (with I.D.) for only $1.00, one was virtually guaranteed an evening of emotional mayhem, aural intimidation, and psychic terror. A glorious Grand Guignol, American-style.

There is a practical message here on how to hype an event that should be shared with our staid brothers and sisters in the classical music industry.

Popular artists have known for some time that the threat of pain can whet the public appetite. Didn't Bob Crosby imply he would claw us with his "Bobcats?" Or Woody Herman propose to squash us with his "Thundering Herd?" Most recently, the British "Sex Pistols" successfully blended eroticism with the stunning prospect of a bullet through your head.

Classical musicians and institutions have inexplicably remained immune to the seductions of sado-masochistic hype. More's the pity, because there are audiences out there who haven't yet discovered the delicious dimension of suffering the arts can provide. The possibilities are legion for classical artists to broaden their appeal by breaking out of their crystalline cocoons and into the slash-and-strangle, burn-and-blast real world.

Think, for instance, of the marketing potential among urban police chiefs, ex-cons and Parole Board officials if the New York Philharmonic were relabeled "Zubin and the Calcutta Cutthroats." Or how retired Navy and Air Force officers would flock to hear a concert by Boston's major symphonic ensemble, "Kamikaze." Imagine the new audience of closet sadists, psychiatric counsellors and porno shop operators for George ("The Lash") Balanchine's new

This article first appeared in *Market the Arts!*, compiled and edited by Joseph V. Melillo, and published in 1983 by Foundation for the Extension and Development of the American Professional Theatre, Frederic B. Vogel, Executive Director. *Market the Arts!* is available through FEDAPT, 165 West 46th Street, Suite 310, New York, NY 10036. Reprinted by permission.

work, "The Rack" (formerly "Giselle"), performed by the New York City Brutes at Lincoln Center.

And for the thousands of psychologically disturbed mortals in search of relief from their primal anxieties, what better sanctuary than a performance at "Scream," sometimes called The Met.

Pain-soaked hype is abroad in the land, and establishment culture had better learn to adapt. Millions of dollars and thousands of new customers are being missed. A few crusty trustees may object, but we'll simply have to torture, crush, and blow them away.

Let's hear it for the detonating dynamics and roaring resonance of that annihilating pianist, Vladimir Howitzer.

Presenting: The Joy of Being Nuts

Having a few loose marbles in our skulls is a basic prerequisite for being in the business of presenting. Not handicapped by complete sanity makes it easier to put up with an enterprise that is devoid of rational guidelines, subject to unpredictable social or political change, viewed as a largely irrelevant activity, often strangled on its own nitty-gritty, and is ultimately (as currently practiced) a demeaning occupation. Hardly the sort of career one might encourage one's children to enter—unless, of course, you dislike your kids.

"Irrational" barely captures the maddening unpredictability of our profession. It would give a medieval sorcerer heartburn if he had to deal, as we do, with formulas concocted as much out of whim as fact; that depended as much on gut reaction as on long experience; as much on freaky good luck as on tested recipes or careful planning. It's a little unsettling to realize what a large portion of our business is like Russian Roulette—never altogether sure which chamber will come up empty (a dud) and which will fire off (and succeed). My failures as a presenter are rarely surprising. It's the unexpected triumph that alarms me—particularly if all evidence and analysis points to a "bomb." It makes one feel a little like Zero Mostel at the end of Mel Brooks's film *The Producers:* "God, what did I do right?"

And if staring into clouded crystal balls wasn't enough, our jobs are complicated by being deeply vulnerable to the stormy changes that occur with awesome and increasing frequency in the world

around us. There's no way we can shield ourselves from the shock waves generated by a major shift in political philosophy (MX Missiles triumphing over symphony orchestras); by major convulsions in economic policy (and the effect of unemployment, interest rates, swelling number of bankruptcies, plant shutdowns on the psyches of ticket-buyers and donors); by reinterpretations and rewritings of laws and regulations (threat to charitable deduction regulations, the notorious circular A-122, postal revenue foregone subsidy); by unpredictable shifts in human behavior (with their impact on tastes and habits of concertgoers); by the threat of violent disruptions in the fragile balance of foreign powers (try to grab space for a feature story on the enchanting harpsichord when Syria decides to invade Israel), and by the revolution in communication technology that may irrevocably alter all our comfortable and romantic views of the arts experience.

We are not immune; there is no shelter. There is no screen of intellectual or cultural privilege or aesthetic mumbo-jumbo to protect us against the tentacles of the real world. (This suggests the old axiom: "If you can't beat 'em, join 'em." Which makes it more valuable, perhaps, to read the *Wall Street Journal* or *U.S. News and World Report* than most publications in our field.) We can be sure that when Wall Street traders begin to scream over a 30-point drop in the market, the echoes are felt in our concert halls.

Perhaps questions of unpredictability or vulnerability are not worth the worry, since we seem to be a largely irrelevant enterprise anyway. Indulge, if you will, in a bizarre scenario: A wierd virus appears, one that is very selective. It attacks only arts presenters. It strikes fast. By Monday morning, you have vanished from the face of your community—along with your visiting dance companies, instrumental soloists, boy's choir, and zither quintet. Who would care? What would happen? To the first question: damn few, a microscopic number of souls, less than 3 percent of the population in most towns. To the second question: very little. There'd be a little groaning from the handful worried about the "quality of life" and other such glistening ambiguities. Some kids or senior citizens might get culturally short-changed, but there's always film or TV to amuse them. You might be out of work, and your passing might be dutifully noted in a three-line editorial squib, but for the most part the town would survive. The supermarkets would continue to sell bread, fire departments to extinguish blazes, the religious to praise the Lord. The final, and maybe only, note of tribute to your effort to

"enlighten" and "enrich" might be a large communal shrug—a melancholy salute to our cherished illusion about the importance of the arts.

It's good to preserve a realistic perspective and not delude ourselves. For the most part, American citizens are not enthusiastic arts consumers—making us, unhappily, eminently expendable. The thought doesn't thrill me, but as presenters and sponsors, we're still a long way from being an "essential service" in our communities. The proof is cruelly obvious: would your community accept a reduction in police or fire protection in favor of subsidizing the Ailey II Dance Company? Do we rank higher or lower than a broken water main? (Not an idle question in view of the collapsing infrastructure in most American cities.) Are we as relevant as a sewage treatment plant? If we're not nuts to begin with, such questions will surely drive us there.

Frankly, it's very healthy to concoct such bleak scenarios, if only for jolt effect, if only to underscore how rarely we stop, pull back, look very hard at ourselves, and ponder a little on what we're doing, for whom, and what sense of mission or purpose, if any, is guiding us where; to explore whether we've been aggressively trying to weave ourselves into the total fabric of our communities, or persist in being content as its decorative fringe.

What deters us from this periodic self-analysis seems to be the way we relish, and interminably grouse about, our day-to-day frenzy to survive. It is the most popular subject at conferences and over cocktails, but I suspect (down deep) we have a perverse love for crabbing over contracts, squeezing out more subscription sales, cajoling and organizing volunteers, wringing hands over cash flow crises, sweating out the deadline on brochures that are folded wrong, scrounging up the white elephants for the benefit auction that won't sell, stroking patrons and donors who don't give, going to the trenches with local and state bureaucrats who don't listen, grinding out releases to newspapers that won't print them, coping with the maddening logistics of performance, the whimsical behavior of audiences, the sometimes fascist demands of artists, and the balky system that expires exactly eight minutes before curtain.

It is all surely a recipe for insanity, but it all has to be done. And in the process of fretting and scrambling, it makes us prey to a kind of tunnel vision, a loss of perspective on what, ultimately, we're in this business to accomplish. (Being a little cynical by nature, I half suspect that we indulge in this frenzy as a way of dem-

onstrating the nobility of our suffering and as an excuse for *not* having to think about what we're doing to and for the future.)

At the moment, what we seem content to accomplish is the rather demeaning function of middleman, broker, hustler, service delivery boy, or as some skeptics like to label us: cultural pimps.

Personally, I resent and reject all these labels. If that's all I am, I'm more than crazy, I'm stupid.

Frankly, my ego rebels at the idea of being stupid. So to deal with that, it may be that we have to become even nuttier, more presumptuous, more flamboyant in what we want to happen, what we want to change.

Like many of my colleagues, I'm a presenter. We offered 125 events in '85-'86 for a contract value of over $200,000. It may be heresy, but presenting artists is only a secondary consideration, only a strategy to accomplish something different, more durable, more long-lasting. I want to get more bang for my $200,000 bucks. The act of presenting—the offering of a series of performing artists attractions as if it were a shopping list or colorful garments strung out on a clothesline—is not enough. I also want to be an advocate, an apologist, a modifier of attitudes and perceptions. I want to (and how's this for gushing rhetoric) carry out the Athenian code: to leave my city better than I found it by trying to unleash *all* the energy and influence inherent in the arts, not just to provide the occasional small dose that titillates the handful of aficionados. In a nutshell, I need to be crazy enough to believe that I must not only feed the cultural appetite of my community, but also to create that appetite; not only to stroke its creative muscle, but to stretch and toughen it.

Presenters in the U.S. seem to fall into three categories: those who dictate taste; who serve taste; and who try to alter taste. There's some overlapping, to be sure. But the general classifications hold.

Without benefit or blessing of any statistical evidence to support the contention, it's not hard to believe that 95 percent of American presenters are in the first category: they are dictators, endowed with some ephemeral authority to elevate (or that loathesome word—*educate*) the public to the level of their own aesthetic standards. They tend to do it with an autocratic, the masses-be-damned spirit that would have made Sol Hurok salivate. They seem to declare that "I know what I like, and what I like is good for you." It is not an evil attitude, certainly; although it's much better suited to

large markets (New York City, Chicago, Los Angeles) where there's a generous enough selection of receptive culture buffs, as well as alternative program options than in most smaller communities—where a tyrant may be the only game in town.

The dictator approach is also the *easiest*—no empathy or research are needed—and also the least effective in sensitizing the larger community to the unique satisfaction of the arts. The anointed get what they expected, and it usually stops there.

To *serve* taste is the flip side of the dictator. Here, program design is dominated by box office reports and market studies. "Give 'em what'll sell" seems to be the motto. "They *loved* the Vienna Choir Boys. Bring 'em back!" "Nutcracker always sells. Let's do it every year." It's a classic phenomenon of the tail wagging the dog. It's also the *safest* approach—though audiences have been known to scuttle "sure things" with chilling regularity. There's nothing sinister about serving a ready-made market. But it does reaffirm the image of the presenter as pimp.

To alter taste is the most frustrating of the three, and the approach we're usually the most uneasy about. It requires a terribly long-term commitment, stretching out into the next generation or two. It involves some risks because novel booking and marketing strategies may not pay off right away. It can provoke criticism from colleagues or trustees who may interpret your off-beat packaging and outreach as a threat to the "purity" of the arts. It takes immense and sustained powers of persuasion to seduce, slowly, the "enemy" into your camp—because its goal, ultimately, is to cultivate consumers rather than promote products. And it is, in my judgment, the *only* legitimate strategy for presenters of foresight and conscience as we race toward the twenty-first century.

To alter and expand taste (if that's what I really want to do), I need more equipment than contracts for six artists, a subscription list and a nervous accountant. I need, frankly, a philosophy—an overriding set of principles and beliefs that embody the convictions I hold about myself, about the role of my agency, about the constituents I serve, and still haven't reached, and about what I hope will be the image of my community.

This set of principles and beliefs acts as a guidance system, giving us the motive and direction for presenting and, incidentally, protects us, like a rock in a storm, against burn-out from all the exasperating conditions of the job. This guidance system can take any form you like; be expressed in any language you choose.

I certainly won't presume to write your set of principles for you; but I will presume to share with you a few of the principles that animate our operation. (These were not, by the way, formulated for the purpose of these remarks, nor do they claim any great uniqueness. They're what we truly believe and what, as I'll describe in a few moments, we put into practice.)

First, and not very surprisingly, we hold that the arts—in whatever manifestation—are truly relevant to all human beings, because all human beings have the genetic and emotional equipment to respond to the arts, assuming our definition isn't so narrow that it chokes off 95 percent of the population.

We hold that there is no such thing as high art or low art; there is only good or bad art.

We contend that the arts are not an isolated, precious cocoon spun by the privileged few, but are only one point on the vast spectrum of human achievements in history, science, government, law, technology, medicine and education—and being part of a huge matrix, there are boundless sources of energy, inspiration and support from the interplay of disciplines.

We believe that our motive for presenting is *not* to get people to "love the arts" but to use the power of the arts to get people to love themselves; that is, to make the happy discovery that they can indeed perceive, understand and thereby experience a new level of self-regard, a strengthened image of themselves and by extension their society.

We deeply love the thought of filling the house for next Saturday night's event, but we care even more deeply about who'll be out there to love and support us next century, and what investments we're making in the next generation or two.

We're convinced, for instance, that we can radically alter the perception of the arts by an entire generation by mercilessly hammering away at kids through multiple levels of programs. We want the little darlings to be perfectly clear about their priorities and values when they inherit the earth.

And we're committed, as is everyone in our field, to audience-building—but *not* in the sense of the blinding obsession to sell more tickets. Rather in the effort to create a community-wide climate in which the arts are as visible and familiar as a church, a fire truck, a tree-lighting ceremony at Christmas. Maybe the results won't show right away, but I'd like to leave a legacy of something better than deficits or ghosts.

Well, you might say, who can argue with such a lovely set of high-principled declarations?

The point of evolving and formulating them is to give me the foundation for a long-term cultural policy, one that's built on what may seem to be a wildly ambitious set of goals. Perhaps so, but if nothing else, it lends a sense of intense drama to my job and makes it a hell of a lot more interesting. Now, you see, it's not just me vs. the appetite of ticket-buyers; it's me vs. the psyche of the entire community. There's a combat worth the trouble.

These beliefs are not, incidentally, merely an exercise in rhetoric and ego. They're very pragmatic. I want to survive. And I know that the strength I need to keep my institution alive and valid is not going to come only from the grab-bag of artists I present annually, nor can I rely very much (especially if the woods are burning) on the coterie of aficionados I attract. It's going to come, ultimately, from a deeply held philosophy of service, one that creates pathways into both the entire community and into the future. It is a philosophy that is comprehensive, optimistic, not a little daring, and imbued with a genuine empathy for the emotional and aesthetic needs of everyone in town. We are, all of us (for better or worse) the surrogates for community taste. It's a heavy responsibility. And it ought to be based on something more solid than a 30 percent discount if you subscribe now.

It is one thing to talk grandiosely about having a philosophy; it's quite another to test it, apply it, try to make it work.

I'm not going to pretend to offer novel, sure-fire, ready-to-wear gimmicks that will extend our reach, boost our relevance, or guarantee a blinding revelation about what our larger mission should be.

But I'll take the liberty of sharing with you a few of the specific approaches we use to help the arts slip over, under, around, or through the traditional barriers that typically keep the bulk of the community at a safe distance from our concert hall and theatre. The approaches work for us and they have significantly changed our image. We used to be viewed as a hummingbird, elegantly sucking the juices from pretty flowers; now we're seen as an octopus with tentacles grabbing in all directions.

It's really very simple, if you're nutty enough to try.

For instance, we feel guiltless when we put the Juilliard String Quartet on the same season with B.B. King, or The Amazing Kreskin virtually back-to-back with the Vienna Symphony, or a

bluegrass ramble in the same month with the Dance Theatre of Harlem. It makes a statement: Art is a spectrum, not a totem pole.

We rarely book an artist that we can't, in some way, exploit the hell out of. Example: the black classical pianist Leon Bates came in on a Thursday for a Saturday night performance. He spent most of Thursday and all of Friday rapping with kids at three neighborhood houses, jamming with prisoners at the County Pen, talked at the Friday Chamber of Commerce lunch and did two radio interviews. (We also had some shopping malls, senior citizen residences, hospitals and employee cafeterias lined up but he politely and wearily declined.) Four stories, with photos, were generated by the local press in two days. It had a powerful marketing effect. On Thursday, ticket sales stood at thirty-two. On Saturday night, the 460-seat house was full. We more than earned back the extra few hundred to bring him in early. But more than that, as community servants, we were heroes. (It's not always possible, I must caution, to so fully exploit an artist; but it's important to have a network of contacts and agencies in our pocket, ready to plug an artist into on very short notice.)

We virtually never accept the contents of press kits the artist's agency sends us because the press kits virtually never tell you anything useful about the artist. Dreary information is supplied about the artist who studied with Dmitri Klotznikoff or won the Wallbanger Piano Prize in Romania; but rarely is there the kind of information about the personal life, hobbies, or interests that would help us to humanize the artist enough to take him or her off that remote and unapproachable pedestal. It's amazing how the public appetite is excited by learning that the artist is also a landscape gardener, is a model train freak, raises sheep, is a prize-winning chef who'll be happy to share some of his or her favorite recipes with the home and food section editor of the local press.

We don't ever accept the notion of an empty seat—one of two cardinal sins of presenters. (The other: not paying the artist.) Knowing we won't always sell out, every event then becomes an opportunity for red carpet guest treatment for a group targeted for development. A technique for "papering" the house? Of course—but with a specific purpose: curry and stroke, but get some aliens across that threshold for the first time and into the seats.

We never announce a season. The word "season" doesn't evoke anything dramatic or tantalizing. We announce an idea, a concept, a theme—a word or phrase that might trigger a broader level of

interest, that might translate "culture" into more palatable and provocative signals. Madison Avenue doesn't sell soap—it sells sex. The new car isn't the product—status and power is. Rather than announcing the season, we announced "the mysterious case of what's happening at the Civic Center." The mystery unfolded in a cartoon strip that ran through six pages, showing a weird little character discovering why so many different kinds of people were rushing to the Center to get tickets. Another season was captioned "The Winning Hand" and was expressed by five aces (a small liberty) spread on a poker table—each card depicting a major performer. The message was clear: by attending the events, you win. The metaphor of the cards—while not original with us—generates quick and familiar imagery among more people than just the culture buffs.

A few years ago we were considering a brochure with a cover that shows a brick wall on an inner city street. Scrawled across the wall is the phrase: "Wanna Have a Good Time? Call 425-2155." It didn't fly. Some of our conservative staff chickened out. (The dignified box office manager was especially appalled. She wasn't sure she wanted to satisfy the request of some callers.)

But the theme or metaphor approach, we discovered, has two values: it makes us squeeze our brains to extract from the season what we believe will be the real product, the transcendent kind of kicks and reward the potential audience will get; and it speaks a language that we hope will narrow the gulf between us and them.

And who says presenting has to take place in an auditorium? Why not the state fairground, a bank lobby, a large restaurant, a church sanctuary? They might not always be appropriate, but it can be very exhilarating to change venues—if only to establish the notion that art and entertainment can happen almost anywhere, and doesn't have to be confined to the sanctified temple of culture. Unhappily, many presenters have no alternative but to be migrants and gypsies, having no home of their own.

Finally, we use our own attractions, whenever possible, to build bridges between ourselves and all those "others" out there who don't normally gravitate into our cultural orbit.

Like the merchants in town. There is the example of the jeweler who agreed to help underwrite a percentage of loss, if any, of a particular attraction. A *quid pro quo* was arranged. Everyone who attended the event received a small chamois bag. One of the bags

held a real diamond. In the rest was a paste imitation. The hooker was that you had to go to the jewelry store to find out if you had the real thing. He did 20 percent more business the following week. The event nearly sold out. The disdain over the "commercializing" of the event expressed by several board members evaporated in the face of the box office report. A local McDonalds proposed a champagne and cheeseburger party as a post-concert gala. The black tie and silk gown set loved it.

Like the politicians in town: the County Executive did the narration for *Peter and the Wolf;* the Mayor did the honors for "A Young Person's Guide to the Orchestra." A lot of elected officials and a lot more political appointees attended, you can be sure—many for the first time.

Like labor unions. The local electricians, steamfitters, carpenters, and welders take turns providing gifts and balloons to handicapped and disadvantaged kids in the theater after a performance. It is very good for their image, they feel. It also helped that a special deal was struck to provide blocks of tickets to professional youth theater events, at special prices, for the kids of union members. (One local felt so flushed by its good deeds, the president walked in with a $1,000 gift.)

Like nature lovers. Prior to a performance of *Wind in the Willows*, we filled the lobby with birds and animals—in a cooperative effort with the Beaver Lake Nature Center. Live frogs, owls, opossums, and snakes were on display, to the utter surprise and enchantment of the parents and kids. (Who says the show starts only when the curtain goes up? A lobby's a performance space, too.)

And the local Democratic Party Committee planned a slide show and display of memorabilia—again in the lobby—in recognition of Harry Truman's 100th Anniversary and to boost our presentation of *Give 'em Hell, Harry.*

These are only a few of the possible "bridges," and we've really only scratched the surface.

We're convinced that every event can and should be a catalyst for community involvement in some form. Otherwise it becomes a very temporal gratification for a handful of devotees, the effect of which is lamentably very brief.

The search for bridges can accomplish some very good things: it creates partnerships that never existed before; it provides tantalizing, hard news that produces expanded press coverage; it gives an

agency new visibility and importance; and maybe it persuades the untapped audience that the product you offer is really within its sphere of interest, and is worthy of its time and money.

Clearly, the goal of all these strategies is terribly simple: to make ourselves an inextricable link in the chain that binds a community together.

To achieve this goal requires that we relax a bit; start to have a little fun; that we *not* take ourselves too seriously or piously; that we keep our cultural antennae raised high enough to pick up signals from every direction; that we try to discard some stultifying myths about who's got culture and who hasn't; and to honestly accept as a viable mandate the goal of helping our community discover that the arts can be a powerful catalyst for a better image of itself.

And if being a little nuttier helps achieve this, there isn't a better reason to be crazy.

Meanwhile, Over in China

I didn't know what to expect in the People's Republic of China.

I was on my way to a theater in downtown Peking to see a performance by the Acrobatic and Magic Troupe of Hunan province. It would be my first experience in a Chinese audience, watching a highly popular form of Chinese light entertainment.

The Acrobatic and Magic Troupe was playing Peking on that sultry Sunday night, we learned later, because it was scheduled to do so at an annual booking conference sponsored by the Ministry of Culture. There are more than 3,500 professional performing arts troupes in China—all government-owned—and the booking conference establishes where they play and when.

From attending that performance—and many others in other cities—there emerged a fairly consistent picture of what to expect when you go to the theater in China.

Expect absurdly low prices. The arts in China are a high priority matter to the central government, so the subsidies are substantial. Average ticket price (in U.S. money): fifty cents.

Expect a friendly, casual, relaxed mix of theatergoers: factory workers, clerks, officials, whole families, chatting amiably on the front steps of the theater or in the foyer, nibbling avidly on their favorite refreshment: the one-stick popsicle (a gift of the Russians).

Expect, from time to time, the aura of garlic to permeate the air. It's a favorite food stuff, believed to possess certain healthful and curative powers. It's not unpleasant, but very evident.

Expect the curtain to rise at different times for different shows, usually at an early hour. The Western custom of the 8 or 8:30 P.M. curtain is based on the assumption of private transportation—we get ourselves home in our own cars. There are no privately owned vehicles in China, making virtually everyone totally dependent on public forms of transportation, or one's bicycle. It was confusing, but not surprising, therefore, to attend shows that began at 6:40 P.M., 7 P.M. and 7:15 P.M. I assume that the Chinese knew what time the show began. We had to trust our hosts to get us there on time.

Even with an SRO house, expect most seats still to be empty five minutes before curtain. The Chinese seem not to suffer our anxieties about reaching their seats on time. It's no sign of disrespect to the performers; it's simply not necessary to rush. As a rule, in fact, the audience still is seating itself thirty minutes into the performance and no one seems particularly distressed.

Perhaps it's because the amiable chatter and conversations that preceded the curtain go on after the curtain has risen, and continue throughout the show. There is none of the polite and arbitrary silence expected of Western audiences. The chatting is not rude or disruptive. Chinese audiences simply like to discuss with one another what's happening on stage.

Expect a loud bell to be rung once, sometimes three times, to alert the audience to the start of the show. Expect, also, the bell to be ignored. The Chinese will assemble when they're ready.

If it's a popular entertainment—like the Acrobats and Magic Troupe, or any of the many song and dance ensembles—expect a very beautiful woman, tastefully coiffed and gowned, to serve as a master of ceremonies, introducing each act, announcing the intermission, and informing the audience the show is over. If it's a performance of a "classical" work—a traditional opera—expect subtitles to be projected on oblong screens on both sides of the proscenium arch. With at least fifty-six minority dialects in China, there's no guarantee the audience will understand the spoken or sung words. The audience, however, is likely to understand the printed characters on the screens because they're taught in all the schools.

Expect most programs will be subject to change—and they did. Often.

Expect very little applause at the end of each act. A smattering, perhaps, that comes mostly from (we suspect) foreign visitors. Bursts of hand-clapping seem to occur only when something feverish or flamboyant occurs on stage—instrumentalists who play very fast or bands that play very loud.

Finally, expect a large number of the audience to rush to the front of the theater during the final number of the evening. They will stand there along the front edge of the stage during the curtain calls, simply enjoying a close-up look at the stars.

On the way out, plan to buy another popsicle (about seven cents) to help cool you in the humid Peking night.

This piece is not, obviously, a commentary on the community arts movement in the U.S. It does, however, provide an intriguing contrast—in arts policy and practice—to Western producers and presenters.

The Dusty Bow Tie

Glitz and glamour, huh? Candlelight and crystal at preconcert dinners and champagne receptions for the artists following the concert, right? Galas and black ties, tinkling laughter and clever chat, yes? A cozy drink with Mischa, a bowl of pasta with Luciano, a corned beef sandwich and pickle with Isaac. A rhapsody of glamour, a symphony of mink, a deluge of divas—swirling, glittering, elegant, all cocooned in gold lamé and silver threads. Rubbing shoulders with Superstars. What a life we concert hall managers lead!

And it's all true, of course. Except for an occasional distraction.

Like the toilet bowl that rips all the wall of the mezzanine ladies' room from which emerges a lady, utterly unflapped, marching stoically to her seat; or like the stage lights that blink erratically during a performance because utility company repairmen are fixing the wrong transformer; or like the doctor's beeper that goes off during a hushed and tender musical moment; or like the guerrilla tactics employed by seat-jumpers who hold balcony tickets and try to infiltrate orchestra seats.

The lure of the champagne gala is somehow diminished by the proliferating patchwork of cigarette burns in the lobby carpet; the clever chat is muted by the costly prospect of erecting a thirty-foot scaffold to replace the burned-out ceiling lamps that are now causing spotty illumination on the frothing conversation; the voluptu-

ous divas will have to really bellow to be heard over the haggling about splits and percentages with lobby program hawkers; and there isn't enough mink in the universe to muffle the cries of outrage as forty ticket holders discover that their forty seats are already occupied by forty different persons—tickets for each seat having been issued twice.

Seat repair, snow removal, bouncing checks, employee disputes, contract squabbling, printing errors, postal rates, political lobbying, service club luncheon speeches, the undersupply of programs, the oversupply of programs, the cooling system that misbehaves, building security, payroll taxes, performers who arrive late, performers who don't arrive at all—seem to conspire, somehow, to make me late for the candlelight dinners or to contribute very little to the level of the tinkling laughter.

For all the glamour associated with concert hall management, one might just as well be supervising a gang of construction workers.

Yet there's no remorse, no melancholy, no sense of sacrifice. My tuxedo (the symbolic uniform of the heady concert society), the blue dress shirt with the frilly front, and the black tie wait in my closet. The tuxedo was last worn on opening night, ten years ago. It didn't fit well then. It would fit less well now. It has collected a little dust also.

But I can't worry about that either. Both the dusty black tie and the concert galas will have to wait. Right now we need to investigate further how an expensive tape deck managed to vanish from a locked room.

O.K., Ma

My mother helped design the Civic Center of Onondaga County.

Quite a remarkable feat, actually, when you consider that she passed away fifteen years before it opened. But her spirit, at least, moved the architect's pencils.

My mother, you see, had arthritis.

Now that's not an earthshaking piece of news. A lot of people have it.

But what she also had was a powerful appetite for the performing arts. She'd willingly climb to a third balcony to hear Enrico

Caruso. She'd stand for a long time in a long line for tickets to a popular musical revue at the R.K.O. Keith's in Boston. She'd sit on hard, rickety wooden seats to watch her son act in a play at Tufts College.

She had little formal education. Fifth or sixth grade, maybe. (As an immigrant, working to support the family had a higher priority than learning geometry.) But the lack of diplomas or degrees only intensified her thirst to learn what school never had the chance to teach her.

In her 60s, the arthritis got bad. Reaching a third floor balcony became a crisis. The knees wouldn't support standing in long lines. Rickety wooden seats were a nightmare.

Reluctantly, and a little mournfully, she was gradually forced to abandon one of her great delights. Theater designers and operators had bumped another customer by making it virtually impossible for an infirm senior citizen to patronize their buildings.

When, in 1967, we started planning the three theaters for the Civic Center, my mother was whispering in my ear. "Help me get to the balcony." (We must have escalators, elevators.) "Let me sit comfortably." (Cushioned, roomy seats, please.) "I can't push those heavy doors." (Carefully balanced doors must be designed that don't swing back and attack you.) "And if I have to go to the bathroom . . ." (Correctly positioned grab bars, absolutely.) "I'm afraid of missing the words." (An audio reinforcement system must be installed.) And so it went. We did everything she suggested.

My mother would really enjoy going to a show at our Civic Center. And why not? She helped design it. I hope she knows.

From Blight to Bach

R eversing the gnawing decay in the urban core of many U.S. cities of the Northeast and Midwest is, in principle, very simple. All that's needed is a daring and innovative political leadership, a massive infusion of new dollars, a major influx of free-spending tourists, a comprehensive rehabilitation program and, above all, a bold reexamination of that ephemeral but critical phenomenon called "community image."

None of the cures are normally viewed as being among the salutary effects of the arts. Yet, surprisingly and increasingly, the arts are being recruited as saviors of a city. They are being perceived as catalysts to precipitate change: the revitalization of a few grimy blocks downtown (restoration and conversion of the old movie house into a performing arts center), the regeneration of excitement downtown (planning and producing street fairs, arts and crafts shows), attraction of tourists (annual art and music festivals), improvement of the business economy (the "multiplier effect" of spending for the arts) and the creation of new real estate (the glistening new cultural center that will serve as the anchor for a dramatic redevelopment plan).

The impulse is right—the arts can restore a sense of excitement, wonder, and fun to a sagging town. The expectation of dramatic change should be viewed guardedly—the arts, alone, are not wonder drugs. They are, at best, one form of treatment that works best in tandem with vigorous doses coming from local government, urban redevelopers, business, education and the media. As a collective effort, a city can be changed. A *corps de ballet*, however deft and

147

athletic, cannot drive out porn shops or erase the paranoia about a downtown at night.

The pieces in this section explore the new flirtation between the arts and the city—a flirtation one hopes will develop into an enduring love affair.

From Blight to Bach

It's something the Surgeon General ought to look into.

Inspecting the dark, dank, and moldy innards of a 1925 movie house that has been sealed up for ten years can be hazardous to one's health. I know. I've been led through a couple dozen of such houses, brushing away cobwebs, petrified apple cores, and ghosts of silver screen idols.

These risky encounters with the redolent past have been prompted by the lofty and slightly presumptuous purpose of saving a city.

In the sometimes frenetic search for the magic that will dispel urban blight and bleakness, community officials have discovered a potent potion: Mix money, vision and hope, rub it on a mouldering movie palace and, in a puff of culture, transform it into a performing arts center.

From Dorchester, Massachusetts, to Tacoma, Washington, from Jamestown, New York to San Antonio, Texas, and hundreds of other towns in between, old movie houses have often become the linchpin in the urban redevelopment dream of pumping new energy, glitter and economic vitality into downtowns. Reclaiming, refurbishing and reopening decaying cinemas has become almost a national urban fad. City officials who might otherwise wince at ballet dancing, suddenly find themselves clasping the arts, like a life preserver, in the hope that the enchantment of a reincarnated theatre will rub against and dissolve the accretion of sleaze in the urban core. And with the sleaze gone, hordes of people will surely begin streaming in to enjoy a revitalized downtown.

Mostly, it works. A restored theater *does* have a catalytic effect, changing the way people perceive a downtown; it *does* have an economic effect, generating new spending and new business enterprises; it *does* have a symbolic effect, announcing that a town is hungry for a dose of civility, a touch of class.

It can work magic, not miracles. Believing that a restored theater by itself can turn around a downtown is a fallacy. Miracles are possible only when the old Palace (or Strand or Majestic or Bijou or Schubert) is viewed as but one component of a creative and comprehensive plan to attack *all* the roots of urban depression. Only when the restored movie house is part of a *district* targeted for improvement will the streets, parking lots, shops, and restaurants re-fill with eager concert and theater-goers. A dime invested in theater restoration is too much to spend if the greasy spoons, porno shops, empty stores, and the myth of the "dangerous downtown" remain.

A restored movie house, no matter how expensively or tastefully done, simply cannot live on Bach alone.

A Billboard Lovely as a Tree

Have you heard the little jingle that goes:

> I think that I shall never see
> A billboard lovely as a tree,
> And, indeed, until the billboards fall,
> I'll never see a tree at all.

Humorous, right? Yet this little verse jingle could serve as the epitaph carved on much of the American countryside and on the commercial pathways of most American cities.

What pretends to be an example of aggressive, competitive American business spirit is, in fact, a desperate bid for attention in a commercial universe that seems to award medals for crowding and bad taste.

So what business is this of mine? I'm supposed to discuss fine orchestras, terrific theater groups, or great sculpture shows.

That's fine. But art isn't just a matter of what paintings are hanging on a wall or what a symphony orchestra is playing tonight. And "culture" is a lot more than the pretension of enjoying the "finer things of life." Let's not get into a narrow box.

It doesn't matter how beautiful the pictures were in the gallery you may have visited if, when you leave the gallery, you have to cross a dirty street. It doesn't matter how splendidly the orchestra played if you felt unsafe and uncomfortable on your way to the con-

cert hall. And it doesn't matter if you've been taught the ground rules for courtesy, intelligent communication and good taste if, when walking through the business district of most American cities, your eye and mind are numbed by the brashness, clutter, and dreariness of the signs that hang out over the sidewalks in front of most stores.

Who cares? Maybe we hardly notice them. Maybe it's time we did.

Whether we care a lot or we don't—the fact remains that we're obliged to live in a particular environment. Leaving aside the whole matter of how we've loused up the air and water, we have to live in that environment, and are going to be affected by it. We are affected by the height and closeness of downtown buildings, by the width of a sidewalk, by odors, by exhaust smoke, by pneumatic drills, by honking horns, and shouting kids, and swearing grown-ups, and, as part of all this, by the signs, posters, and billboards that compete frantically with one another for your attention and your money. Our mood and spirit are deeply affected. And we find that our interaction with the environment is like a psychic obstacle course.

I'm not against signs or sign-painters. We need the information supplied by the former to identify an establishment and the skills of the latter to make a sign attractive and readable. Signs, in fact, can be a great experience in the graphic arts.

What concerns me is that a city—an intense concentration of buildings and people working and living together at a relatively high pitch—is itself one of the great phenomena of human culture. It's like a great lively show, with a cast of thousands, and monumental scenery, and terrific dramatic events happening every moment. But when the show gets sloppy and crude—as any big show can easily become—what should be an exhilarating experience in a city becomes an oppressive experience.

What concerns me also is that we're not going to restore an exhilarating experience to the city merely by stopping the erection of more billboards or imposing stricter limitations on the size, design, or overhang of store signs. It would help, but it's not the answer.

The real issue seems to be that in the frenzy of trying to grab a customer's eyeballs, it's the *signs* that are competing with each other and not the merchants.

Have you noticed that the merchant with the greatest confidence in himself, in his product or service, and in his staff, usually

has the smallest sign? Rather like an ego or personality matter. If a businessman is pricing his products fairly, is dealing in high quality merchandise, is insisting that his customers receive honest and civilized treatment, and is willing to back his product or service with legitimate guarantees, how big a sign does he need? We'll find where he does business. A lot of us will find him.

As I mentioned earlier, the arts are deeply interwoven into the total fabric of a community. The arts thrive in a community when the community itself becomes conscious of the disciplines that the artist himself works with all the time: selectivity, clarity, restraint, harmony, appropriateness.

One of the great, frustrating ironies, of course, is that the merchant who faithfully supports a local symphony orchestra with gifts every year may be the same merchant sporting the ugliest sign in town.

Let me conclude by altering the verse jingle quoted at the beginning:

> I think that it's a first-rate pity,
> When dreary billboards hide a city;
> No signs or posters that I can see,
> Are quite as lovely as a tree.

Symbiotic Planning

Symbiotic planning, or the three-legged stool concept of urban redevelopment, seems to be the ruling principle in major cities across America. It's a principle of planning that abandons the isolated development (a high-rise apartment building) in favor of a matrix of resources that enhance living in that building (a park for strolling with kids, a food store, a dry cleaner, a recreation facility).

This concept is an especially relevant strategy in the skirmishing, if not outright warfare, among cities that battle each other to attract the convention/conference dollar. Many dollars, actually. Big bucks.

Civic leaders salivate over the economic impact of such gatherings and such dollars: 2,000 conferees, say, spending $200.00/day for 3 days amounts to $1.2 million. Multiply that by three—a conserva-

tive "ripple effect" multiplier—and the total economic impact rises to $3.6 million. Not a bad three days' work.

If. And it's a big *If.* If the three-legged stool concept is applied.

There are many big, boxy convention centers (the first leg) that stand in aloof isolation, remote from the mainstream of community life. Often a hotel (the second leg) is part of, or adjacent to, the center—facilitating the passage from sleeping to doing business. In many instances, the planning stops there. Ever try sitting on a two-legged stool?

The third leg—the one that stabilizes the stool and rounds out the package of services available to conventioneers or conferees—is the performance facility. After business is done, and before sleep sets in, there is a universal and compelling need to be entertained.

But more than entertainment. There has never been a conference or convention that did not, at some point in its proceedings, require an elegant, theatrical space in which to hold key plenary sessions, to dramatically showcase products or services, to lend significance to the annual awards ceremony or the maiden address of the newly elected president, or in many other ways to enhance the prestige and image of the organization. An element of snobbishness? Of course. But what regional or national society—commercial, professional, educational, or otherwise—does not think of itself as worthy of a "classy" setting, of an environment that only an attractive theater or concert hall can supply?

Symbiosis: The mutual interdependence of sleeping place, meeting place, and entertainment place. The nuclear "family" of services that make one town more appealing than another.

Symbiosis: The competitive edge that wins the battle for the big bucks.

Culture and Community

In the grand tradition of a snake oil salesman with a traveling carnival, I would love to hold aloft a bottle of freshly brewed Elixir of Cultural Center and, in my spiel, promise miracles. I would swear that it will clear up the acne of crime; it will rejuvenate the fluids in dirty rivers, streams, and lakes; it will soothe the aches and pains of unemployment; it will restore youth and vigor to

ghetto or decaying neighborhoods; and it will energize, overnight, the fiscal health of merchants and manufacturers.

It would be fun to make the pitch, but it would fail. In the context of the many urban stresses and frustrations, there is no magic tonic, no instant remedy. The notion, moreover, that the building of a cultural center may be an ultimate panacea for these stresses and frustrations may not appear to warrant a very high priority.

Appearances, however, like the label on the snake oil, are both deceiving and elusive. The role of culture in a community—only *incidentally* manifested by a building devoted to it—is so elemental as to be virtually invisible. Culture is, ultimately, the privilege we give ourselves to grow, to search, to evolve, to seek a kind of improved harmony between each other and our society. Culture is sustained by personal vision, taste and imagination; it draws heavily on tradition, human emotion, and all those other phenomena of genetic inheritance too deep to easily expose and package: myth, memory, and the desire to somehow live forever.

Culture is not, as it would seem, alien to a community's purpose or survival. Quite the reverse is true; it is utterly compatible. Think of all the solemn public pronouncements, the official positions and commitments that a community's leadership proclaims about its goals: decent places for people to live, equal justice under the law, fair and honorable employment practices, a healthy and safe environment, proper education for the young, and a host of other pledges and dreams. All these objectives are motivated—whether it's said aloud or not—by an *ideal vision* of a rational and humane society, one that fosters the growth of human potential and protects the integrity of the individual.

It is in this effort to articulate an ideal vision that culture (the embodiment of this vision) and community touch and begin to flow together.

Ironically, the enjoining of community and culture become most evident in wartime. I'm not referring to the patriotic songs that stir the blood, or Bob Hope entertainments that divert the troops. I am referring to the peculiar distinction made in war between killing people and killing culture—and how the former is carried out with grisly aplomb and the latter with curious circumspection. During World War II, bomber pilots were explicitly instructed to avoid certain cultural landmarks such as museums and churches. In the Vietnam mess, our military was told to avoid any damage to a par-

ticular temple in the village of Hue because the temple housed a throne chair of great historical and cultural significance. There is something evidently in human nature that rebels against wiping out those artifacts that most uniquely embody a community's or a nation's cultural identity.

Why does it require the bloodiness and insanity of war to realign priorities? Do we have to view urban calamities as a form of combat in order to reaffirm the relevance of culture to a community's fundamental character?

It's not my intent to minimize the importance and urgency of our urban dilemmas. They are discomfiting enough. They are, however, on the verge of becoming out of hand, producing an unwholesome obsession with the perceived deficiencies and frailties of a social order that can be characterized as civic hypochondria.

While it's an act of good citizenship to be deeply concerned about the malaise of cities, it is equally the duty of responsible citizenship to be just as deeply concerned with the assets and strengths of a community, if only as a search for an effective antidote to the malaise.

It is, in fact, *because* of the dreary inventory of urban woes that it is more than ever the time to celebrate those resources—creative energy, ambitions, dreams—that declare we're not about to go under; that we'll make it; that we'll survive and grow.

And we don't need snake oil—just the wit, vision, and creativity that already exists abundantly.

You Can't Afford Not to Bring Us Back

"You can't afford not to bring us back," observed David Richardson, as he studied a sheet of figures while sipping on an after-work Scotch. A member of the New York City Ballet company, David was reacting to an exercise in computation which revealed that the seven-day, six-performance NYCB residency in Syracuse pumped more than $600,000.00 into the economy of the city.

That was late in March. The company, whose performances were made possible by grants from the New York State Council on the Arts and the National Endowment for the Arts, executed six works with the easy excellence that is its hallmark. Nearly 12,000 tickets were sold to patrons who came in carloads and busloads

from 142 Central New York communities, Pennsylvania, and Canada. Judging by the number of inquiries about the location of the theater and places to park, we estimate that 50-60 percent of the attendees had never been in the Civic Center complex or, for that matter, never been in downtown Syracuse. (An alarming number of these inquiries came from people who lived within a fifteen-mile radius of the theater.) But they came—in jeans and gowns, in dashikis and sport jackets, in wheelchairs and on crutches. And the absence of the injured Mischa didn't really seem to matter. For seven days, ballet dancing was hard, front page news in Syracuse.

It was, by any standard, a cultural Event of the first magnitude. It was also, for the community at large, an economic winner of the first magnitude.

The figures that David saw were these:

Number in Company (120) × $ spent per day ($55)	$ 6,600	
× 7 days	46,200	
× 2.5 standard multiplier	115,500	
		115,500
Revenue from Ticket Buyers	124,170	
× 3.0 standard multiplier	372,510	
		372,510
Money spent for:		
Promotion	24,000	
Orchestra	30,000	
Stagehands/House Staff	15,000	
	69,000	
× 2.5 standard multiplier	172,500	
		172,500
Total $ Impact on Community		$660,510

He was right. We can't afford not to bring them back.

Art for Money's Sake, or, Who's That Knocking on My Cocoon?

We arts folks are a nice bunch, but sometimes we're a little slow. We've become, for instance, so paranoid about our deficits, we've failed to notice that we're generating a lot of money.

Arts organizations, large and small, are beginning to squirm uncomfortably in the snugness of their cultural cocoons, the walls of

which are being battered by the incessant demands of the real and pragmatic world to demonstrate the practical value, the economic impact, and the social relevance of the arts. It's not surprising. The art for art's sake mentality has, for years, been spinning itself into a thick-walled cocoon.

Sheltered by the intellectual elite of the eighteenth century, toyed with by merchant kings of the nineteenth, and patronized by a handful of the indulgent wealthy in the early twentieth century, the arts now face an awesome dilemma: how to prove their worth in a language the world understands, without compromising their standards and goals.

Well, a handful of organizations have discovered how to deal with the dilemma. And it's about time. They have turned, unashamedly, to a different discipline—economics—and discovered that a long-standing, highly respected, widely applied, and very available device is the clue to untangling the dilemma: the infamous "multiplier."

Arts agencies from Ottawa, Indianapolis, and Baltimore have used it. And so has Syracuse. It's really very simple.

Dollar numbers were collected from eight arts and history agencies in the Syracuse area (five performing arts groups, one art museum, one history museum, one arts council). To the collective figure for salaries paid in one season ($4,373,790.00) a standard multiplier of 2.5 (the number of times money "turns over" before it "leaks out") was applied. Salaries, in other words, generated and circulated the equivalent of $10,859,475.00. To the collective dollar figure for ticket buying ($1,569,808.00) a multiplier of 3.0 was applied (what is spent additionally for baby-sitters, car, parking, dinner, drinks . . .) resulting in an actual expenditure of $4,709,424,00. And there's a third multiplier: the $135.00 per day spent by 6,935 people for 1.2 days while attending conferences or conventions at the Civic Center (a very small portion of total convention business in Syracuse), producing another $1,123,470.00 in revenue. Voila! The arts in Syracuse are, in fact, a $16,692,369.00 industry. How's them bananas?

So when the world—in the form of priority-setters or politicians—comes knocking on our cocoon demanding to know (a) why we can't support ourselves, or (b) why we think we're as important as bread on the table, or (c) why we expect support from municipal agencies, we can peek out and announce: we pump $16 million into the economy; we pay our way; we go forth and multiply.

Civic Centers—A Celebration of Us

You'd hardly know it to look at them. You wouldn't believe that members of a community's establishment—city officials, planners, businessmen, educators, and other respected elders—are secretly card-carrying, radical revolutionaries, participating in a national conspiracy to overthrow old attitudes and change the world. Or at least that part of the world known as their own community.

In dozens of cities, large and small, born-again revolutionaries are coming out of the closet, and mobilizing to fight for a new priority system. Curiously, and refreshingly, the object of their reordered priorities is, of all things, culture. Specifically, their goal seems to be the raising up of a temple of culture—a performing arts or civic center.

Why, one may legitimately ask, are towns all over the country suddenly experiencing a cultural itch and are determined to scratch it? Don't the venerable leaders of these towns have anything better to worry about—like trash removal and potholes?

The revolution that now appears to be possessing solid citizens has its roots in the social upheavals of the 1960s, precipitated by the demand of citizens to start, finally, plucking and tasting the fruits of a democratic society; government, business, and education were put on strident notice that they had better start seeing, listening, and caring about the ambitions and dreams of the people.

The insurrection against impersonal bureaucracies, racial inequities, and pointless wars had its share of violence and sadness. It also had the uncommonly beneficial effect of fomenting a little healthy unrest among the more dignified citizens, inspiring them to begin exploring protest pathways of their own.

The revolution widened. It now began to be directed at a batch of environmental and social issues that had been ignored for too long. The abuse of our planet (strip mining, marauding developers in Alaska), the abuse of our animal life (fowl-killing oil spills, reckless harvesting of whales), the abuse of our minds (the stifling of excellence in the schools) are just a few of the evils that had become intolerable and needed immediate relief.

And the revolution widens still. Communities of every size are being drawn, willy-nilly, into it, vulnerable to this electric atmosphere of change. Influenced by a surging "participatory democracy," enlightened citizens yearn to retake control of their own

towns, to remold them into livable and civilized habitats, if only as a way of not drowning in the interminable wave of crises that threaten to wash away their city.

We are drenched in them every day. Last week, in a momentary lapse of good judgment, I read the evening paper. I should not have. The headlines and stories had the effect of a pile-driver, hammering me deeper and deeper into the armchair cushion. The mayor and city council were locked in deadly combat over who has the right to raise their own salaries using tax dollars that don't exist; the water main had erupted outside the hospital raising dire threats that the entire infrastructure would soon collapse; the teachers in the city had just announced a strike; a suit was being brought against the city by a guy who broke an axle on a pothole; anguished protests were raised about the lack of police protection, forcing senior citizens to turn into hermits; the sewage treatment plant overflowed into a little league park that can't be used for night games anyway because the money to replace the lights wasn't in the city's capital improvement budget, which the voters turned down (along with the school budget) because of the high unemployment and low tax base which caused the city's bond rating to drop from AAA to B, which was all really the fault of welfare cheats. At this point, my one glass of Scotch proved woefully inadequate.

A community can be saturated in crisis pretty quickly, impelling the citizenry to cry out: Enough! Is this all I get for my money, for my commitment to be a decent citizen in this town? Are potholes, strikes and welfare cheats my reward for living here? Can't something *nice* happen, something we can invest in that celebrates what's good, what's worth preserving, what's creative about us? Is it dumb or naive to dream that we can carry out the ancient Athenian code: I wish to leave my city better than I found it?

And while we're lamenting the lack of balance between order and chaos, a different kind of hand-wringing is going on. Not in living rooms, but in city council chambers and corporate offices. It's virtually simultaneous—but with a different motive.

Establishment leaders are agonizing over other dilemmas: the economy is shaky; it's getting tougher to lure new businesses here; the tax base is eroding; investment capital is about as plentiful as bars in Salt Lake City; the downtown is looking seedy; tourism has dwindled to an annual busload of senior citizens whose driver got lost; the inventory of hotel rooms and meeting spaces can barely

handle a cub scout troop, so there's no way to compete for major conferences.

The lamentations may seem to be exaggerated a bit, but not much.

Now if—by some sublime magic—the appetite of the citizens and the motives of the leadership should join together; and if the chemistry is right, they might jointly conclude that the solution for each might just be the solution for both. It's been tested and used in many cities—as a way of counteracting a negative with a positive, of injecting creative vision into the flagging corpus of a community. Namely, a cultural center.

Let me quickly define the word. By "cultural" I mean those activities that give residents of a community an incentive for growth, fulfillment, and satisfaction; activities that give residents a sense of joy in discovering and improving themselves. By this definition there's no high or low culture, only opportunity to become very good at whatever you enjoy most. Bowling? Glider flying? Making clay pots? These are all part of the matrix of a community's culture—the arts, incidentally, being only one component.

It would be nice to think that a civic or cultural center can satisfy everything from bowling to learning the Japanese tea ceremony. Obviously, it can't. But assuming everyone thinks that it's a good idea, and comes up with a good plan and a functional building is erected, what has it got?

It's got more than it thinks it has—once it recovers from the shock of the price tag.

It has a powerful statement of the community's respect for its most precious commodity: the creative intelligence of its citizens. Just as a school celebrates the mind, a hospital the sanctity of the body, a church the reverence for a Supreme Being, the presence of a cultural center declares that the *spirit* of a community—the hunger to learn, practice and joyously share personal skills—is a tangible force that must be protected and cultivated.

If nothing else, it asserts that it is a civilized town, and with a little class, a yen for sophistication, and a desire to establish a tradition we can pass along to future generations with a little more enthusiasm than the tax burdens, debts, and rickety bridges we usually leave to the unborn.

Not only is it a statement, but also a potent catalyst—capable of precipitating change. It may not create miracles, but it does work some magic.

Experience has shown that requests for urban development grants from property owners within a 3-6 block radius of a cultural center increase by 15 percent; land values increase by 25 percent; activities in bars and restaurants before a show increase by 30 percent. Commercial and residential developers like to build near and be associated with cultural centers because it says something about how upbeat and attractive the neighborhood has become.

Spin-off spending by audiences attending events at the center can make one's mouth water and eyeballs spin like a slot machine. Economists have established the "multiplier effect"—for every dollar spent on a ticket to see a play or a concert, audiences will spend $2-3 more on related services—baby sitter, gasoline, parking, beauty parlor, restaurant, maybe a souvenir program, drinks during the show, and after the show. It is interesting to note that arts groups moan a lot about their deficits, but we don't hear much moaning from the merchants who gleefully rub their hands together when there's a good show in town.

A cultural center is, in other words, also a money center—generating it, multiplying it, circulating it, inspiring others to invest it.

The air of boosterism that I may be conveying about the salutary effects of a cultural center on the psyche and economy of a community must be tempered a bit.

For a center to work as both a statement and catalyst, it has to be conceived right up front as something a lot more than the private clubhouse for the elite crowd (1-2 percent usually) who simply adore the ballet or the symphony. A cultural center with this kind of narrow focus will fail. It'll be viewed as a monument to a privileged class. Worse than that, it will be empty most of the time, a condition that turns tame taxpayers into bloodthirsty headhunters.

There once was a day, to be sure, when the very rich could, with the wave of an accountant's wand, cause a concert hall to materialize as easily as a fifty-room cottage for themselves in Newport or buy a little villa in Venice. The IRS snatched that wand a long time ago. Besides, it's hard to find the very rich these days. They're either hiding behind family or community foundations, or driving around inconspicuously in their Volkswagens or battered Volvos.

In the 1980s, pressured by a robust cultural democracy, civic or cultural centers are obliged to serve many masters. It cannot settle for being a palace of the arts and thereby perpetuate the "edifice complex." Rather, it has to become at least four different but inter-

related kinds of "houses": a playhouse, a schoolhouse, a community house and a conference center.

This seems to be a lot to burden a building with? Not at all, particularly if we remember there are 365 days in a year, and each day with three rentable parts (morning, afternoon, evening), which creates 1,095 opportunities to use the place. Most communities are lucky if their local arts groups can use 150 of those 1,095 openings. What do we do with the remaining 945? The answer lies in the multiple house concept.

Let me elaborate briefly on those four functions.

It must be a playhouse: a first-rate, professionally equipped and managed facility for the arts—to perform them, exhibit them, experiment with them, and enjoy them. The arts become the centerpiece, the prized jewels, the greatest source of community glamour and excitement. A very profitable convention by, say, East Coast milk producers simply doesn't generate the ripples, the electricity as does an evening of opera with Beverly Sills or a visit by Willie Nelson. Milk producers (God love them) simply don't put a town on the map the way that Sammy Davis, Jr., does.

It must be a schoolhouse—a place to learn, to study, to explore. As a schoolhouse, it can offer, in a non-academic, non-threatening atmosphere, almost anything: creative dramatics classes for kids, workshops to help high school trumpet players become better jazz musicians; seminars to help aspiring businessmen and women understand federal tax advantages; there can be classes in dancing, losing weight, playing chess, improving macramé skills. The schoolhouse role is limited only by time and space, but not by imagination and community need.

It must be a community house—not unlike the concept of the old town hall—where business is conducted by the dozens, or hundreds, of community civic, social, fraternal, patriotic, educational, religious, political, and professional organizations that are really the matrix of a community's character. Many of these groups, incidentally, need an auditorium and stage to conduct debates (League of Women Voters), honor achievers (United Way), hold benefits (Heart Association), or offer ecumenical services (United Church Council).

The affairs of these agencies can constitute 50 percent of the annual program of activities in a center—agencies that, not incidentally, can become loyal supporters of the facility.

And, finally, it must be a convention center. It may not be able to accommodate 3,000 Agway delegates, but it can attract and prop-

erly handle medium to small sales meetings, stockholder meetings, new product exhibitions, and awards ceremonies. The point is that a civic or cultural center has the obligation, in its own best interest, to be a lively partner in a community's effort to generate "foreign" dollars, knowing how these impact so sweetly on a community's economy.

These four roles surely frustrate the myth of the cultural center as a posh concert hall, soaked in red velour and gilt, dripping with chandeliers, and appealing to a microscopic segment of the community. Instead, we are looking at a multi-service, multi-functional facility that can (indeed must) not only treat the arts with respect, but also treat the mind with honor, treat the phenomenon of community service with appreciation, and treat the economic viability of the town with the enthusiasm and support it needs. In other words, a celebration of us—who we are, how we live, and what we want to become; a community civic or cultural center as the large mirror that reflects our total image. Should the cultural purist feel alarmed at this populist approach, there is no need to worry. A pluralist philosophy for a cultural center works. The symphony crowd is not outraged because vacuum cleaner salesmen got awards in the same hall two nights earlier. The school boards association couldn't care less about the lecture on alcohol abuse scheduled for two nights later. Each agency will do its own thing, in no way feeling compromised by other events, if the facility creates a friendly and supportive environment for each. Culture does not get watered down, it gets spread out, embracing the concerns, ambitions, and talents of a sweeping spectrum of community life. It is that spectrum that most faithfully captures what a community's culture is all about.

Daydream #3006

"If people want that kind of stuff, they ought to pay for it themselves!!!" The elected official slammed the palms of both hands down on the table to emphasize the anthropoidal sincerity of his pronouncement.

The "stuff" he was alluding to was, of course, the arts. The rationale he was applying was familiar and primeval: a savagely

democratic knee-jerk reverence for mass taste, popular consensus, safe priorities, personal choice, and getting re-elected.

My reply unsettled him a bit. "I agree completely, sir."

"Oh?" he retorted eloquently.

"Yes, sir. I like that idea. 'If you want it, pay for it.' Beautiful. But the idea shouldn't be confined just to the arts. It probably ought to be applied to everything."

"Huh?" he queried, showing more restraint.

"Well, I was just thinking. . . . There's a stretch of county road up north that connects three small towns. I never drive on it. Why don't we let just the people who live in those towns pay to maintain it? Fair enough? And the elementary school in my neighborhood. My kids are grown and long gone. How about we ask only the parents who have kids enrolled there to chip in the bucks to pay for teachers and books? It might cost 'em a bit more, but if they want that kind of stuff . . .

"And the Fire Department. If your home is burning, I suggest a service charge for a house call (cash or check only) to have them come over and douse it. Neat, huh? Why penalize folks who don't have fires? And the penitentiary you're building. . . . Would you deny crime victims and the Law and Order zealots the satisfaction of paying for construction and upkeep? They'd be crushed if deprived of that privilege. And the county parks, and the community college, and the zoo, and the public library, and the baseball park, and the nature center. I don't think raccoon and snake lovers would mind paying the whole shot to watch their favorites skitter and slither, do you?

"But what I like best about your philosophy, sir, is the glorious and stunning effect of it. In one fell swoop, we erase all social, educational, humanitarian, recreational, and cultural institutions. What a relief! No more rivalry; no more competing among agencies for the bucks or the attendance; no more arm-twist politics to pressure you into funding special interest groups. Only people who want penitentiaries, public schools, parks, fire departments, dance companies, or frolicking raccoons—those scavenging little devils—will pay for them. And if they can't come up with the bucks, we'll simply, as a civilized society, shut down, relieving you of any further responsibility for making uncomfortable decisions."

"Now wait a minute—!" he huffed.

"Just following the vision and mandate of our President, sir.

You know . . . more private initiatives, less government interven-
tion.

"So have we got a deal, sir? I'll use my money to help the sym-
phony and the opera. And unless I'm mugged some day, you won't
ask me to cough up the shekels to build the slammer. O.K.?

"By the way, sir. . . . Do you suppose you could persuade the Fire
Department to accept credit cards?"

On Being Asked How a Dance Company Can Thrive
in Today's City,
or, Leaping Tall Buildings in a Single Jeté

"How," I was asked by the grimly earnest dance company man-
ager, "can we be *really relevant* to our community without compro-
mising the autonomy and integrity of the dance?"

There was such an overpowering innocence to the question that
I forcibly resisted the temptation to guffaw, not wishing to belittle
either the young man or his query. Nonetheless, a dab of facetious-
ness crept into my reply.

"Not very easily."

His expression turned quizzical, then forlorn. Evidently he
caught my innuendo of impatience, and the put-down inferred by
my frivolous answer to his weighty question.

Fortunately for us both, he was abruptly distracted by an afflu-
ent dance maven who wanted his opinion of the resilience of a stage
in a local high school. The two of them drifted away to the buffet
table and began to nibble on cheese.

I had escaped the ordeal of a reply; I had not escaped wrestling
with the question.

It bothered me for some time. It reminded me of the man who
asked the price of a yacht and was told: If you have to ask, you can't
afford it. Similarly, if the young manager knew the diverse phenom-
ena of community, and genuinely understood the resilience and
adaptability of dance, he wouldn't have to ask.

I decided to reply to Tom (a pseudonym) in the form of a letter.
Here it is.

Dear Tom,

You asked me a serious question during the wine and cheese

bash last Friday. I didn't answer you right off, partly because light replies to heavy questions always sound vapid and limp, and partly because Mrs. You-Know-Who lured you away to the wine decanter.

But I've thought about it. It's an important question and deserves a reasonably thoughtful reply. Also a candid reply. So here goes.

I think, Tom, you weren't so much posing a question as making a plea—a plea for greater acceptance, larger support, more popularity than the dance normally enjoys in most cities the size of Syracuse. Give me, you were saying, the best of both worlds—enthusiastic public approval for your creative efforts and, at the same time, the right to pursue an intensely private vision of dance.

There's nothing wrong with that. There's also nothing wrong with Santa Claus or the Good Fairy. But only a handful of the nearly legendary dance companies get to enjoy both.

It's very hard to expect the best of two worlds, Tom, if both are viewed—and I think you're a little guilty of this—with tunnel vision. You are looking at your dance company and your community through the wrong end of the telescope. You're making both much smaller than they really are.

Your delicious dream of your ensemble becoming "truly relevant" to this town begins with a simple premise: if your dancers expect (and often deserve) a sensitive and sympathetic response to their artistry from the public, it follows that the public will similarly expect that *its* visions, concerns and ambitions will receive an equally sensitive and sympathetic treatment by your artists. It's the oldest premise on the planet: *quid pro quo.*

Forgive me if I sound a little presumptuous. But if you really want to begin basking in the radiance of a new relevance, you'd better get your eyes, ears, mind and pores wide open, and begin exploring what's happening "out there" in the community and how what's happening might transform your company into an object of the love, respect and cash that you cherish.

Out there is a veritable treasure chest of ideas for fresh dance subjects and for a new relevance. But the chest has to be opened. But it won't be if you behave like the unborn chick, insulated from the real world and all its provocative and challenging opportunities. In other words, Tom, it's time to hatch.

The unscratched resources are right at the tip of your dancers' ballet slippers—the history and people of the city. The history of Syracuse, not unlike the history of virtually every city in America, can be a choreographer's delight. Imagine how vividly and theatri-

cally dancers can interpret the ordeal of the salt miners who established Syracuse's early identity; imagine a choreographed re-creation of the intrepid Jesuits transforming the wilderness near Onondaga Lake into a civilized outpost; imagine the dance imagery possible in portraying the drama of those who passed through Syracuse on the Underground Railway. And imagine how useful and illuminating such dance experiences would be in regenerating a community's pride in its history—and how heavy the bookings might be as the chamber of commerce, historical society, public schools, churches and a host of other agencies discover you have something to say to *them.*

Onondaga Lake may not be as romantic a subject as Swan Lake; but, after all, Tom, how many swans have you seen in Syracuse?

And if Jesuits or runaway slaves don't turn you on, how about the Legacy of the Iroquois Confederacy, headquartered just a few miles south of Syracuse? The folk tale, myth, and ritual of the Indians offer, as you know better than I, a veritable avalanche of dance ideas and metaphors. They also offer the chance to reinforce a few of the rickety cultural bridges between whites and native Americans. Dancers aren't social workers or anthropologists, Lord knows, but they wield an ancient power—they communicate in a universal tongue.

And how about those ethnics, Tom—that kaleidoscope of German, Italian, Polish, Greek, Ukrainian, and other traditions that give a community like Syracuse a unique color and texture? They're not melting in the melting pot, Tom. Quite the opposite, in fact. National heritage enclaves are getting stronger, fed by a rediscovery of ethnicity—another word for identity. Do you suppose that any of the traditional dances of the Greeks, Armenians, or Chinese might tickle your choreographer's brain or is he forever locked into the stretch-extend-leap school of dance? Can you conceive a dance program that actually *combines* your *entrechat* with a Hungarian *Csardas*? Remember, Tom, that the ethnics represent nearly 70 percent of this community's population. How's that for a gateway to exposure, to that elusive dream of relevance?

There's one other group of people in town you ought to meet, get friendly with, and work out an alliance. It's a group with considerable clout—it'll get three pages of press coverage every day to your two-paragraph coverage once a month. I'm referring to athletes, and the popular enthusiasm they generate. Any reason why you shouldn't hitch yourself to the notoriety and appeal of sports?

Do you suppose a little energetic marriage brokering might be possible, wedding the grace of the ice skater or fencer, the deft

footwork of the boxer, or the live hip-swiveling of the quarterback with the dancer? Don't they all, in many ways, exhibit the same need and respect for poise, balance, control, fluidity, and discipline? Don't the dramatic encounters on the playing field or in the ring, the defiance of gravity on the ice or the pounding rhythms on a basketball court titillate the imagination of a choreographer?

I recall you mentioning several times how dancers are called in to work with football players and improve their "moves." How about—maybe it's crazy—extending and reversing this arrangement and inviting a football player or boxer to a dance rehearsal to develop a new choreographic idea? Who knows? Maybe the boxer will *perform* in the dance program. Can you imagine the kind of press coverage you'll get? And can you imagine further—do I see your accountant smiling—how many tickets you'll sell?

Are these snorts of contempt emanating from some of your board members at the idea? Too bad they either hate *machos* or love poetry. In either case, they'll kill your company and never know how or why it happened.

Well, Tom, I think you can see why I couldn't lay on you this long answer to your legitimate question at the reception. It would not have been—how shall I say it?—decorous.

My point in all of this is so elementary it's prenatal. The dance—any art form—will atrophy and maybe die, like the praying mantis, when it feeds off only itself. It becomes inbred, isolated from the vortex of popular experience, and thus from the people who are the matrix of that experience.

In a nutshell, Tom, the only way to prosper, and ultimately survive, is to recognize that a commitment to *service*—exploring and enhancing the history, institutions, and people of our community—is sometimes more important than the formulation of a *season* of esoteric dance programs. The latter, by itself, can turn people off. The former can turn them on. At some point, with a lot of luck and passion, service and season will merge and be one.

When that happens—man, will you be relevant!

Sincerely,
Joe

How Do I Love Me? Let Me Count the Tourists

I want desperately to stick to the subject at hand; namely, the beneficial effect of the arts on tourism. I want to jump right to the heart of the matter by offering some stunning insights about the

Spoleto Festival in Charleston, South Carolina, the Lilac Festival in Rochester, New York, the Arts Festival in Baton Rouge, Louisiana, the Shakespeare Festival in Ashland, Oregon, and many others. These festival cities have ignited the imagination of travelers and drawn them, like a magnet, into their downtowns, their hotels, bars, shops, and even into their concert halls.

But the harder I thought about these familiar examples of how the arts can heat up tourism, the less I wanted to discuss them. In fact, I found myself being drawn away from the traditional notion of the arts as bait, and being pulled toward the notion of the city itself as the canvas, as the theater, as the concert hall; the city itself as the embodiment of the arts.

Frankly, trying to limit myself to just the arts makes me uncomfortable. Basically, there's nothing wrong with the idea of organizing performing or visual arts events that might inspire a family to drive a hundred miles out of its way to enjoy them. Most cities possess the arts leadership and institutions that could concoct a staggering catalog of cultural goodies, an absolute Eden of artistic wonders. They can, and do, produce festivals of every imaginable kind, stage concerts, mount crafts shows, organize folk music or ethnic entertainments.

For those towns with a P.T. Barnum flair and a shameless sense of show biz, there are no lengths to which they couldn't go: Let's be the home of the International Kazoo competition, boast the world's longest wall mural (six blocks long), become the egg, dish, and rock painting capital of the universe. Why not the only place in the galaxy where a Brahms Concerto is played by musicians wearing wet T-shirts? Why not poets declaiming their verse on street corners, string trios at the exits of parking garages, a 200' x 100' abstract painting suspended by weather balloons a thousand feet over a downtown shopping mall?

Why not? From the traditional to the hysterical, there's a broad spectrum of possibilities for making any city a place tourists absolutely have *got* to visit for a memorable experience in the arts. Simply fuel the imagination with whatever gets the juices flowing and let it rip. The sugar plums will surely begin dancing in the heads of the chamber of commerce.

First, whatever is done—novel or weird—had better be done very well; that is, tastefully prepared, professionally managed, and with real concern for the amenities, necessities, and security of the

spectators. Newcomers to the grab-the-tourist business are up against tough competition from other cities.

Second, an arts festival must not be merely cosmetic, something slapped on like a rhinestone patch on a courtesan's cheek. It has to be an experience that is indigenous to the community and to the recognized skills of local artists. It will be, otherwise, a bland imitation of imitations.

Third, it might not produce the desired miracles; that is, the assumption that some form of annual cultural bash will work magic is dangerous. It's the same mentality of desperate optimism that has convinced a lot of cities that if they merely convert the decrepit 1928 movie house—that was turned into a skating rink, then into a Kung Fu house, then into a porno film house, then into a decaying pile of moldy seats—it will, all by itself, trigger the revitalization of downtown. Wrong.

Fourth, will the attraction be a constant factor? Can a tourist depend on it happening as promised year after year?

Fifth, it will have to be marketed vigorously and widely, with implications of regional or national promotion that may cost a few bucks. And the return on the investment may be slow.

Sixth, who or what will be the leader? Is there *one* institution or agency which by dint of its imagination, programming, voracious PR strategies, commitment to quality, can develop the kind of regional/national reputation that compels tourists to attend? One aggressive institution will be needed to polarize all the others.

The seventh caveat is the most critical, because to get tourists to love us we have to love ourselves.

Given all these caveats, I hope I may be forgiven a small heresy: the arts may simply not be enough by themselves to make a city a focal point, a magnet, an oasis of fun and culture, to which tourists will be irresistibly drawn.

It is certainly not inconceivable that a community's fortunes could be, at least in part, tied to the tails of a symphony conductor, or bound up with the dance as tightly as toe shoes on a ballerina.

There is much more involved than sprinkling the magic powder of the arts on a flame that heats up tourists.

The total environment in which a festival occurs will either enhance or demolish the festival. The environment is, of course, the *total city*—its people, shapes, colors, contents, sounds, and movements.

Think of the cities we have visited, enjoyed very much, and would return to again. Was it primarily the modern art museum or the resident theater company that really dazzled us, that would draw us back? We might have taken advantage of a show in town or strolled through a street crafts fair, if one happened to be going on.

But what we liked most was probably the intangibles: the milieu, that indefinable ambience, the aura a city emanates. We speak of "a clean city," "a friendly city," a "lively city." A city is, after all, a living organism, like a person. It has, or has not, a personality, a style of communicating information and ideas, a way of moving and dressing; it conveys an attitude about order, a sensibility for patience and politeness; it accents, or hides, its best features, whatever they may be. And like an interesting person, a city has an integrity—it's "got it all together" as they say—in the way that it finds a nice harmony among people, institutions and spaces. You get a good "feeling" about it. You want to know it, enjoy it as a friend. As with a human being, however, a city can be terribly vulnerable, and do dumb things. It often needs a lot of guidance and monitoring.

I've often thought, incidentally, that every city should have an "alien committee" or a "stranger committee," perhaps attached to the chamber of commerce. This would be a group of people who regularly prowl their own city as if they were newcomers or visitors. They would simply drive around (with out-of-state license plates, preferably) searching for:

- street signs that are illegible or missing;
- traffic instructions that are confusing, misleading or leave you stranded;
- visual eyesores that can subconsciously grate on a visitor and start developing negative associations with the town;
- empty store fronts (looking like missing teeth) that could be used productively for displays and exhibits;
- how easy it is to find, get into and get out of parking garages;
- the proliferation of illuminated signs that clash, glare, confuse;
- evidence of rubble, trash, litter;
- how easy it is to get information about interesting places or events, such as calling the tourist "hot line," if there is one, and see if anyone answers;

- hotel clerks who really have the information a tourist might need.

The list could be longer. The point of organizing a cadre of civic spies is self-evident. More often than not, cities will irk, frustrate, even outrage visitors because too many visual and physical impediments have been put in their path. A great symphony orchestra, ballet theater, museum or concert hall aren't worth a hoot if the total experience of encountering the city is annoying or negative. When a tourist is trapped on one-way streets, enters the wrong ramp in a parking garage and gets yelled at, stumbles on several beer cans on the way to the hall and arrives forty minutes late for the concert, there's no music in the world that will soothe that savage breast.

It is so easy for cities to get careless and defeat their own tourist goals, especially when hammered by urban crises. Plagued with dwindling tax bases, degenerating infrastructures, political conflicts, and unfilled potholes, who has the time, energy, or dollars to think about the preparation of an attractive logotype system of signs to lead visitors gracefully from one location to another; to identify and develop historic, entertainment and cultural districts, each with a distinctive appeal; to stand firm on strict zoning codes when there's a chance to sell off a piece of open land to a factory developer; to fight the noble and usually losing battle to impose sign ordinances?

An arts strategy to attract tourists will be no more satisfying or effective than is the city in which the strategy must be made to operate. It is when the two are inextricably woven together that tourists get double their money's worth, because the city is the container for the art: and the container is an art itself.

The art experience, in fact, begins long before tourists get to the festival or the concert hall.

It begins when they approach the city limits and are impressed, even subliminally, with the logical and friendly instructions they receive about how to get somewhere (the way a good painter leads your eye to an object); with the rhythms of the structures and spaces that pass along the periphery of one's vision (like the cadence of a good piece of music); with the steady intensification of activity and volume as they get near the center city (the way a playwright builds to a major climax); with the sense of surprise and delight as a park emerges in an unlikely place, a pool of water appears, a stunning

piece of sculpture towers up ahead (the way a magician pulls rabbits from a hat); with the disarming splashes of color that appear on buildings, banners, and flowering things (as if a talented muralist had been at work). The city-as-art experience continues right up to the registration desk at the hotel, where the clerk offers your wife a tiny pink rose in welcome, and we begin to experience the sensation of being applauded for being there.

Is it foolish and impractical to expect a city to become the embodiment of what the arts represent? Is it naive to imagine the city itself as the first movement of the symphony we will hear later? Not at all. It has more to do with attitude—on the capacity of a city's leadership to see its city as theater on the grandest scale.

For the arts to work as a tourist lure, the city has to work as a compatible and reinforcing environment for the arts. They should not, as is often the case, work in opposition to one another.

When they work together, it's a city you want to go back to often. It's a place where "ambience" and "milieu" are not abstractions, but cultural realities. It's a city inhabited by residents who have found much to love and protect, and who become, ultimately, a city's most potent attraction for tourists.

Welcome to the Club, Mayor

Strange sounds have been emanating from City Hall lately.

In itself, not unusual. A lot of strange things—sounds and otherwise—escape from City Halls all across the country. But this is different. It's not the customary clamorous rhetoric, the defensive and offensive posturing, the piddling platitudes that often characterize a political bureaucracy.

The new sounds are odd, tentative—even alien to the ears of rank-and-file citizens. Carried on the sounds is the seed of a startling message: we can become the Beautiful City, the Humane Haven, and—do I dare say it?—the City of God.

Wow! Heavy stuff, awesome sounds. If I'm guilty of over interpretation, so be it. But the beginnings are there—the germinal probings, the tentative feelers.

Our Mayor has begun uttering what I thought was an obsolete, if not downright heretical word among high elected officials: *beauty.* Holy mackerel—what are politicians coming to?

But that's the word. Prominently ranked with pothole, garbage, and taxes is the provocative word *beauty*. And not just talk. The Mayor invited children to write essays about what's good and beautiful about our town, and then launched a task force to remove dead auto carcasses, smelly dumpsters, and miscellaneous rubble.

If he really pursues it in a gutsy fashion, who knows what'll follow—more lovely wall murals, pocket parks, flowers, historic preservation, sign ordinances that get rid of eye pollution, noise abatement ordinances that reduce ear pollution, commissioning of public art, maybe a City Arts Task Force. It makes everything boggle.

The inspiration for this new talk about beauty is, I think, our Mayor's visit to Baltimore, to the city whose Mayor is unashamed of the notion that a handsome city is a happy city; that a civilized and appetizing environment is the most powerful statement a city can make about its identity, values, and future.

And more than Baltimore. There are potent stirrings all across the country, from Portland, Maine, to Durham, North Carolina, to Seattle, Washington—an unsteady and still awakening perception of the city as something a lot more than a cluster of dull and often grimy habitats for work and commerce.

This was the subject of "The Art's Edge," a major conference in Pittsburgh a few years ago that attracted several dozen mayors and urban planners, all eager to explore and exchange ideas for rediscovering the lost good looks of their towns. It was the subject of a statewide gathering in Santa Barbara, California, when nearly two hundred community officials soaked up sessions on the role of cultural facilities as medicine for their ailing downtowns. It was the subject of a nation-wide conference in Winston-Salem, North Carolina.

The theme that runs through these and other conferences? Cities have been dumped on, beaten down, abused, diminished in their once strong role as the focal point for history, government, commerce, and culture. A gloomy and decaying urban environment breeds a gloomy and decaying citizenry. Conversely, when a city delights, astonishes, stirs and inspires; when sound, light, and color stoke the spirit; when the noise of a fountain is at least as strong as the noise of a truck, remarkable things happen to the psyche of citizens. They begin to like the place. Maybe even love it. And they're a lot more eager to sustain and protect it.

The dream of finding and restoring beauty to a city (don't chuckle, it's really possible) is gathering more and more believers every day. It should; it's a dream that can produce quick and compelling results. There are now enough believers, in fact, to form the ABC—the Association of Beautiful Cities.

Keep making those alien sounds, Mayor. Enroll as a full member in the Club.

Trying to Reach Bottom

1979 was a banner year for weighty resolutions on the arts.

If we bathe long enough in the warmth of their heady and courageous prose, we could have concluded that the arts were home free, that individual artists were shortly to be restored to Olympus, and that state, city, and educational bureaucracies were about to transform the American community into a cultural Eden.

The vision of a renaissance begins to dance in the battle-weary soul.

At least three major national organizations forthrightly declared, in convention assembled, the need to realign community priorities to open the door, more than a crack, and let the arts rush in.

The National Conference of State Legislatures resolved to encourage its national constituency to give more money to the arts, to recognize and protect creative work, to stimulate support from the private sector, and to help communities understand the economic benefits of the arts.

A month earlier, in Pittsburgh, the National Conference of Mayors' Special Standing Committee for the Arts, spearheaded by the then Mayor of Atlanta, Maynard Jackson, adopted a resolution aimed at stirring interest by local government in the sociological, aesthetic, and economic values of the arts. It went further by calling on Congress to provide funding to cover one-third of the cost of municipal arts efforts.

And then the National PTA got on board at its Convention by resolving that PTAs create a public awareness of the arts, be strong advocates of improved arts education programs, emphasize the value of the arts as useful tools for everyday living, and to encour-

age school districts, officials, and teachers to integrate the arts into the school curriculum.

The barrage of high-echelon, national support was most welcome, long overdue and emotionally stirring.

But what, one may ask, has been its rate of percolation? How rapidly did the rhetoric that reverberated in the distant convention hall begin to echo in the local city hall? How long will it take for the radiant goals of PTA national delegates to shine in the middle-school classrooms of Anywhere, USA? The heroics of the dais may easily be dissipated on a long plane flight home.

The high level resolutions of '79 are important and beautiful.

But when will they begin to reach bottom?

Out of the Closet—Almost

The deception has been practiced long enough. It's time to discard my false identity and come out of the closet—somewhat.

For years I have been hoodwinking my friends, colleagues, and even my innocent children by pretending to be an arts manager. The truth is, I'm no such thing. I don't run an arts agency; I run a business—a bottom-line, no-glamour, balance-sheet business. I listen to a violinist and I don't hear music; I hear a sobbing CPA. I watch a dancer and I don't see *pliés*; I see a huge payroll. And while the stormy declamations of Shakespearean actors are rending the scenery, I feel the rumbles emanating from the board room as trustees rage with discontent over a disappointing season.

There. It's out. The arts may continue to be the symbolic evocation of truth and beauty, but for me they are products that must be packaged, promoted, and sold to consumers at a markup sufficient to cover costs and, maybe, make a profit.

For those colleagues who may think that I've either defected to the enemy or gone mad, I will prove what I am. For instance:

I operate out of a "place of business" located at 411 Montgomery Street, Syracuse, New York. Our papers of incorporation do not refer to our establishment as a citadel of culture.

I have twenty full-time employees, and a variable number of part-timers, who expect monthly or bi-weekly paychecks, benefits package, safe and sanitary working conditions, paid holidays, and the right (for the distaff side) to get pregnant;

I'm obliged to deal with several trade unions—Musicians', Stagehands', and Service Employees', which has helped me perfect my skills at walking on eggs;

I need to cope (that is, haggle) with suppliers—otherwise known as Artist Representatives—who will occasionally send me a piece of operatic merchandise who won't perform because the dressing room lights are too dim, or because house rules prohibit her mangy cocker spaniel from sharing her dressing room;

I have to apply stringent controls to make all expenditures cost effective—right down to analyzing the unit price of paperclips;

I'm responsible for a huge inventory of large and sophisticated equipment, all of which is part of a sinister conspiracy to burn out or wear out ten minutes before the curtain goes up;

I'm required to prepare annual operating budgets and P&L statements. In my business, red appears more frequently than black;

I'm intimidated by the usual assortment of thin-lipped, cold-blooded auditors who seem to forever hover at my shoulder, and by unannounced visits by the friendly neighborhood IRS staffer;

I have stockholders—over a half a million of them, all county citizen taxpayers—who are notably unreluctant to tell me what I'm doing wrong;

I must carry a clump of heavy insurance policies (to cover everything from stubbed toes to implosion of the solar system) and retain regular legal services (to defend us in court against the man who stubbed his toe rushing to the bar at intermission);

And I have, as do all struggling businessmen, my share of dissatisfied customers—such as the elderly lady who treated her granddaughter to a George Carlin performance, not knowing the colorful and smoky language he uses.

My bible, my inspiration, is no longer the Collected Works of William Shakespeare or John Dewey, but Drucker on management principles or the *Wall Street Journal.*

Despite all these obvious manifestations of the businessman syndrome, I must confess that I'm finding it difficult to come completely out of the closet.

There are just a few nettlesome things that make my kind of business deviate from that of a widget manufacturer; and that may, in fact, forever deny me an award as Businessman of the Year.

The widget maker and I have some fundamental differences. He deals in objects that have a reassuring, three-dimensional solidness to them; I market an intangible phenomenon—beauty.

He makes money directly from his customers; I make it indirectly by generating audiences that will spend money through a community.

Our widget maker may endure an occasional nightmare induced by the thought of profits seeming to evaporate in a particular quarter of the year; I have a recurring nightmare about my business evaporating permanently.

The nightmare is always the same. An alien, highly selective virus suddenly appears. It attacks and obliterates only the performing and visual arts. Within twenty-four hours, all the words, sounds, and colors that artists normally produce vanish. Everyone associated with my business—the business of arts and entertainment—with the making of products that brighten the eye with colorful images, fill the ear with lovely sound, or excite the mind with challenging ideas, are gone.

At first, most people don't notice the change.

Slowly, the impact of the virus begins to be felt—in two very tender places: in the economy and in the climate of this community. The economic impact of the collapse of my business is easier to grasp.

That awful virus would force more than one thousand people into unemployment lines, and immediately wipe out $5.9 million in payments for salaries and services. The annual volume of sales by nearly four hundred local merchants and suppliers would drop by $2.2 million; 1.8 million people—drawn from a fifteen-county area of central New York, Canada, and Pennsylvania—who enjoy the resources in history, science, and the arts of this area—would have no place to spend $2.7 million annually on tickets for shows or admission fees.

When all the lost dollars are tallied, and the standard multiplier is applied, that nasty virus would have demolished my $33-million-a-year business.

It's the second impact of that deadly virus, however, that explains why I've never been solicited for membership in the chamber of commerce or invited to join the venerable Century Club.

Defining the impact of my business on the climate of a community—on its "quality of life"—is like holding mercury and

mist; you can't put it in the freezer, wear it on your feet, or send it to your mother for Christmas. Yet, it's the most desirable and useful product in my catalog.

One of the hallmarks of a vital and sophisticated community is the way it demands a certain "quality of life." It's an overused and fuzzy phrase, to be sure; but I think it means having choices; options; knowing that you can find what you need (emotionally or physically) in your own city. It means knowing that there are resources out there of all kinds—commercial, cultural, recreational, educational, religious, medical—of a quality high enough to make us feel secure and confident about finding the kind of protection and fulfillment that we need for a satisfying life.

This "quality of life" factor makes the difference between liking where you live or hating it; between being an avid consumer or community activist or staying locked up in your house; between believing that your city has a future, or writing it off as a bust.

There is validity to the notion that a community has a distinct "atmosphere" or "climate." And this climate is really a composite of a lot of institutions, programs, people, services, and businesses that make a place interesting, civilized, livable.

It's this "climate" that major corporations study (after labor force and taxes) when they size up a town as a place to build and operate. What are the schools like, they want to know, the shopping, and can my little girl continue her dance lessons?

It's this "climate" that major urban investors and developers try to analyze before committing to multi-million dollar projects.

It's this "climate" that smart realtors push when they try to sell or rent property to out-of-towners. (A brochure prepared to market a new high-rise apartment building in a redeveloped downtown area of Syracuse stressed its proximity to shopping, the Everson Museum, and the Civic Center performing arts facility.)

It's this "climate" that major colleges and universities emphasize when trying to lure students into their city.

And all things considered, my business hasn't done too badly in creating a good "climate," a good "quality of life." It remains, however, a hard product to wrap and put in a bag.

The two pesky and unsolid features of my business—the indirect boost to the local economy and the ambiguous force called quality of life—will not, I'm afraid, ever let me feel comfortable, like one of the guys, in the circle of card-carrying businessmen at a Kiwanis lunch.

Well, so be it. I'm doomed to remain, at least in very small part, an unregenerate arts administrator. Besides, I'm not that keen on the lunches they serve at Kiwanis.

6

Freeing Pollyanna

The most striking development in the American arts scene in the past twenty-five years did not occur in the fashionable ateliers, galleries, or concert halls of New York City, Los Angeles, or Chicago. It occurred in LeMars, Iowa, Arvada, Colorado, Lusk, Wyoming, and Spruce Pine, North Carolina, and at least 3,000 other communities, large and small. It spread, like wind-blown seed, from coast to coast, taking root and sprouting rapidly as arts "councils," "commissions," "associations," "alliances," "centers," "programs," "foundations," "federations," and "confederations."

The development is the "community arts movement," a powerful grassroots phenomenon of communities asserting their cultural democracy and taking possession of their own cultural destinies. There has not been a proliferation of locally-based arts activities since the WPA scattered paintings, poets, playwrights, and composers around the nation in the 1930s.

The movement took shape during the social turbulence of the 1960s—as a gentler manifestation of the cry for independence and identity—and energized by a Pollyanna-like optimism about its mission of transforming culturally arid communities (the "wasteland") into luxuriant artistic oases.

The motive was pure, lofty—even visionary. It was also eminently pragmatic. Every community is endowed with a healthy crop of talented citizens. It makes simple good sense to cultivate and harvest that crop, to package and deliver it to one's own town. It's logistically, politically, and economically smart. It is also, not incidentally, a genuine boost to the communal ego. It injects just

enough class to serve as an antidote to the sense of cultural inferiority many communities suffer.

Given the legitimacy of its origins and the high-minded goals of its mission, why does the grassroots arts movement so often appear to be in peril? Whence the long faces, provoked looks and survivalist chatter at national conferences? How did Pollyanna end up getting pricked and scratched in the unfriendly Brier Patch?

There are many reasons—cultural, historical, sociological, and financial. Some have already been explored in the essays that make up this book. By way of recapitulation, however, three reasons seem to predominate. Youth, stability, and mission.

The youngness of the community arts movement—barely a generation old—is the source of its pervasive charm, remarkable energy, and robust ambition. Like the adolescent thirsting to experience life and grow up fast, the movement betrays its youth in a number of revealing ways. It is still struggling, for instance, with the formulation of a language; or a vocabulary that is universally understood by peers. (Ask six arts council directors for a definition of "festival" or "outreach" and there'll be at least eight different answers.) Pollyanna may be crying out for rescue from the briers but she may be speaking in a tongue that is alien to her colleagues.

As a youthful creature, the movement is still searching for how to characterize itself—what principles, standards, or guidelines will give it a recognizable identity. A number of major national organizations—the National Endowment for the Arts, the National Assembly of Local Arts Agencies, to name just two—are still drafting and re-drafting criteria that tried to capture and contain the mercurial quality of the thousands of agencies that comprise the movement. The exercise in criteria-writing was like catching wind in your hand.

There is also a certain youthful bravura still evident in the way many community arts agencies labor valiantly to become instant bureaucrats. They have been forced to study and speedily digest, goaded by grant-giving foundations and corporations, sophisticated techniques of long-range planning, budgeting, promotion and marketing, office management, and a host of other skills that are normally antithetical to the unfettered spirit of the sculptor-turned-administrator. Acquiring these skills is a matter of acquiring enough legitimacy and credibility to be taken seriously by foundations, corporations, and even the local city council.

The youngness of the movement is apparent in one other way—lobbying. Only in the past several years have community arts agencies discovered that they were covered by the U.S. Constitution and could diligently organize and aggressively carry out a campaign that would influence the decision-making process in city halls, state capitals, and the U.S. Congress. Indeed, nearly a dozen states have formed "advocacy alliances" to mobilize broad public support for pulling the arts out of the priorities cellar. Many such alliances have been remarkably effective.

Even with some occasional lobbying success, the arm-twisting and pressure is characterized by a fitfullness and inconstancy consistent with a very young movement. For all of Pollyanna's radiant aspirations, she'll often forget to write the letter, make the phone call, or to realize that she, along with her thousands of grassroots peers have the capacity to form a network of lobbying power that could rival the AFL-CIO or the National Rifle Association.

The second overriding reason for Pollyanna's plight is the matter of stability. For a movement that is widespread, vigorous, and still growing, it is just slightly less than miraculous that many community arts agencies are able to survive from Monday to Friday.

Over half the community arts agencies in the United States are run by volunteer staff, or part-time paid staff. No aspersions on volunteers are being either cast or inferred. Without them, there would be a complete cultural void in many towns. But volunteerism merely equates with continuity; and without the sustained, single-minded and persistent implementation of cultural services and goals, an agency's credibility and impact will remain vaporous.

And even when a full-time, paid director is in place, the wages are invariably pathetic—sometimes on a par with, but usually below, that of school teachers or librarians. Often, no fringe benefits, health or life insurance are available, exacerbating a director's impulse to move on, move up, or move out of the field altogether. (And the moving out has begun. This is common to any field; it's particularly hard when, as in the case of community arts, the ones who are moving out are the ones who have given the movement its substance and credibility.)

Money threatens the stability in other ways. Two familiar plagues—"deficit mentality" and "cash flow crisis"—erode the spirit and cripple the creativity of arts agencies. Long-range planning processes are melancholy exercises when an agency's muscle is denervated by the gloomy prospect of insolvency.

Contributing further to undermining the stability of community arts agencies are boards of directors. This is not the blanket condemnation it may appear to be: directors are, for the most part, a zealous and abiding bunch, faithful to an amorphous cluster of cultural ideals, but troubled by a tacit uncertainty of both their individual roles and their collective mission. Inadvertently, they destabilize their own agencies by plugging away at day-to-day programs and crises at the expense of the long-range process of change these programs and crises are supposed to precipitate in their communities. They threaten stability by donning their charitable, culture-is-grand, not-for-profit hat at meetings, and leaving their banker, insurance, and manufacturer hats outside the boardroom. They weaken the agency further by neglecting to establish clear, written standards of job performance for both themselves and staff; or if they have such written guidelines, are negligent in applying them with the necessary harshness. (How long would a director of Exxon last if he or she failed to attend meetings, denied the company the expertise or influence he or she possesses? Arts boards are much too tolerant of dead wood.) They diminish their own effectiveness when they neglect to protect themselves and the corporate entity they serve as trustees by not insisting on an "indemnification clause" in the bylaws, by not subscribing to directors' and officers' liability insurance, and by not enforcing strict guidelines that prevent conflict of interest. (A major midwestern arts council was decimated when the executive director hired a board member—her husband—to conduct certain architectural studies, and paid for them with federal funds.)

Both staff and board are often victims of benign indifferences— to themselves (by a much too casual conduct of business) and to the communities they serve (by not developing the kind of stable organization a community will trust and protect).

The youthfulness of the movement, and the uneasy stability of the agencies that comprise the movement, seem to coalesce in the third reason for the dilemma of Pollyanna: the maddening, almost schizoid pursuit of a clear and consistent mission. It is like a juggling act using diamonds and daggers; if you catch them or drop them, either way you're in trouble.

Community arts agencies are charged with, and expected to properly carry out, a welter of chores (their "mission"), but are confounded by enough real-world constraints to induce a raging paranoia. Example:

- be socially responsible (to the aged, the handicapped, the disadvantaged), but where is the Good Fairy with the money to support free programs?
- be politically sophisticated, but don't really expect those politicians to listen, care, or even understand why culture is more important than highway repair;
- be fiscally sound, but let's not hesitate to conduct a bold experiment or two with the unknown or the untested;
- be innovative programmers, but please favor those fundable, sure-thing, money-making projects;
- be savvy fundraisers, but don't expect the very busy board to meet its quota of dollars;
- be sensitive to native (local) talent resources, but, ah, how we love the Big Stars;
- be cooperative in servicing brother and sister arts agencies, but don't step on their toes, invade their turf, or deny them the lion's share of promotion and dollars;
- be astute long-range planners, but how in God's name can we meet the month-end payroll?
- be a solemn custodian of the earth's cultural riches, but don't be a snob, fella—some of us like to swing.

The list could be longer, but the point is evident. Purpose and practicality, high service and self-service, remain somewhat like oil and water.

Will Pollyanna escape the brier patch reasonably unscathed? Given the slightly morose tone of the preceding observations about youth, stability, and mission, it appears that Pollyanna—that incarnate symbol of a cultural paradise reborn—may bleed to death from the puncture wounds.

This is not the case, however. The community arts movement is a profoundly democratic phenomenon. It will not be relinquished by citizens who have discovered the uniqueness of the arts as a vehicle for self-discovery, for civic and social enrichment, for enhancing the economy of a town, for revitalizing an urban core, for energizing the education of the young, or for conveying a sense of growth and civility.

The movement may seem shaky at times, of uncertain origin and destiny. But there is no uncertainty about its intuitive compulsion to survive, to serve, and to radically alter the arts climate of a community.

The adolescent skin of the community arts movement will shed quickly. The halcyon days of cultural rapture and support—if they ever really existed—are long gone. The movement has been booted out of Eden. It now has no choice; it must learn and implement survival skills or die. Some arts agencies will pass away, victims of insolvency, rigidity, and ineptness. So be it. But most will adapt to a less hospitable clime and become savvy, resilient, and stable agencies; many are there already. They will even have to resolve the maddening contradictions, the annoying ambivalences that afflict policies and programs, because they will realize that contradictions and ambivalences are an inherent and challenging manifestation of the American *persona*.

By 2010—one generation hence—it is possible to envision a National Congress of the Arts, a coast-to-coast consortium of tough-minded visionaries, hardy and toughened Pollyannas who, in a single voice, will proclaim the realization of the Third Revolution: the arts as the keystone of American culture.

It is invigorating and necessary to be presumptuous. Community arts agencies, when they view their mission rightly, are more than a delivery service for cultural products. They are, instead, perpetuators of a magnificent hypothesis: that the human race is not a doomed species; that it wishes to preserve a humane and civilized society; and that its appetite for sanity is manifested most eloquently by the quest for excellence that is the inexorable mandate of the artist. The community arts movement must be audacious enough to believe that it can feed that appetite.

Why do it? To give and receive a blessing. A Canadian poet, inspired by the incantations of the Ojibwa Indians, captured the fundamental reason for the existence of the community arts movement in the form of a prayer:

Blessed be the musicians of the world who sing out the song that fills my heart;

Blessed be the painters of the world who capture the forms and the colors dancing behind my eyelids;

Blessed be the poets of the world who take the plain words from my lips and hurl them with their magic like sacred birds into the sky;

Blessed be the guardians of legends and dreams for they let music and words of love swell within our souls so we can offer them like a prayer.

Marielle Bernard, author of *Blue Sky Takes A Wife*. Stage adaptation by Theatre Sans Fil, Montreal, P.Q. Canada. Reprinted by permission.

POLLYANNA IN THE BRIER PATCH

was composed in 10 on 12 Century Schoolbook on a Compugraphic Quadex 5000
by BookMasters;
with display type set in Reiner Script by Rochester Mono/Headliners;
printed by sheet-fed offset on 55-pound, acid-free Glatfelter Antique Cream,
Smyth sewn and bound over 70-point binder's boards in Joanna Arrestox B
by Maple-Vail Book Manufacturing Group, Inc.;
with dust jackets printed in two colors by New England Book Components, Inc.;
designed by Will Underwood;
and published by

SYRACUSE UNIVERSITY PRESS
SYRACUSE, NEW YORK 13244-5160

0